MW00812513

David Brussat is an eloquent defender of the traditional city against the assaults and insults of our time. His efforts have helped preserve and improve the gem that is Providence. Plus, he writes beautifully.
—*James Howard Kunstler, author of* The Geography of Nowhere

This is a marvelous book. It complements previous work (including his own), yet manages to be original and to cover much new ground. I am delighted by this book's carefully delimited scope, to which Brussat adheres consistently throughout, never straying far from his design-centered theme. I am impressed by the richness of his research and the originality of the case studies and anecdotes that buttress his narrative; the rigor of and consistency in his use of solid evidence; the corrections that he politely makes to distorted past renderings of elements of the Renaissance story; and, in particular, how he manages to rein himself in at just the right moments, halting just ahead of the precipice of unsupported assertion and grandstanding.
I find that Brussat has been vigilant with the data, appropriately cautious when gaps in the record demand it, and bold only when the truth is self-evident and an ugly façade literally strikes us numb…or dumb.
I love this book.
—*Mark Motte, co-author of* Providence: The Renaissance City

LOST
PROVIDENCE

DAVID BRUSSAT

FOREWORD BY ANDRÉS DUANY
CO-FOUNDER OF THE CONGRESS FOR THE NEW URBANISM

THE
History
PRESS

Published by The History Press
Charleston, SC
www.historypress.net

Front cover: "Butler Exchange," VM013_WC0299, Rhode Island Photograph Collection, Providence Public Library.
Back cover, top: "Union Station," VM013_WC1526, Rhode Island Photograph Collection, Providence Public Library; *bottom*: PC7653-11, Rhode Island Postcard Collection, Providence Public Library.

First published 2017

ISBN 9781540225719

Library of Congress Control Number: 2017938332

Notice: The information in this book is true and complete to the best of our knowledge. It is offered without guarantee on the part of the author or The History Press. The author and The History Press disclaim all liability in connection with the use of this book.

To Victoria and Billy

We shape our buildings; thereafter, they shape us.
—*Winston Churchill*

CONTENTS

CONTENTS

FOREWORD

ANDRÉS DUANY

This book is about cities—the way they look and the ways in which they change, for better or worse. Specifically, it is about the city of Providence. But it is also about a certain kind of hero: persistent, well-intentioned, passionate, smart, risk-taking amateur. There are many of them in this story of an urban revival—and the author is principal among them.

That downtown Providence has been the work of so many would tend to reduce their identity, but David Brussat corrects that—and embeds their role in a series of lessons quite adaptable to those other midsized Northeastern cities where the glacier of industry has receded, leaving behind a set of beautiful and mangled old landscapes.

Because of his modesty, one might easily overlook the contribution of the author to twenty-first-century Providence. As a daily journalist, he is expected to play the role of disinterested reporter. But that has never been his stance. Brussat crossed the line to become a motive force. I do not know of an architecture journalist more deeply committed to his city or more prepared to go up against the powers-that-be—for he has also been very, very brave.

And what of the city of our interest? It is evident to this professional outsider who has worked in several other similar cities that there is something about Providence that is uniquely proactive. This is in contrast to the more common flattery of calling a city uniquely resilient. For Providence, astonishingly, has in the past three decades implemented all of its major urban plans. It is a city that gets things done, in contrast to the

notorious reality of most postwar urban plans, which remain on the shelf. Completing plans has not been the problem with Providence—the problem has been that most of these plans were awful! They were typical of postwar urban theory: downtowns should compete with their burgeoning suburbs by suburbanizing the city. The flaw in that thinking is that the retrofitted city, with its pedestrianized main streets, parking lots in place of buildings and proliferation of national retail tenants, is inferior to the purpose-built suburban model. Rhode Islanders assumed that, because things had gotten worse and worse for decades, they had failed to follow the advice of their planners. In fact, they were too often following the plans. Blessedly, the worst of these plans were stopped: the sinister Downtown Providence 1970 plan, which would have demolished much of the central business district; and the barbaric College Hill Study, which would have demolished too much of the city's oldest and dearest neighborhood. Both historic districts would have been pockmarked with strikingly insensitive architecture.

How obviously wrong those plans seem now! For Brussat's generation, the challenge—now largely implemented—was to restore the downtown to its original, excellent urbanity. This required plenty of people working in parallel, with small-scale repurposing of buildings for dwellings, restaurants and shops, and a cooperative government's helping out with cultural activity—both edgy and mainstream. And in the case of Providence, the work included quite a lot of ripping out of monstrous infrastructure—such as the Chinese Wall and, even more notorious, the Widest Bridge in the World—and then, as it is now inevitably phrased, moving rails, moving rivers and moving highways. There has been nothing like it anywhere. Nowhere else have so many radical infrastructure modifications been coordinated and implemented. Most cities manage to accomplish only one such change.

And unless someone like David Brussat points all this out, Providence would continue to underestimate how remarkable these accomplishments have been. Perhaps it will shed its pervasive sense of modesty—there is too much of it going around and, besides, it is false. Yes, the twentieth century was not kind to Providence. But let's get used to this: in most ways that count, the twenty-first century promises to be a great one for this city. Even if the individuals described in this book become hazy memories, the two generations that precipitated the transformation will be considered important in the history of Rhode Island. Not bad for having fun—because that they also did!

I am thrilled that this story is being told in detail and that it was written by David Brussat. As a journalist he has the skill to communicate with

regular folk in ways that academics and professionals cannot. This will add impetus and coherence to what is happening in Providence, and it is likely that this book will be wielded as a manual by other cities. They would do well to have a journalist like David in their midst.

ACKNOWLEDGEMENTS

Rummaging around the closet of one's memories covering architecture and development in Providence for a quarter of a century on the editorial board at the *Providence Journal* may not be the best way to write a book. But I must acknowledge that my memory has been backstopped in this process by my voluminous library and archives.

For the inspiration to write this book I thank my original editor at The History Press and Arcadia Publishing, Edward Mack, who saw my *Providence Journal* column "Providence's 10 best lost buildings" and asked me to expand it into a book. Ed supported my desire to expand the book's theme to cover lost development plans as well as lost buildings, and he kept up my spirits as I began writing not my familiar output of eight hundred words for the next day but forty thousand words for some months in the always insufficiently distant future. For pushing me through to completion and directing me, like a ship's pilot, through the shoals of a writing project's end-game, my deepest thanks to Banks Smither, who stepped in after Ed took off to see the world.

For backstopping my way through the first half of the book, I thank John Hutchins Cady, author of *The Civic and Architectural Development of Providence*, published in 1957, and Wm. McKenzie Woodward of the Rhode Island Historical Preservation and Heritage Commission, author of the commission's survey "Downtown Providence," published in 1981. For the second half of the book I am indebted to Mark Motte and Francis Leazes, whose 2004 book *Providence: The Renaissance City* provided a fascinating and comprehensive trove of information about how the renaissance developed.

ACKNOWLEDGEMENTS

If anyone wants to learn more about all of the many factors in this process that are beyond the scope of *Lost Providence* and, for that matter, entirely beyond this writer, they should read that path-breaking work of investigatory development history.

My library and archives were, I hope, sufficient to help me inject fact and truth into *Lost Providence*, but I needed much help to secure the illustrations, for architectural writing demands a visual link to its subject. I cannot begin to express my appreciation in providing this and in some cases other types of assistance to the following: Kate Wells of the Providence Public Library; J.D. Kay of the Rhode Island Historical Society; Caleb Horton of the Providence City Archives; its former director, Paul Campbell; Raymond Butti of the Hay Library at Brown University; Ted Sanderson at the Rhode Island Historical Preservation & Heritage Commission; Peggy Warner, artist and widow of Bill Warner; Brent Runyon of the Providence Preservation Society (PPS); and Cornelis de Boer at Haynes/de Boer Architecture + Preservation, located conveniently around the corner from PPS.

For all the help I have received in assembling my first book, every one of the mistakes in the book that are discovered and telegraphed to the world by fussbudgets and know-it-alls (members of a venerable tribe, in which I count my own self) are properly blamed on me.

I also thank the *Providence Journal*, first for allowing me to write about architecture for a quarter of a century and then for granting me the time to write this book. In 1990, I was encouraged to stop writing weekly about politics and was then permitted to write weekly about architecture, for which I thank my editor at the time, Philip Terzian. He gently nudged me off the pundit treadmill and onto a unique path of service to society as the only voice in daily American newspaper journalism advocating traditional over modern architecture.

Finally, my heart and soul beat with appreciation for the patience and love shown by my wife, Victoria Somlo, and son, William Laszlo "Billy" Brussat, age eight, to whom this book is dedicated. Okay, and also to Gato, our cat, who thinks she's a dog but cannot bark and yet watchdogs our new fish, Bluebird. Thank you, Gato, for that!

INTRODUCTION

G o two blocks and turn right where the Outlet Building used to be."
You can substitute your own lost building of choice. This way of offering directions to strangers may not be the exclusive preserve of Rhode Islanders, but it does illustrate the adage that change is the only constant.

This book is about that change as it has unfolded in Providence, the capital of Rhode Island. Buildings everywhere are torn down and replaced with other buildings, but that may be far less true of Providence than of any other city of its size, or larger, in this nation.

So why should Providence be the subject of this book? Well, the author lives in Providence and knows it better than any other city. But the fact that Providence has lost fewer buildings than most American cities makes it more beautiful than many if not all of those cities. In short, while change remains the only constant—even in Providence—the city has managed to slow the pace of change.

People who care about cities—including people with the authority to speed up or slow down a city's rate of change—don't know why cities change as fast or as slowly as they do. This book describes how Providence has changed building by building, but it also hopes to describe some of the principles that regulate change in cities.

Providence has had the good fortune of changing slowly, but not because the city and its leaders have a policy of slowing the pace of change. Hardly. In the first three hundred years since its founding as a colony in 1636, the city's rate of change has been slow or fast largely independent of municipal

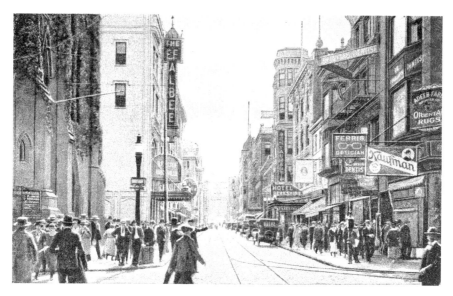

Westminster Street, postcard circa 1915. *"Westminster Street, Providence, R.I." PC7653-11, Rhode Island Postcard Collection, Providence Public Library, Providence, RI.*

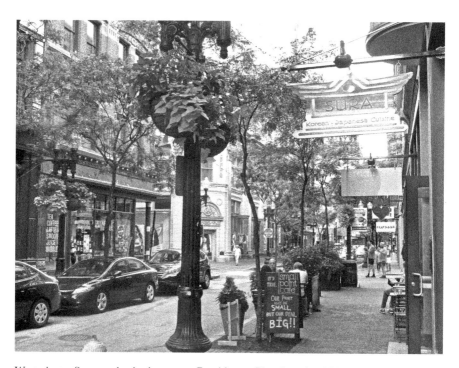

Westminster Street today in downtown Providence. *Photo by author, 2015.*

policies. For much of the city's history, the replacement of old buildings and houses with new ones was a fact of life, rarely deplored. Look at the postcard of Westminster Street in downtown from a century ago. Very few of those buildings remain with us today. And yet the street has retained its pleasing appearance. Over the past half century, city leaders have tried to accelerate the pace of change, but most efforts to do so hardly got off the ground. The result is that fewer beautiful historic buildings have been demolished in Providence than in many cities of its size.

Between 1979, when the Hoppin Homestead Building was demolished, and 2005, when the Providence National Bank Building was torn down, no major historic buildings in the old downtown were razed. This means that a quarter of a century passed without the loss of a single venerable and venerated building, at least in downtown, where most of the change described in this book takes place. Yes, the Hoppin Homestead site has been a parking lot ever since 1979. And the Providence National Bank site has been a parking lot ever since 2005. That sounds appalling, but a parking lot is a better alternative than a new building that fails to live up to its

View from portico of 283 Benefit Street through Hope Club (1885) parking lot to First Unitarian Church (1816). *Photo by author, 2016.*

predecessor's standard of beauty. You can still build something nice on a parking lot, whereas a new building is often destined to poke us in the eye for decades to come until it, too, is demolished and replaced.

That is why the dark cloud of the demolition of the Edward Pearce House in 1960 had a silver lining: the resulting parking lot for the next-door Hope Club. The author lived for six years on the third floor of the Bush-Updike House at 283 Benefit Street, directly north of the Hope Club parking lot, whose existence improved the author's own world by liberating his view to the south of the First Unitarian Church across Benevolent Street. A future new building, let alone a nicer one than the Pearce, on the Hope Club parking lot is highly unlikely now or at any future date. But it is possible to conceive of one, and it is pleasant to wish for it. Meanwhile, the parking lot is surrounded by a lovely wall of brownstone topped by a wrought-iron rail.

The author here dares to reveal a prejudice that underlies the thesis of this book. It hinges on the fact that after a certain point in the city's history, paralleling the history of cities everywhere, a very sad transformation took place. For centuries, going back long before Providence was founded in 1636, way back to the beginnings of cities in ancient times, the demolition of a building was rarely cause for distress. It was generally followed by the erection of a better building—often bigger and more elegant, but certainly using advances in construction materials and techniques along with the latest features to enhance the convenience and efficiency of residing in or working in a new house or a new building. The owner of a piece of city land naturally would want to replace a building he owns with something better. This was called progress.

Alas, beginning more than half a century ago, it was increasingly the case that the demolition of a building was followed by the erection of a worse building, often bigger but usually less adorable as measured by conventional standards. By 1950, the old ways of building had been largely replaced by the new ways of building. The new ways became the operating template of the planning and design establishments. From that time on, city lovers and homeowners had increasing reason to expect that demolition would be a greater source of dread than of hope.

The author's preference for traditional over modern architecture underlies this book's thesis that change has generally been a bad thing for cities since about 1950, at least in America. Citizens did not take it lying down. Historic preservation, which had been a hobby mostly of antiquarians seeking to preserve buildings of historical importance ("George Washington slept

On Dorrance Street, a clash of styles between the fourth Howard Building (*left*) and the Union Trust Building. *Photo by author, 2016.*

here!"), was transformed into a mass movement to preserve not just vital buildings but whole neighborhoods and sections of town from the threat of modern architecture. This transformation into a movement took place swiftly, matching the speed with which the old ways of building were superseded by the new ways.

In girding up this book with a prejudice in favor of the public's abiding taste for tradition and fear of change, the author believes he is making the case for a better built environment. He likes to think he argues on behalf of a large majority of the population that, as a sort of defense mechanism, has tuned out their unlovable surroundings. People believe not just architects have tuned out the public, but so have municipal officials who oversee building projects and development. People believe the deck is stacked against the public's tastes.

Providence is very well preserved, but it must be noted that preserving a given house or building merely preserves the existing beauty of a street. This effort is admirable, but it is not enough to counteract the erosion of

beauty over time. It is imperative that if preservationists want to protect what they preserve, they must eventually come around to promoting *new* architecture designed under the same principles that produce beauty worthy of preservation in the first place. Only then will a city evolve in ways that ensure that the desire to spend time, money and effort preserving the city—rather than the desire to shut one's eyes to the city—will continue into the future.

This book, therefore, judges lost buildings as tragedies only to the extent that they are replaced by worse buildings. Bad enough if they become parking lots, but that still leaves room for hope. Standards exist for making these judgments.

While hardly qualifying as a screed against modern architecture, this book seeks to convey an understanding of those standards, first at the level of the loss of a single building. As conceived, the book maintains a kind of loyalty to its genesis in the column "Providence's 10 best lost buildings" that The History Press editor Edward Mack asked the author to expand into a book. Each of the early chapters in the book will quote each building's entire column entry. Each entry's ideas and associations are extrapolated into a full chapter. Many buildings mentioned in this book deserve their own chapters, but since most of those buildings have *not* been lost, they are squeezed into chapters on lost buildings. The Arcade and the Superman Building are good examples of that. Other buildings that were lost but didn't make it into the original *Journal* column are also mentioned, but many are not. A chapter is devoted to some of these, mindful that an entire book could be devoted to all of them. This is not that book.

(This book's publication is accompanied by an online repository of photographs and other images that illustrate the "lost but not listed" buildings referred to here and gathered in chapter 11, which bears that name. Also included are other pictures of explanatory merit or beauty that would have been included in a fatter tome. All of this may be found on my blog at http://ArchitectureHereAndThere.com.)

People looking at a city street normally see it as a collection of buildings, not just one building, often not even its best building. A street should be a little symphony, a harmonic set of variations on a theme. That is why streetscapes should not be jolted by the addition of houses or buildings that depart drastically from the theme set by neighboring structures. Speaking of neighbors, people who buy houses in a neighborhood have a right to defend their investment, the value of which can fall when a neighboring property owner builds a house that is out of sync with its local melody. If

this book is anything, it is a manual that homeowners can use to defend their property values, not to mention the civility of their streets. In his masterful *The Classical Vernacular: Architectural Principles in an Age of Nihilism*, philosopher Roger Scruton sums it up:

> *The classical idiom does not so much impose unity as make diversity agreeable.…The classical wall, which is humanly proportioned, safe, gregarious, and quietly vigilant, constantly reminds the pedestrian that he is not alone, that he is in a world of human encounter, and that he must match the good manners of the wall which guides him.*[1]

Even without switching out an old house for a new, a house gets older and is refurbished now and then. A green door becomes a red door, with a new brass gooseneck knocker. A new mailbox replaces a shabby old one, a pair of new flowerpots flank a stair stoop. The flowers bloom and die. They are replaced with different flowers. And the same happens at the next house over, and the next and the next again. Such small but constant tinkering by man and nature brings constant change to streets. It is often said that cities should not be museums—but even museums change regularly: new dust on old exhibits, new exhibits, new arrangements for old exhibits and, now and then, even new wings to hold more exhibits. This book is interested in change on the greater scale.

Lost Providence departs from its genre's conventions by expanding the discussion from lost buildings to lost plans—plans for civic growth and renewal. This offers an opportunity to address the idea of change in Providence that has not been sufficiently addressed in that city, and in a manner that might be of interest to other cities. While the author considers himself a fan of Jane Jacobs and her opposition to major urban-renewal projects, he also considers himself a fan of nineteenth-century Chicago architect Daniel Burnham and his dictum to "make no little plans; they have no magic to stir men's souls." The history of change in Providence bears out a refusal to reject either big or little plans just because they are big or little.

In short, if a city will not make big plans that embrace continuity with its past, it should suffice with little plans that at least do not enrage our eyes. That is, cities should say no to their inner "power broker." Robert Moses, the title character of the book of that name by Robert Caro, spent decades ramming highways through New York and replacing small-grained and workable (if impoverished) neighborhoods with mammoth

and unworkable public housing complexes. Moses was finally brought low after Jacobs used community activism to block his plan to run a highway through Greenwich Village. Fortunately, many city planning officials these days in America have embraced the wisdom of her 1961 book *The Death and Life of Great American Cities*.

As have planners in Providence in recent decades. For *Lost Providence* has a happy ending. In the last quarter of the last century, the city found its lost waterfront. The River Relocation Project in the late 1980s and 1990s razed the world's widest bridge, replaced it with a dozen narrow but beautiful bridges and lined the river embankments with parks, river walks and other amenities friendly to people. The phenomenon known as WaterFire was one result. The revitalization of the waterfront stimulated the revitalization of downtown. Andrés Duany, a founder of the New Urbanism movement (the old urbanism revived), is the author of this book's foreword. He played a major role in reviving the "Downcity." The riverfront as a whole does not reject the historic look of the downtown through which it flows but embraces the city's enviable heritage of beautiful architecture. A major factor in saving downtown was the refusal to change its historical appearance. That is a rare if not indeed a new phenomenon in American city planning. Along the riverfront, nevertheless, mainly around Waterplace Park, appalling aesthetic choices based on outdated ideas have been made of late by authorities in Capital Center, and they seem about to be repeated in a new development district where Route 195 used to be.

The story of the rise and fall and rise of Providence—now widely known as the Renaissance City—tries to put a positive spin on change. Change does not have to be big or small—and it does not have to be bad or something that we have good reason to fear. Maybe someday, if that lesson can be learned, the citizens of Providence will find their city so lovable that they will no longer direct visitors to "turn right where the Outlet Building used to be."

PROLOGUE

The town of Providence was formed in 1636 by an itinerant preacher, Roger Williams, after his expulsion from Massachusetts for insufficiently puritanical ecclesiastical views. These included what we now know as religious freedom—"soul liberty," as he called it. He bought land from the Narragansett tribe along the east bank of the Great Salt Cove and split it into long, thin plots for him and his followers. There was to be no common, no place of honor for churchly authority. The colony, soon called Rhode Island and Providence Plantations, became a haven for dissenters and malcontents who grubbed a slender living on the land and argued a lot. As the town grew, trade expanded, first up and down the Eastern Seaboard and eventually to China.

Providence has grown throughout most of its history but has gone through periods of relative stasis and of booming growth. In the seventeenth century, the colony was largely agricultural and grew slowly. In the 1700s, mercantile shipping's success spurred maritime construction of wharves and warehouses along the Providence River. During the Revolution, the British occupation of Newport, until then the colony's most thriving town, drove commerce, including shipping, up Narragansett Bay to Providence.

In the nineteenth century, shipping was superseded by the textile industry. Mills were constructed on the banks of the Providence, Moshassuck and Woonasquatucket Rivers. Rhode Island's "industrial revolution" moved up the rivers and then inland after electric power freed industry from the geographical requirements of water power. The

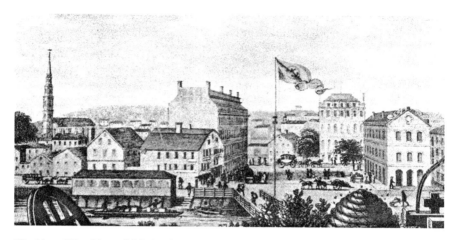

"Beehive of Providence," Market Square, circa 1823. This is a fragment from a bank membership certificate, engraved by Annin & Smith, Boston. *Courtesy of Providence City Archives.*

mechanical production of fabric stimulated the growth of industry to make the machinery. The town's commercial district, on Towne Street (now North Main) south of founder Williams's original settlement, was gathered around Market House and became known as Cheapside. Market Square was considered "the beehive of Providence." The first major commercial venture across the river on the West Side, then residential, was the Arcade, built in 1828 by Cyrus Butler between Westminster and Weybosset Streets. By the middle of the century, the West Side had been transformed from a residential neighborhood into a commercial district, a downtown surrounded by industry to its north, its south and its west. College Hill, hard for horses and buggies to climb, lost residents to areas to the west of downtown, where fancy new houses arose for the owners and managers of new and growing businesses.

The 1840s saw the city's first major redevelopment project: filling in the Great Salt Cove, at first along its edges, eventually creating the Cove Basin, a pond encircled by a park, on whose southern rim the city's first railroad station was completed in 1848. The next major project filled in the Cove Basin so that more trains could squeeze through the center of the city. Meanwhile, the Woonasquatucket and Moshassuck Rivers, as they met to form the confluence of the Providence, were decked over in sections between 1843 and 1904 to make room for horses and wagons of the city's public market. This 1,147-foot deck was anointed the world's widest bridge by the *Guinness Book of World Records*, though many who passed over it may not have recognized its "bridgeness."[2]

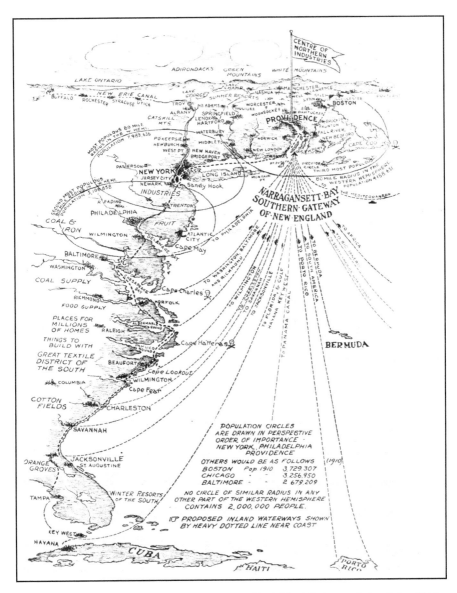

Map, "Providence Centre of Industry," *Manual of Rhode Island Businessmen's Association*, 1912 edition. *Courtesy of Providence City Archives.*

By the end of the nineteenth century, the heirs of Cyrus Butler, whose Arcade was referred to early on as "Butler's Folly," owned much land downtown. By the beginning of the twentieth century, the city rivaled not just the nation but the world in several major industrial categories, not just

textiles but tool and machinery manufacture and costume jewelry design and assembly. The emigration from Europe of workers to operate factories had long since begun to multiply the city's population. Providence was feeling its oats; its civic leaders expected it to rival New York, Boston, Philadelphia, Baltimore, Hartford and other major cities of the Eastern Seaboard.

In the early twentieth century, manufacturers began to move operations out of state, mainly to the South, where labor and other aspects of production were less costly. World War I's shipping and industrial needs briefly stoked the city's more grandiose illusions. Then came the Depression, and then respite in armed conflict. After World War II, industry in Providence resumed its shrinkage. Population began to fall. It reached its apogee at 240,000 in the 1940s. Today, it is 180,000.

In the middle of the twentieth century, highways were driven around and through downtown, dispersing populations in their paths. Urban development focused on slowing the flight of city jobs and city residents to the suburbs. Curiously, downtown was jammed with shoppers and workers well beyond the announcement, in 1961, of the ambitious plan intended to lure them back, Downtown Providence 1970. That plan's massive proposed demolition of historic buildings—including City Hall and Union Station—seemed to presage the infamous remark by a U.S. Army officer in Vietnam to the effect that "we had to destroy the village in order to save it."

Not much of the plan was carried out. Those parts that were carried out failed. The city was too poor, and its leaders saw themselves more as caretakers of a municipal basket case, with a cascading set of mounting civic problems that prevented them from focusing attention on the future of Providence. And at midcentury, that was a good thing. An ambitious, energetic mayor might have managed to lay waste to the city. Today, Providence may be said to have been preserved by its own poverty—its fiscal challenges, yes, but also the poverty of its artistic imagination.

This desultory tale ends more happily in the third quarter of the twentieth century and the early decades of the current century. A longstanding desire to relocate a vast yard of railroad tracks and sidings (eventually parking lots) between the State House and downtown was finally realized in the late 1980s. That opened land for development much nearer to the central business district than was common in America's declining cities of the Northeast. Capital Center, a plan to fill the seventy-five acres with offices, was proposed. Before much of its preliminary suburban design could be realized, another plan to move two rivers and remove the decking of a third between downtown and College Hill generated an entirely new design for

Capital Center, with more commercial and residential development along a new waterfront with a much more traditional feel than any city had seen fit to propose in a long time. It was built, and it was good.

This happy ending and the lessons it conveys will be, of course, a prelude to the next chapters in the city's history of change—for good, it may be hoped, or for ill.

PART I

1

LOST: BENJAMIN HOPPIN HOUSE

The Benjamin Hoppin House (1816) was a beautiful twin bow-fronted residence. It dated from the era before the Whitman Block (1825)—where the Turk's Head was built in 1913—and the Arcade (1828) signaled a shift of commerce across the river from Market Square and Cheapside. The Hoppin House was razed in 1875 for the Hoppin Homestead Building.

The photograph of the Benjamin Hoppin House suggests that beauty placed it first among the best lost buildings in my *Providence Journal* column of March 27, 2014. But perhaps it's really a matter of age before beauty. At the time of its construction in 1816, the house described by historian John Hutchins Cady as "the most distinguished dwelling on Westminster Street" was built a year after the great gale of 1815 and two years after the end of the War of 1812.[3] The Hoppin House was set amid a residential neighborhood already well established at Westminster's intersection with Snow Street— the latter named for Deacon Joseph Snow, who in 1743 split with the First Congregational Church on the Neck (as the land around the early settlement by Roger Williams was known). Snow took his followers across the river to found the first settlement on what came to be known as the Weybosset Neck or the Weybosset Side or, later, the West Side. Abbott Park, next door to Snow's New Light Meeting House (eventually the Beneficent Congregational Church), was the town's first park and its first common, or village green.

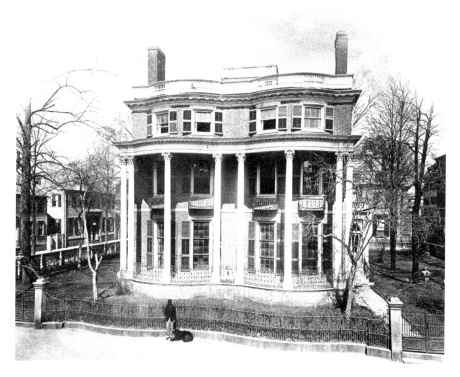

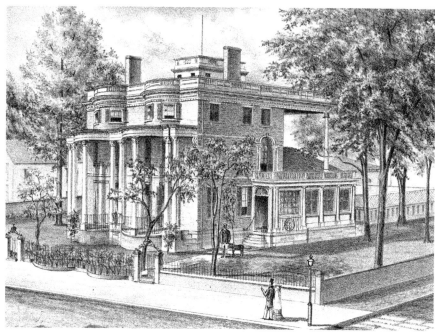

PART I

The congregational breach is described in *Weybosset Bridge* by Arthur E. Wilson. Suffice it to say that Roger Williams's principles of religious freedom—"soul liberty"—did not preclude schism, secession and every sort of doctrinal squabble. Indeed, in the previous century, the aging Williams was given the post of toll-taker for the Weybosset Bridge by the General Assembly, which stripped him of the post not much later for reasons that have not come down to us but that may stem from the founder's argumentative character. As one can imagine, he may have caused unwanted delay in crossing the bridge. Williams was long gone by the time Snow set up the New Light, but his cranky spirit lingered, as suggested by Snow's petition to the General Assembly in 1770 to split off his village, too, from Providence to form the town of Westminster ("Weybosset" is scratched out and overwritten on the petition). In London, Westminster was (and is) the seat of Parliament, which often tried the patience of British royalty, much as Snow and his followers chafed under the "despotic rule," as they put it, of the descendants of Roger Williams on the Neck. The assembly rejected the petition.

Hoppin built his house long after that but a decade before the erection, in 1828, of the Arcade by Cyrus Butler. This signaled the coming transformation in the character of the neighborhood from residential to commercial. The Arcade went up several blocks east of Hoppin's house, which filled the lot between Snow and Aborn, itself a block east of Abbott Park. The photograph of the Hoppin House must have been taken at least three decades after the house was built and about three decades before the photograph of Westminster Street was taken in 1868. The Hoppin picture shows a multitude of well-heeled houses reaching down Snow and Aborn. Cady describes the house as

> designed by [John Holden] *Greene with three-story brick walls and a low hipped roof and deck, the cornice crowned by a balustrade. Its unusual feature was the front, which had a stone terrace and a two-story Corinthian porch in the Colossal order, with curves concentric with those of two bay windows and repeated in the fence on the lot line.*[4]

Opposite, top: Benjamin Hoppin House (1816) on Westminster Street. *"Hoppin Homestead," VM013_WC0817, Rhode Island Photograph Collection, Providence Public Library, Providence, RI.*

Opposite, bottom: Benjamin Hoppin House, lithograph circa 1875. This image exaggerates the twin bows. *Courtesy of Providence City Archives.*

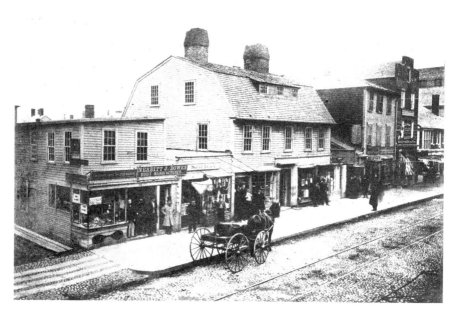

Westminster Street in 1868, as businesses supplanted residences. *"Westminster Street,"
VM013_WC1446_3, Rhode Island Photograph Collection, Providence Public Library, Providence, RI.*

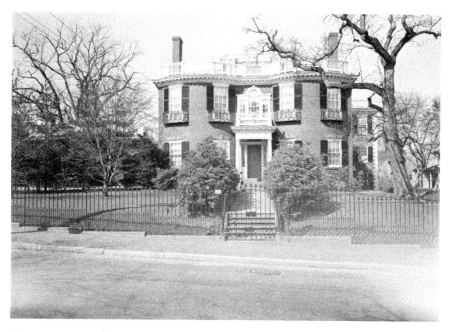

Halsey House (circa 1800), the oldest local twin-bay home, on Prospect Street, College Hill.
*Library of Congress, Prints & Photographs Division, Historic American Buildings Survey (HABS), HABS
RI,4-PROV,133-.*

PART I

In the engraving of the house published after Benjamin Hoppin's death in 1865, the bows in the fence are slightly exaggerated. "The front bowed out in a double swell," writes Antoinette Downing in *Early Homes of Rhode Island*.[5] The bow on either side of the doorway presses out against the double curvature of the portico, and the portico pushes out against and creates a soft bulge in the fence. The twin expressions of gentle pressure in the character of the house strike the observer, if he may be so bold, as a lady's bosom. "I would in that sweet bosom be," wrote James Joyce.[6] The feeling can easily transfer to a house. Reading a book on a settee behind one of those bays would be joy unbounded. Perhaps that is enough to account for its place atop the list of Providence's ten best lost buildings.

It is gone, but a house of similar curvature, even older, abides on Prospect Street, east of Benefit on College Hill. The Thomas Lloyd Halsey House, built around 1800, is "the most prominent extant example of a dwelling with projecting curved bays."[7] It was immortalized in H.P. Lovecraft's 1927 novella *The Case of Charles Dexter Ward*. The key passage, as the protagonist returns home down Prospect in a taxicab, reads: "And at last the little white overtaken farmhouse on the right, on the left the classic Adam porch and stately bayed facade of the great brick house where he was born."[8] At the time the tale was written, the house was believed by many to be haunted. It was recently sold by developer Stanley Weiss, who lived there, to real estate mogul (and former mayor) Joseph R. Paolino Jr., who figures in the next chapter, among others, of this book.

Not to look down on the magnificence of its pulchritude, the Halsey Mansion's bosom is merely naked. It may be said to lack the layers of architectural clothing—the twin bays, the paired porch curves and the slightly bulging wrought-iron fence—that were noticed by Antoinette Downing and that give an air of restrained if not suppressed sensuality to the Hoppin House. Speaking of which, Lovecraft will reappear later in this book, too.

In the photo, nearby houses are seen. A black boy stands in front of the Hoppin House, his dog lying on the sidewalk. In the engraving, a man in a top hat walks down the sidewalk with a woman while just inside the fence, at an entry to a side porch that leads to the main door at the right of the "double swell," stands another man, also with a dog. The legend under the engraving reveals that the house was "torn down, 1875," so the illustration must have been published a decade after Hoppin's passing, just as the house was being replaced by the building in the next chapter.

2

LOST: HOPPIN HOMESTEAD BUILDING

The Hoppin Homestead Building (1875), at Westminster and Snow, designed by [James C.] Bucklin, was an early site of both Bryant and RISD. In 1979, it was razed—the last major downtown building demolished for a quarter of a century, until a decade ago. It remains a parking lot.

About a decade before the demise of his father, Benjamin Hoppin, Thomas Frederick Hoppin, an artist and socialite, built a swank East Side mansion on Benefit Street. It was erected after fire took its predecessor, the Clarke Mansion, whose design was inspired by the nearby Nightingale-Brown House, the mansion across Power Street from the John Brown House. The latter was designed for merchant John Brown by his brother, Joseph Brown. John Quincy Adams, the nation's sixth president and son of its second, called the John Brown House "the most magnificent and elegant private mansion I have ever seen on this continent."[9] The John Brown House survives, as do the Nightingale-Brown House and the Thomas Hoppin House. All three mansions along the east side of the north end of Benefit today serve institutional purposes as, respectively, a house museum of the Rhode Island Historical Society and a pair of academic institutes associated with Brown University.

Artist Hoppin's most celebrated work today is *The Sentinel*, a bronze statue of a mastiff called Black Prince that is said to have broken its chain to alert the Jenkins family of the fire at the Clarke Mansion in 1849. The life-sized statue of the dog is said to have been the first cast in bronze in America. It

Thomas Hoppin House (1853), architect, Alpheus C. Morse, on Benefit Street. *Library of Congress, Prints & Photographs Division, Historic American Buildings Survey (HABS), HABS RI, 4-PROV, 66--2.*

won a gold medal from the New York Academy of Design and was shown at the Crystal Palace Exhibition in London.

Hoppin married a Jenkins daughter, Alice, who survived the fire, and they built their new home on the site of the Clarke. The house, designed by Alpheus C. Morse and completed in 1853, fit well into the statuesque architecture of that section of Benefit. Cady describes it as "brick, with brownstone trimmings, its design suggestive of contemporary London mansions."[10] In 1896, the Hoppin family gave *The Sentinel* to Roger Williams Park, where it has been relentlessly climbed upon by generations of youngsters visiting the park zoo.

But to return to Westminster Street on the Weybosset Side, and ultimately to the Hoppin Homestead Building, it should be noted that the fecund Hoppin family had a house that predated both the Benjamin Hoppin House and its twin-breasted predecessor, the Halsey House. The Auton House was built in 1807 two blocks west of the Hoppin, at Westminster and Walnut. Walnut no longer intersects with Westminster today but ends at Cathedral Square, where Westminster once rejoined Weybosset Street to form a bow whose other end still originates near the Providence River. The bow

concluded at the Cathedral of Saints Peter and Paul, built in 1889, which survived the demolition of its surroundings, including the Auton House and most of Walnut Street, by urban renewal in the 1970s.

The Hoppin Homestead Building, seen here in an engraving, is mainly remembered today as the first address, soon after the building opened in 1878, of the Rhode Island School of Design, which moved to Waterman and North Main in 1893. It was also an early address of the peripatetic Bryant and Stratton National Business College, originally a national chain of business schools founded in 1863 that grew to forty locations by the end of the nineteenth century. Its stay on the fourth floor of the Hoppin building lasted from 1876 to 1916, then moved to the Butler Exchange until the Industrial Trust "Superman" Building was erected in 1928, after which the school did a stint on College Hill. In 1971, it moved to a new, modern campus in a wooded area of Smithfield, Rhode Island. In 2004, Bryant College graduated to Bryant University.

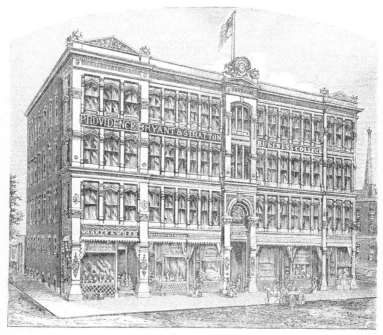

The Hoppin Homestead Building.

Hoppin Homestead Building (1875) on the downtown site of the Benjamin Hoppin House, 1881 engraving. *Courtesy of Rhode Island Historical Society, Negative No. RHi X3 2790.*

PART I

When the Hoppin Homestead arose, this section of Westminster Street was still largely residential, but residential use was fast switching to commercial use. Amid a torrid boom in business, houses with retail or service firms on the first floor, often inhabited by their owners on upper stories, were quickly outgrown and pulled down and replaced with structures intended entirely for business. As with the Hoppin, the trend among these structures was often toward a more ambitious architecture, and it is difficult to deny that since most of the houses that came down during this period were less elegant than the Hoppin House, the street took on an increasingly distinguished mercantile countenance.

Cady describes the Hoppin Homestead Building, designed by James C. Bucklin, as having "a steel frame, cast iron and glass storefronts and three stories of closely-spaced windows on the main façade."[11] The *Grove Encyclopedia of Art*'s article on Bucklin—better known for his role in designing Cyrus Butler's Arcade in 1828 farther east on Westminster—describes the Hoppin as "Neo-Grec."

The engraving reveals the ornate demeanor barely hinted at in Cady's description of the Hoppin building. And yet its place on Westminster is more nobly displayed by a photograph of a view east along Westminster Street focusing on the line of buildings at the photo's left. It was probably taken not long after the Conrad Building, at the far left, was erected in 1885, a decade after the Hoppin Homestead Building. The two buildings evoke the playful relationship of their fanciful embellishment. While differing considerably in their style, they contribute to an almost symphonic flow of patterned vertical bays that sing an elegant variation of theme.

These two buildings are typical of the commercial structures that spread a robust architectural character up and down Westminster Street. The street became the core of the city's downtown after the market area known as Cheapside hopped across the river from the Neck. Most of its buildings arose between 1870 and 1930, including many that replaced the mostly wood-frame houses turned shops that remained—like the Hoppin House—from the neighborhood's former residential period. Such was the vigor of construction over these sixty years that many other ornate buildings replaced already sumptuous commercial buildings that had themselves replaced wooden houses.

The wintery photo looks not east but west on Westminster, venturing through slush, with the Hoppin Homestead and Conrad to the right and, to the left, a string of lost buildings, including the French Renaissance building with the mansard roof that was once a music hall. This photo

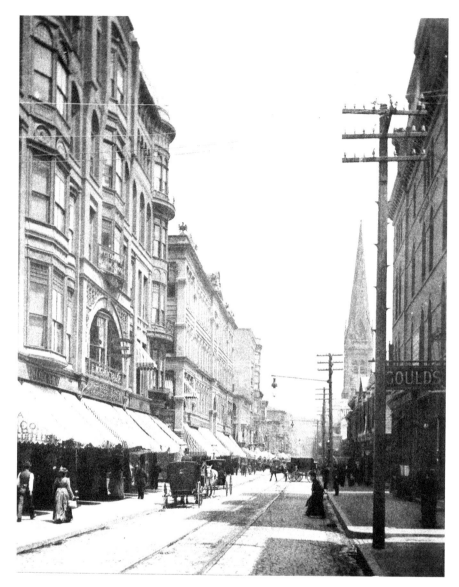

Hoppin Homestead (*left center*) beyond the Conrad Building (1885), looking east on Westminster Street. *"Westminster Street," VM013_WC1433, Rhode Island Photograph Collection, Providence Public Library, Providence, RI.*

seems to have been taken at some point between 1885 and 1903, when the Caesar Misch Building went up. (Known for Harris Furs, it served much later as the city's department of planning and development.) The photo appeared at the top of the "best lost buildings" column and was intended

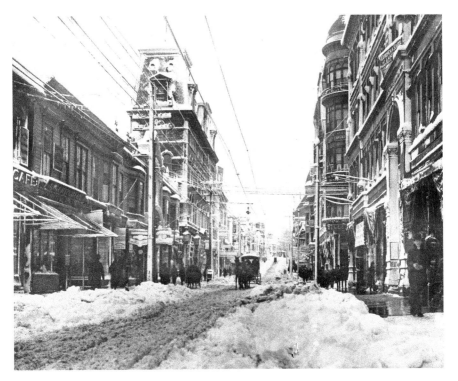

View looking west on Westminster Street, circa 1990, in winter. *"Westminster Street," VM013_ WC1436, Rhode Island Photograph Collection, Providence Public Library, Providence, RI.*

to illustrate the pace of change on the street: only the Conrad Building survives to this day.

Except for the Conrad, all of the buildings in the photo were demolished. All or most of them—except the Hoppin Homestead Building—were replaced by other buildings that were themselves eventually razed. The Hoppin was the last to succumb, doing so in 1979 amid a debate between city planners and local preservationists. They disagreed about whether the federal government, which sought office space downtown, should favor new construction over reusing old buildings. City planning officials, who believed that new construction would energize the remaining older buildings, won the argument.

In 1978, state Historical Preservation Commission chairman Antoinette Downing had written to Providence mayor Vincent A. "Buddy" Cianci Jr. about this issue. She referred to a letter sent by her staff to the U.S. General Services Administration that expressed a key idea:

Any construction on site "A" [opposite the Hoppin Homestead on Westminster] *will have an effect on the historic district and, in accordance with the Procedures of the Advisory Council on Historic Preservation, the GSA should seek the comments of the Council and the SHPO* [State Historic Preservation Office] *to determine whether the new structure will adversely affect the historic district. Any construction on site "A" should be carefully designed and of a quality so as to contribute to the character of the district.*[12]

The large, tedious modern brick federal office building erected thereafter, which continues to bore and oppress its Westminster Street environment, shows that Downing's concern for the character of the district went unaddressed by the feds. But was this really so? The problem wasn't that it was brick but that it was tedious. And what did Downing really think of the new federal building erected in the face of her opposition?

She is certainly the iconic figure of Rhode Island's vaunted preservationist history. And yet for years she was a member of the Capital Center Commission's design review panel. During those years, the panel approved tedious building after tedious building, some brick, some not. She was heard by the author of this book expressing dismay that a developer was proposing a building of brick in the new development district. Confirming that recollection years later, reporter John Castellucci, interviewing architect and panel member Derek Bradford in the February 26, 1996 *Providence Journal*, quoted Bradford as saying that Downing had said: "If I see another red brick building, I think I'll be sick."[13]

So it may not be absolutely certain that the feds ignored local concerns for the historic character of Providence. They merely applied a questionable sensibility to the matter, a local sensibility that reflected a broader status quo that supported (to be gentle) tedious architecture. The date of Antoinette Downing's letter to Mayor Cianci in 1978 is already well past the moment in time when there was any reason to assume that any new building would be an improvement on any old building it replaced. And perhaps because of local queasiness about that in downtown Providence, the demolition of the Hoppin Homestead Building by Paolino Properties marked the beginning of an extraordinary quarter of a century (1979–2005) during which no major historic building was demolished downtown.

And that is why the silver lining in the demolition of the Hoppin Homestead Building is that it was replaced by a parking lot. It is part of a vast stretch of broken parking asphalt that extends from Washington Street

to Westminster, hopping over Westminster and continuing to Weybosset Street. This huge swath constitutes the largest rip in downtown's enviably intact historic fabric. But as such, it boasts no modern building to filibuster the erection of a beautiful building in the future. So it represents a beacon of hope, such as it is these days.

LOST: PROVIDENCE NATIONAL BANK

The Providence National Bank (1929) was demolished unnecessarily, along with an equally fine 1950 addition, in 2005 to make way for an unbuilt skyscraper. The Weybosset façade survives, partly masking a new parking lot.

As with the Hoppin Homestead Building, the Providence National Bank Building obeyed conventional wisdom—and the lyrics of a Joni Mitchell song:

> *They paved paradise*
> *And put up a parking lot.*

The refrain of that song, "Big Yellow Taxi," begins with even more prescience:

> *Don't it always seem to go*
> *That you don't know what you've got*
> *Till it's gone.*[14]

Some will deny that the Providence National Bank Building was a dead ringer for paradise, but here's the thing: It had two fronts, one on Westminster Street and another on Weybosset. You had a choice: either a brick Colonial

Opposite, bottom: Providence National Bank (1950), Weybosset Street façade. The façade was preserved in 2005 for incorporation in a proposed tower, never built. *Photo by author, 2016.*

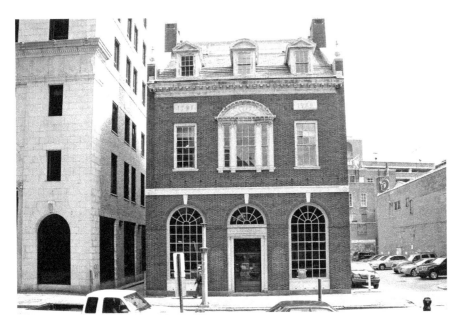

Providence National Bank (1929), Westminster Street façade. The building was demolished in 2005. *Providence Revolving Fund, Clark Schoettle.*

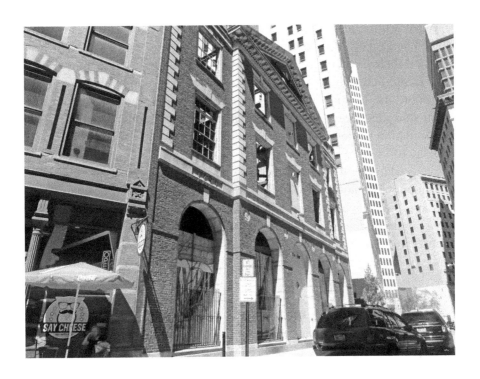

Revival style, built in 1929, or a more Beaux-Arts style, built as an extension in 1950. In 2005, a developer proposed to build on the site a forty-story tower of luxury condominiums that would have been the tallest skyscraper in Providence, topping out at 520 feet, compared with the 428-foot Industrial Trust Bank Building next door. The money side of the proposed building faced College Hill with a curved shard of glass curtain wall. Flush with the optimism of five proposed building projects announced for downtown in 2005, the city allowed the developer to demolish the bank building before it had secured financing for OneTen.

Few tears are shed for another building demolished along with the bank building. The Buck-a-Book building featured a sheer façade of paneled glass ghastly to behold. Before the structure's incarnation as a seller of cheesy literature, it, too, had been a bank, the First Federal Savings and Loan. The Rhode Island Historical Preservation and Heritage Commission's 1981 survey, *Downtown Providence*, describes its 1960 renovation as a "2-story, steel-and-masonry structure with façade articulated into five bays by anodized aluminum strips with concrete-and-plate-glass infill" that "obscured its position in an historical context and effectively makes it a mid-20th-century building."[15] Not a ringing endorsement, to say the least. Buck-a-Book? No, Buck-a-Building!

While waiting for money to build OneTen, the two developers involved, BlueChip Properties of Boston and Granoff Associates of Providence, watched their project shrink. Eventually, it amounted to the chimera of a "W" brand luxury hotel. Its lobby was to connect to one of its immediate neighbors, the Arcade. In other iterations, the W lobby was to host an upscale chain store that would also be entered from the Arcade. Since developers rarely hold news conferences to announce their project's failure, OneTen's final "poof" was barely noticed.

The parking lot that is the result of this civic misstep is, as in the case of the Hoppin Homestead Building, a mixed blessing, a silver lining perhaps, in that someday a better building might be erected on the site. Meanwhile, the lot is cloaked gracefully by the façade at the Weybosset Street end. As a sop to preservationists, the developer had agreed to incorporate this façade in the design of the new tower. Eyebrows might well rise at how this would have looked in the context of a modernist design. This type of palimpsest is often derided as a "façadectomy," a new building erected behind the façade of an old building. To invite the eye to focus on a beautiful façade that defers, however momentarily, the perhaps inevitable glance upward is a consummation devoutly to be wished. If a façadectomy helps protect the

public in this way, then long live façadectomy. As of today, the Weybosset façade stands proudly, a reminder of what once stood on the site—and an argument in favor of building something not unlike it in the future.

That the historical style of the original 1929 bank building was joined in 1950 by an addition even more robustly historical testifies to the bank board's dedication to architectural tradition, and that may reflect the bankers' perception of the attitude of its customers, and of the city population generally. By 1949, longstanding tradition in architecture was being supplanted around the country. Architects here and elsewhere had already met the challenge of modernist design with classical designs stripped of ornament. Both Washington's National Gallery of Art, by John Russell Pope, and the latest Providence police headquarters building—demolished two years after the bank and the subject of this book's chapter 6—are examples of "stripped classicism" in reaction to modernism's vaunted purity of line, albeit etched machine-like in steel, concrete and glass. Both examples of stripped classicism were completed in 1940, and both suggest that profuse ornament is not required to beautify a building classical in its lines and in its essence.

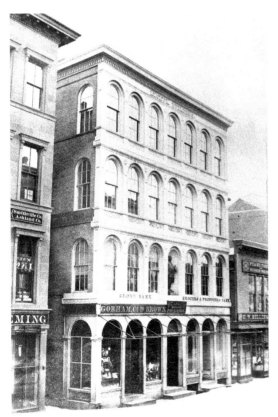

Profuse ornament did, however, characterize the Westminster Street building that was demolished in the late 1920s to make way for the Providence National Bank. Lyceum Hall, the headquarters of the Franklin Lyceum, was dedicated in 1858. Founded in 1831, the lyceum was a private library and membership society that hosted lectures by such

Lyceum Hall (1858), home of Franklin Lyceum Society, demolished in 1926 for Providence National Bank. *Lyceum Building.*" *VM013_ WC0938, Rhode Island Photograph Collection, Providence Public Library, Providence, RI.*

notables as John Quincy Adams (panegyrist of the John Brown House on Benefit), Ralph Waldo Emerson, Oliver Wendell Holmes and Edgar Allan Poe. It featured a life-sized statue of Benjamin Franklin in a niche on its second story. Henry-Russell Hitchcock, of all people, described the "delicacy and elegance" of the lyceum, the "most charming" of several Providence examples of cast-iron façades, in his *Rhode Island Architecture*.[16] (Hitchcock was involved, with Philip Johnson, in the Museum of Modern Art exhibit of 1932 that helped popularize the new modernist style in America.) By the late 1890s, facing competition at the hands of such institutions as the Providence Athenaeum and the vast Howard's Hall in the third Howard Building (see chapter 5), as well as the booming growth of vaudeville and moving picture houses downtown, the lyceum's membership had fallen off. Commercial establishments dominated its tenancy—the Globe Bank and the Grocers and Producers Bank among them—by the time it was demolished in 1926 for the Providence National Bank.

Experts will long debate whether the replacement of the lyceum with the bank building improved or degraded the beauty of Westminster Street. A profusely ornate building of four stories was replaced by a moderately ornate building of three stories, the latter design paying homage, in its relative simplicity, to the domestic architecture of the neighborhood's early history. Either way, the change was close to neutral, neither enhancing nor diminishing the street's beauty by much. It is one of those very few cases in which such a judgment actually is a matter of taste. In the progress of the greatness of a street, avoiding a big step backward is more important than assuring a big step forward. Both the lyceum and its successor qualify as among the best lost buildings of Providence.

4

LOST: THE NARRAGANSETT HOTEL

The Narragansett Hotel (1879) hosted many famous guests, including the Providence Grays baseball team that won the first World Series in 1884. It was demolished in 1960, and its site was a parking lot until Broadcast House (WJAR Channel 10) was built in 1979. Nicknamed the "East German Embassy" for its sinister mirrored blank walls, it mars the east end of the J&W quadrangle.

Walk south on Dorrance Street and you will pass the most hair-raising example of lost Providence. The Narragansett Hotel, erected in 1878, was described in 2012 by Dr. Richard Greenwood of the Rhode Island Historical Preservation and Heritage Commission as "perhaps the finest hotel in the city's history."[17] Contemporaneously, Moses King's *Pocketbook of Providence, R.I.* (1882) described it as "one of the largest, grandest, best furnished and most satisfactorily kept hotels in the world."

A great hotel's lobby makes an excellent meeting place, prized by the city's diverse citizenry as perfect for interludes planned or by chance. Such sites are called "third places" in today's urbanist lexicon, places between workplace and home. In the 1890s, the Narragansett hosted famous out-of-towners such as "Buffalo Bill" Cody, whose Wild West Show performed in Providence in 1884, the same year that the Providence Grays beat the New York Metropolitans in baseball's first World Series. In his account of that season, *Fifty-nine in '84*, Edward Achorn describes some of the hijinks

NARRAGANSETT HOTEL,

L. M. HUMPHREYS. Providence, R.I.

Narragansett Hotel (1879), on Dorrance Street. It was demolished in 1960 for a parking lot, then Broadcast House (1979). Engraving, Farmer, Livermore & Co. *Courtesy of Rhode Island Historical Society, Negative No. RHi X3 2756.*

at the Narragansett, where visiting teams would stay. "[T]he Grays' resident troublemaker, Cliff Carroll, had conspired with a Chicago player in a plot to obtain free food from the Narragansett." The Chicago player "invited all of the waiters at the 225-room downtown establishment" to the Messer Street Grounds, "promising to smuggle them in to watch a big-league game gratis." As the waiters were black and the paying fans white, the jig was up. "Fortunately for the conspirators, manager [Harry] Wright was more amused than outraged, and the little scheme worked brilliantly. The ballplayers ate like kings the rest of their time in Providence."[18]

Some members of the Grays team may also have lived in apartments, so to speak, at the hotel, a common practice before single-family houses became more available. The lobby bar was their living room—a lifestyle immortalized in *The Thin Man* by Dashiell Hammett, about detective Nick Charles and his wife, Nora, who lived it up as residents with their dog, Asta, in a posh Manhattan hotel. A series of 1930s films derived from the novel, starring William Powell and Myrna Loy, must surely have helped popularize a way of life doubtless available even in Providence at such hotels as the Narragansett.

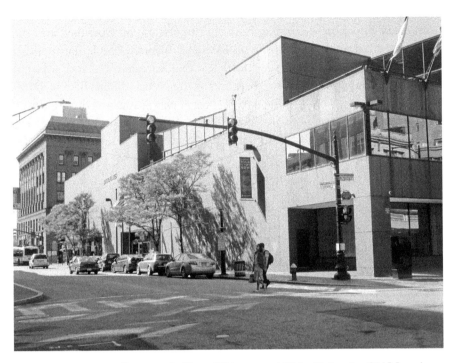

Broadcast House, now library and offices of Johnson and Wales University. Old Masonic Temple (1897) is seen beyond it. *Photo by author, 2016.*

Grays ballplayers often put up behind the Narragansett at the City Hotel, which was demolished in 1903 to make way for the Outlet Company Store.

The Narragansett was demolished in 1960 and replaced, teasingly, by a parking lot. Finally, in 1979, Outlet Communications erected Broadcast House (known by some as the "East German Embassy") for its flagship station, WJAR Channel 10. The severely modernist structure of plate glass and black granite, with its ground-floor mirrored windows set akimbo along Dorrance Street, fairly cries out "secret police!" The design, by the Providence Partnership, is said to have been inspired, if that is the proper word, by the headquarters of NBC-TV at 50 Rockefeller Plaza, known as "50 Rock," part of Rockefeller Center in Manhattan. But the resemblance may have existed only in the mind of Bruce G. Sundlun, Outlet's chief executive officer from 1976 to 1988 and Rhode Island's seventy-first governor for two terms (1991–95).

Broadcast House is as out of place in its setting now as it was in 1979, when the Outlet Company department store still stood just west of the site, reaching up Weybosset. Broadcast House pokes observers in the eye

from every direction, degrading both the streetscape of Dorrance and the academic quadrangle of Johnson and Wales University, the latter intended to continue the brick theme set forth by the Narragansett and adjacent buildings so many years before. Designed by the New Urbanist firm of DPZ, the quadrangle was built in the early 1990s after a suspicious fire destroyed the Outlet Company Store in 1986. (See chapter 9.) The "East German Embassy" should be placed under arrest and then "disappeared" as an architectural undesirable.

LOST: THE THIRD HOWARD BUILDING

The third Howard Building (1859), designed by James Bucklin, replaced the first two Howard Buildings, built in 1847 and 1856. Both were designed by [Thomas] Tefft and destroyed by fire. Damaged by Hurricane Carol in 1954, Howard III was replaced by Howard IV, whose ugliness has only been exacerbated by efforts to tart it up.

This chapter bows deeply to the third Howard Building at Westminster and Dorrance, stretching down the block to Exchange Place (now Kennedy Plaza). The fourth Howard Building on the same site does not qualify for a chapter, because it still stands. It has not been lost. Alas. Its appearance sharpens the regret attending the demise of the third Howard Building. The first Howard Building was consumed by fire six years after its construction in 1847, and the second met a similar fate a mere two years after its construction in 1856. The third lasted almost a century but was finally done in by the hurricanes of 1938 and 1954. It was not knocked over by wind but, on both occasions, flooded, along with much of downtown, causing its foundation to sink. This discovery led to the demolition of the third Howard, after which the fourth Howard was built. The four buildings' namesake was businessman George A. Howard.

The first three Howards featured sizable lecture halls. Cady mentions a host of notables, variously uplifting, enlightening or entertaining, appearing in the first Howard's Hall, including William Lloyd Garrison, Sam Houston and Jenny "The Nightingale" Lind; singer Adelina Patti and violinist Ole Bull

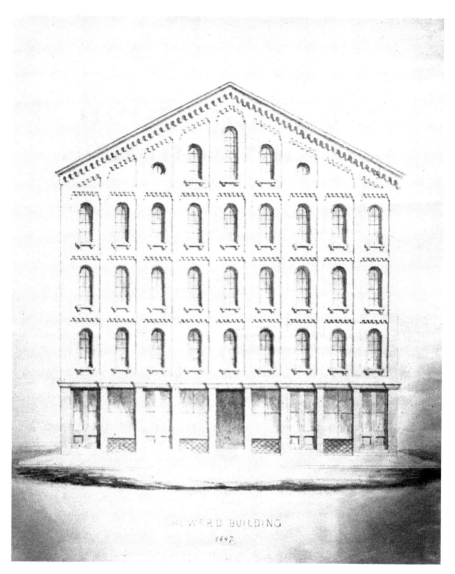

HOWARD BUILDING
1847

The first Howard Building (1847), designed by Thomas Tefft (his drawing). It was destroyed by fire in 1853. *Courtesy of Rhode Island Historical Society, Negative No. RHi X3 2750.*

Opposite, bottom: Third Howard Building (1859), designed by James Bucklin. It was demolished in 1956 after flooding in hurricanes of 1938 and 1954. Photograph, albumen print, circa 1870. *Courtesy of Rhode Island Historical Society, Negative No. RHi X3 2762.*

The second Howard Building (1856), designed by Thomas Tefft (his drawing). It was destroyed by fire in 1858. *John Hay Library, Brown University Library.*

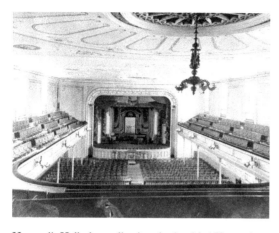

Howard's Hall, the auditorium in the third Howard Building. Edgar Allan Poe and Colonel Tom Thumb spoke here. *"Howard Hall." VM013_WC1516, Rhode Island Photograph Collection, Providence Public Library, Providence, RI.*

visited the second; and in the third hall, listeners heard Daniel Webster, Henry Ward Beecher, Charles Sumner, Artemus Ward, Edgar Allan Poe and Colonel Tom Thumb. In 1908, this final lecture hall, seating 1,200 and rising two stories, including a mezzanine, was purged and replaced by a large suite of small offices. This decision was surely abetted by the declining popularity of lectures at the Franklin Lyceum, plus competition from movie houses popping up all over downtown.

The first two Howard Buildings were designed in quick succession by Thomas Tefft. The third was designed by James Bucklin. All three qualify equally as lost, because all three would fill the space more graciously, if they were somehow to return, than the fourth Howard Building. The fourth was designed by Albert Harkness and Peter Geddes, with an extension added in 1968 by Robinson Green Beretta.

The fourth Howard, completed in 1959, and its 1968 addition were described in the 1981 downtown survey by the RIHPHC as "the nadir of large office-building design Downtown." Never was a building more aptly described as looking like the box a better building came in. Was the gag tag of "nadir" enough deprecation from the state's office of historical preservation? Not by a long shot. Survey author William McKenzie Woodward wrote: "The fourth Howard Building is a poorly designed structure, entirely inappropriate in its setting: the early portion is bland; the later, poorly sited. It has a negative impact on the intersection of Dorrance and Westminster Streets and also detracts from the visual quality of Kennedy Plaza to its north."[19]

Never, indeed, was tan so gray. Reasonable people may disagree over whether or not the fourth Howard qualifies as the "nadir." Is the East German Embassy a "large office building"? If so, then it clearly rivals the fourth Howard's designation as the pits. Let the reader decide.

Fourth Howard Hall (1959), on Dorrance Street at Exchange Place (renamed Kennedy Plaza after 1963). *Photo by Warren Jagger.*

In a forlorn attempt to ameliorate its heroic blandness, the fourth Howard's owners renovated the exterior in 1986. It was covered with EIFS (exterior insulation and finish systems, pronounced "ee-fuss") in shades of cream and tan patterned to suggest a classical arrangement of base, column and entablature. It did not work. As this author wrote

in a March 7, 2002 column for the *Providence Journal* entitled "Full facial for the fourth Howard," a subsequent effort to re-tart the fourth Howard proposed brightening it up again, this time with paint: "Yawn. Why make the same mistake twice? Why throw good money after bad? The Howard Building is not the Liz Taylor or even the Faye Dunaway of buildings. It risks becoming the Phyllis Diller of buildings."

The column continued, suggesting a more alluring alternative:

> *Hire a muralist to paint a new and lovelier building over the existing one. Paint trompe l'oeil pediments and sills above and below its windows. Paint deep window reveals, string courses between each third story or so, and maybe even a pair of vertical setbacks on each facade to make the building even sexier. Paint it all in perspective so that it seems to follow you like the eyes of an old portrait....Turn the "plain Jane" Howard into the Mona Lisa of buildings, a work of architecture as a work of art.*[20]

Not a bad idea, eh? The building is still there, just as tedious, while the city has become even more a haven for the creative arts. Done well, such a façade-lift would fit the building into its elegant setting, flanked by the Union Trust Building, the Woolworth Building across Dorrance and City Hall kitty-corner. That might make the fourth Howard sufficiently good so that the third Howard's demise no longer hurts enough to qualify as a lost building of utmost regret.

LOST: POLICE AND FIRE HEADQUARTERS

The Providence Police and Fire Headquarters (1940), an austere but lovely stripped-classical building, was demolished unnecessarily in 2007. It is now a parking lot.

This sad chapter on the demise of an elegant police and fire headquarters ought by right to follow an equally sad chapter on the fate of the Central Police Station, completed in 1895 to the design of Stone, Carpenter and Willson. The firm was the profession's leading exponent of the American classical renaissance in Providence. Its preeminent accomplishment was the Providence Public Library, which has no chapter in this book because, unlike the Central Police Station, it remains standing.

Both the older police station and the library went up shortly after the World's Columbian Exposition of 1893, in Chicago. In an era before the automobile and

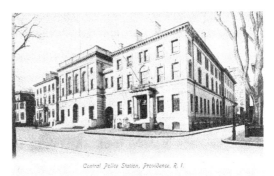

Postcard of Central Police Station (1895), designed by Stone, Carpenter and Willson, on Fountain Street until the 1970s. *"Central Police Station, Providence, R.I.," PC9089, Rhode Island Postcard Collection, Providence Public Library, Providence, RI.*

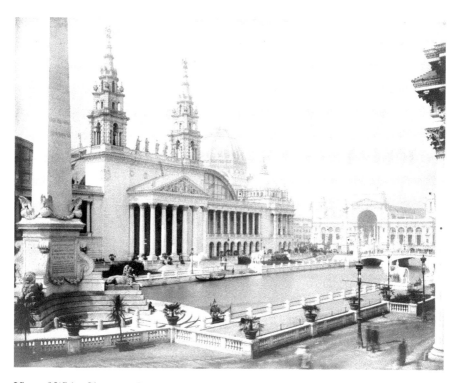

View of White City at the World's Columbian Exposition of 1893, in Chicago, which sparked the City Beautiful movement. *Library of Congress, Prints & Photographs Division, Historic American Buildings Survey (HABS), LC-USZ62-116999 (black-and-white film copy negative).*

the aeroplane, it drew, over six months, 27.3 million visitors (nearly a quarter of the U.S. population at the time). The temporary structures of neoclassical design that housed the fair were laid out on a series of lagoons with a picturesque symmetry. Called the White City for its alabaster stucco, the exposition sparked a City Beautiful movement that brought classicism to the central business districts of many American cities, including Providence.

The American Renaissance in city planning and design did not outlast the next three decades, which saw the rise of a more "functional" architecture. By 1950, this modern architecture had replaced centuries of tradition culminating in the City Beautiful movement as the default template for the design of cities. In the meantime, a style war raged. When the police and fire headquarters building was being designed by the Office of the Commissioner of Public Buildings, formerly establishment architectural firms were addressing the challenge posed by modern architecture. Their

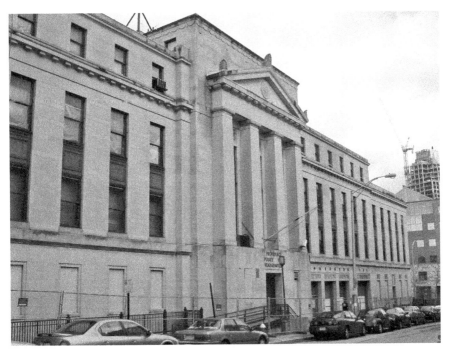

Police and Fire Headquarters (1940), designed by the Office of the Commissioner of Public Buildings. *Photo by author.*

response embraced compromise: "stripped classicism"—classical form largely shorn of ornamentation.

The police and fire headquarters epitomized this approach. The nomination papers submitted by the RIHPHC to the U.S. Department of the Interior to place most of downtown in the National Register of Historic Places bear no hint of the aesthetic battle underlying the station's design, but its comment illuminates the city's attitude toward itself:

> *The police and fire department building demonstrates Providence's continuing interest in a traditional architectural vocabulary for civic structures into the 1940s. Rather austere in its adaptation, this building complements the more elaborate Public Library across [Empire] street.*[21]

The library has a sad story. It is not lost, but hidden. In the mid-1920s, an addition in the Beaux-Arts style of the original was proposed. Ultimately, however, a Moderne style prevailed, merging the streamlined curvature of Art Deco and the sharp-edged formalism of the modernist style. It was completed

in 1954, and it blocked the view of the lovely original building from down Washington Street. Furthermore, the entry was switched to the new building's frontage on Empire—essentially, the basement. Inside, it looked like a municipal tax collector's office, as it does to this day. Charitable and other functions held there today avail themselves of the remaining classical spaces upstairs.

In 1940, the headquarters of the city's fire and police departments moved into the new building. The Central Police Station remained standing after the police moved on. The building was used to house the city's water department and the department of public welfare. It was demolished in the late 1960s and eventually replaced by a postmodern office building that today hosts the downtown studios of Hasbro, the toy and game company headquartered in Pawtucket, Rhode Island. The city welfare department moved into a modern state welfare headquarters, just to its east, that today might soon qualify as the city's *worst* lost building.

That controversial structure, designed by Castellucci, Galli and Planka Associates and called the John E. Fogarty Memorial Building, was completed

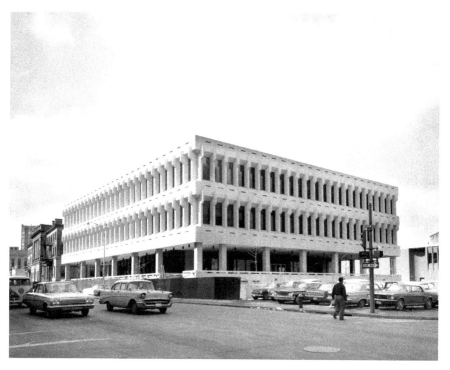

John E. Fogarty Memorial Building (1967). Note the Central Police Station (1895) just beyond, and the Police and Fire Headquarters beyond that. *Courtesy of Providence City Archives.*

in 1967. Its design is a study in orderly concrete massing in the Brutalist style, a style popular among establishment architects in the 1950s and 1960s but never much loved by users or passersby in Providence or anywhere else. The Fogarty was abandoned just two decades later and has been rumored to be on the verge of demolition for years. Preservationists have risen to its defense, albeit tepidly, even though its status as a Brutalist icon was questioned in RIHPHC's 1981 downtown survey:

> *Though lacking the bold plasticity and varied massing of landmark Brutalist buildings, the Fogarty Building is a better solution for its site than those more aggressive structures. It maintains the scale of nearby buildings while keeping its own architectural integrity.* [22]

This suggests that massing and scale can take a building only so far in terms of fitting in. The *Penguin Dictionary of Architecture* describes Brutalism as "nearly always us[ing] concrete exposed at its roughest [béton brut] and handled with overemphasis on big chunky members which collide ruthlessly." [23] Boston City Hall qualifies as the most typical of the more "ruthless" examples of Brutalism. A recent book seeking to demonstrate the "unfairness" of Brutalism's unpopularity is called *Heroic: Concrete Architecture and the New Boston.* Good luck with that!

The Fogarty Building's timidity as an example of the Brutalist style undermines its defenders' call for its preservation. Credit it with being a "better solution for its site than those more aggressive structures" if you like, but such a low bar will not save it from demolition. Nor should it, if a better alternative is proposed. A tall hotel was proposed in 2014, with a suburban office-pod design that has since been radically recast in a traditional mold—alas, a poorly detailed one in its latest incarnation. In order to put a proper kibosh on its predecessor, the design must improve. This may seem very unlikely, but so was the decision by the developer, the Procaccianti Group, to shift the design suddenly from modernist to traditional. The jury's still out on the Fogarty's replacement, if not on the Fogarty itself.

Perhaps it will be the fate of the lamentable Fogarty Building to join the lamented police and fire headquarters building in the limbo status of a parking lot, along with the Hoppin Homestead Building, the Providence National Bank and, for two decades, the Narragansett Hotel. Or maybe the sites of the Fogarty and the headquarters buildings will someday be occupied by buildings that fit into the city's existing historic fabric. Stranger things have happened.

LOST: WESTMINSTER CONGREGATIONAL CHURCH

Westminster Congregational Church (1829) was designed by Russell Warren in the Greek temple style with eight massive Ionic columns. In 1902, it was transformed into the Rialto Theater. Its portico was demolished and its nave retained to seat its audience. The crest of the old church's gable survives and is visible from the parking lot across Mathewson Street.

Nitpickers Anonymous may well quibble with the Westminster Congregational Church's placement on the list of lost buildings. True, the church no longer exists, but on the other hand, it does exist, at least as much as the Rialto Theater still exists, the surviving façade of whose lobby replaced the pedimental colonnade of the church in 1902. Sidewalk archaeologists can still spot the peak of the gabled roof of the church's nave, built 187 years ago, by entering the parking lot across Mathewson Street and peering at the old gable peeping over the roof of Dragon 2000 (a shuttered Chinese restaurant), a convenience store and a thrift shop for the elderly. The retail establishments now occupy what was once, 114 years ago, the lobby of the Rialto Theater.

Russell Warren, the architect hired by the congregation to design its church on Mathewson, was joined, it seems, by James Bucklin to do the work. Oddly, sources disagree on who was involved. Cady identifies Bucklin alone as the architect.[24] The RIHPHC 1981 downtown survey and its nomination papers for listing in the National Register of Historic Places, submitted in 1980, identify the architect as Warren alone.[25] Antoinette

Westminster Congregational Church (1829), designed by Russell Warren, on Mathewson Street. *"Westminster Congregational Church," VM013_WC0421, Rhode Island Photograph Collection, Providence Public Library, Providence, RI.*

Downing's *Early Homes of Rhode Island* cites only Bucklin in her text and both in her drawing's caption. She dates the church to 1840, not 1829, and calls it the "Westminster Street Congregational Church."[26] She uses the word "street" in its name, but it is not on that street. On the other hand, the website of the Library of Congress's Historic American Buildings Survey cites both.[27] The biographies of James Bucklin and Russell Warren included with their entries in the Rhode Island Heritage Hall of Fame list both as the building's architects and also name and date the building correctly.[28] Perhaps the fact that they did work together on the Providence Arcade, which had opened the year before, is responsible for this attributive confusion, along with their working together for about a year after Warren briefly joined the firm Tallman and Bucklin.

In any event, Warren and Bucklin were essentially tossed on the slag heap of architectural history in 1902 after the congregation moved to Adelaide Avenue, farther out into the West Side. The church's portico, described in the 1981 **RIHPHC** survey of downtown as a "stuccoed-stone octastyle Ionic temple" and "a fully realized academic treatment of the Greek order," was

Rialto Theater, added to Westminster Congregational in 1902 after removal of church's pedimental colonnade. Note the surviving church gable visible above the Rialto's parapet. *Photo by author.*

sliced off.[29] William Walker & Sons designed a three-story brick-and-stone façade with five two-story round-head windows to encase a lobby for the Rialto Theater. In the 1950s, the theater was replaced by shops, and the rear of the church was demolished for parking. This left the central segment visible from the building's rear for a more direct but also perhaps less exhilarating sense of archaeological discovery than is offered by the view of the old gable from the parking lot across Mathewson.

The possibility of reviving the Rialto as a theater arose briefly along with Providence Place—a downtown shopping mall built in the late 1990s in Capital Center, a new development district created on land near the Rhode Island State House. The mall owners and the Coalition for Community Development, a local proponent of reviving the old downtown, haggled over the developer's promise to build a small arts theater in the old commercial district to atone for its huge cineplex planned for the mall. In negotiations, the Rialto was rejected in favor of a nearby parking lot across Fountain Street from the Providence Journal building. A design was commissioned, and ground was symbolically "broken" on Mathewson, but the *Journal* declined

to participate in the proposed Downcity Cinema. (The name Downcity was a 1990s-era attempt to brand the old downtown with a nickname from the 1950s and 1960s, when "going down city" to shop was still a popular family outing.) The arts cinema was never built, although Arnold C. "Buff" Chace, who was involved in those talks, later institutionalized free Thursday evening films in his parking lot (formerly the tedious W.T. Grants Building [1949–2005]) shown against a screen attached to the blank side wall of the Train Building (1893) on Westminster Street.

When the mall opened in August 1999, Providence could momentarily boast of having the nation's newest mall and its oldest—the Arcade. This 1828 building, in the form of a Greek temple reaching through the entire block, is among the very early commercial structures in what was to become downtown Providence. The six Ionic columns of granite at either end were, at their erection, the largest monoliths in the United States. The Arcade would deserve a chapter of its own were it a lost building, which thankfully it is not. However, this chapter on the Westminster Congregational Church, with its original temple front of eight columns, represents a splendid opportunity to slip in a few remarks about the beloved cathedral of commerce.

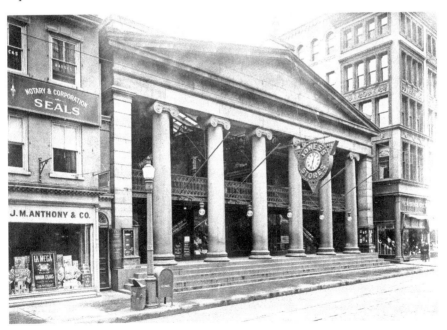

Providence Arcade (1828), Westminster Street façade. It is the oldest indoor mall in America. *"View of the Arcade and neighboring businesses," VM013_WC0012, Rhode Island Photograph Collection, Providence Public Library, Providence, RI.*

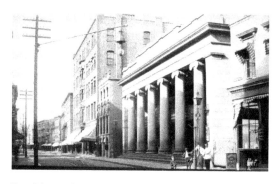

Providence Arcade, Weybosset Street façade. Arcade designed by Russell Warren and James C. Bucklin. *"Providence Arcade," VM013_WC1477, Rhode Island Photograph Collection, Providence Public Library, Providence, RI.*

A local parlor game could be invented in which players cite contemporary newspaper, magazine and web references to the Arcade as the *first* indoor shopping mall in the nation. The Arcade is indeed America's oldest indoor mall. But it was not the first. That distinction belongs to either the New York or the Philadelphia arcades, both of which were designed by John Haviland and completed in 1827, a year before the one in Providence. And both are history. All three were inspired by London's Burlington Arcade, which opened in 1819 (and still exists). The one in New York was an immediate failure, demolished after just a few years; the one in Philadelphia remained in business until it was demolished for a department store in the 1890s.[30] Again, the Providence Arcade is the oldest, not the first. The words are not synonymous.

Local lore has Warren designing the pedimental (gabled) temple front on Westminster Street and Bucklin designing the parapet-style (stepped) temple front on Weybosset. A more collaborative relationship was uncovered by Robert P. Emlen, working with William H. Jordy and Christopher P. Monkhouse on the catalogue for "Buildings on Paper: Rhode Island Architectural Drawing 1825–1945," an exhibit in 1982 cosponsored by Brown University, the Rhode Island School of Design and the Rhode Island Historical Society.[31] But Emlen's description can be read as bearing out local lore, at least to the extent that Warren and Bucklin each had more influence on the entry design popularly attributed to either architect. Cady has the popular attribution reversed. The discrepancies may arise because "shared responsibility" (or perhaps our era's hankering after it) has obscured individual accomplishment in the the design of the Arcade. Lesser scholars, such as those who caption online photos of the Arcade, mix up the pediment and parapet portico styles and their respective streets with a predictable frequency.

The two architects were hired by businessman Cyrus Butler—considered in 1827 the city's wealthiest citizen—and his partner, the Arcade Realty

Company. Each owned half of the building, split lengthwise, but they jointly owned each entry portico. A third story was added to the design well after construction had begun, and the columns were changed, at Warren's suggestion, from Doric to Ionic, upward in the hierarchy of the classical orders.

The Arcade was initially called "Butler's Folly" for its supposedly dubious challenge to the town's commercial center across the river, along Towne Street (now North Main), known as Cheapside. Emlen writes that it was 1870 before the Arcade was 90 percent occupied. Three years later, Butler's heirs built what was then the city's largest office building, the Butler Exchange, between Exchange Place and the Arcade's Westminster entry. The Butler Exchange's lobby featured a commercial corridor leading from Exchange Place to the Arcade, creating an indoor shopping district two blocks long.

After 1870, it may be assumed that Rhode Island's robust manufacturing expansion and rapid population growth allowed the Arcade to prosper. Good times did not last. Prosperity stumbled in the period encompassing Depression, two world wars and the gathering flight of the the state's textile industry to the South. (The map reprinted in this book's prologue, showing Providence as "The Centre of Northern Industries," with trade links to other parts of the country and the world, seems unfazed by the ominous "Great Textile District of the South.") The Arcade joined other downtown businesses in the slow general decline.

In 1944, plans to demolish the Arcade for an office building startled citizens and perhaps generated the first surge of regret at the growing status of demolition as a tactic of civic redevelopment. The 1956 founding of the Providence Preservation Society was still a dozen years in the future, but socialite John Nicholas Brown led an effort to block the attempt to raze the Arcade, ending with its purchase by the Rhode Island Society for the Blind. Rhode Island builder Gilbane Properties bought it in 1977 and, in 1980, financed a renovation by Irving B. Haynes and Associates.

Visitors to the Arcade in the mid-1980s and beyond, including this writer, enjoyed what seemed to be a healthy selection of shops, lunchtime eateries, restaurants and evening entertainment venues (such as the comedy club Periwinkles). Its alleged retail difficulties led, nevertheless, to a brief ownership by Johnson and Wales University, which sold it to a development firm experienced in the management of historic buildings. Yet Granoff Associates put in place a business model of raising rents and evicting retailers, until only thirteen remained. The firm then closed the building, ending, at least in theory, its status as the nation's oldest shopping mall.

Granoff attempted to find a single lessee, such as a Staples. Failing at that effort, which would *not* have rescued the Arcade's status as oldest indoor mall, Granoff hired Northeastern (formerly Newport) Collaborative Architects to renovate the building and, with the advice of the Providence Preservation Society, rescued the building's status as a "mall" by preserving the entire space, placing a dozen niche shops on the ground floor and devoting the two upper floors to residential micro-lofts, most of them with fewer than three hundred square feet of living space. There were more than four thousand names on a waiting list for the lofts, but the occupancy rates seem a bit hazy and some of the shops seem dodgy. At this point, however, downtown again has a mall that looks like a Greek temple and is the oldest such mall in America.

There must be an architectural landmark equivalent of the "five-second rule," whereby those who drop food on the ground can eat it if they pick it up within five seconds. (Is that the average time it takes for a bug or a germ to invade the morsel?) The Arcade was closed in 2008 and remained shuttered for about five years until it reopened in 2013. Nobody grumbled that the Arcade could no longer claim to be the nation's oldest mall. So it appears as if a historic building does not lose its landmark status, so long as it reopens within five years.

LOST: THE SECOND
UNIVERSALIST CHURCH

The Second Universalist Church (1849), by Tefft yet again, was torn down unnecessarily after a fire in 2006. Today, it is a parking lot. The popular Downcity Diner (as it was called) soon relocated down Weybosset to the only remaining Tefft building in downtown.

T he phrase "Tefft yet again" refers to the first paragraph of the *Journal* column "Providence's 10 best lost buildings." Tefft designed Providence's first train station and Benefit Street's Edward Pearce House, two lost buildings that did not get their own listing in the column's ranking of the ten best lost buildings. Maybe they should have. As its author wrote in that column, "Indeed, I'm still quarreling with this selection."[32] And that quarrel goes on even as this book is being written.

The Second Universalist Church, designed in the Romanesque Revival style by Tefft, was completed in 1849. A red brick three-and-a-half story building, its arched fenestration and gabled end facing Weybosset Street were the sole surviving evidence, at the time it burned down in 2006, of the ecclesiastical function for which it was built. In 1852, an upper story housed the state's first private normal school (for instructing teachers), a predecessor of Rhode Island College. The building's design is described by the RIHPHC's downtown survey:

2nd-story windows infilled, five round-head windows with voussoirs and connecting imposts on third story, centered round-head window with tracery

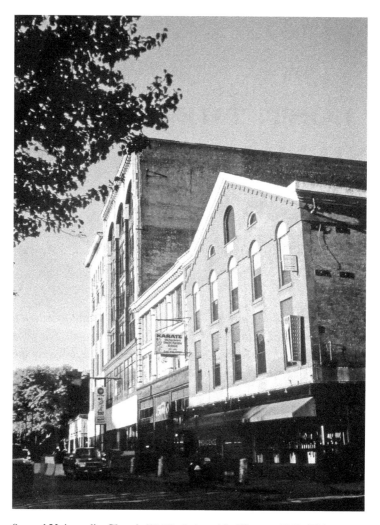

Second Universalist Church (1849), designed by Thomas Tefft. This
building housed Downcity Diner until 2006, when it was demolished after
a fire. *Photo by author.*

*flanked by two lunette windows below datestone in attic.... [A] reminder
of the generally residential nature of this part of downtown before the Civil
War, the Second Universalist Church building, though heavily altered both
inside and out, adds architectural variety to the streetscape in a block of
vernacular buildings.*[33]

None of the rare sources of information about this building reveals
whether it originally had a steeple or any other suggestion of its divine

purpose. Except for a mention in the list of surviving churches by Tefft, the Second Universalist gets no attention in Katherine M. Long's article "Style and Choice in Mid-19th Century Church Architecture" in *Thomas Alexander Tefft: American Architecture in Transition*, the catalogue for a 1988 exhibit by the Department of Art at Brown University.[34]

Tefft and another major Providence architect barely mentioned thus far, John Holden Greene, appear again and again, however, in the history of Providence and also in the history of the author of this book. His first domicile in Providence, between late 1984 and 1990, was at 283 Benefit Street, on the third floor of the Daniel Bush–Walter Updike House, completed in 1854 (architect unknown). The tiny rental unit's two splendid views were of downtown to the west and, to the south, of the First Unitarian Church, designed by Greene and completed in 1816. Out that same window, to the left, is the Hope Club, a large 1885 Queen Anne structure of many turrets and gables, like the church a real eye-catcher. Its parking lot, below my window, at the corner of Benefit and Benevolent, exposes views, once blocked, of the church and possibly of the club. Before 1960, the Edward Pearce House, designed by Tefft and also completed in 1854, would have

Edward Pearce House (1854), designed by Thomas Tefft. It was demolished in 1960 to make way for the Hope Club parking lot. *Library of Congress, Prints & Photographs Division, Historic American Buildings Survey (HABS), HABS RI,4-PROV,101--1.*

interrupted the view, although even a side view of the Pearce would probably have been delightful.

In 1990, the author moved south to 395 Benefit, designed by Greene and completed around 1820. The Thomas Peckham House is a severe Federal square (with a rear ell) of red brick without embellishment except for a heavily ornamented overhanging cornice and a bracketed Victorian entry hood, the latter added about half a century later. Greene might have had a hangover the day he designed this house. It is one of just five houses on Benefit aslant to the street, in this case rotating slightly rightward. That offers the emerging resident an enchanting view of the Tully Bowen House, designed by Tefft and finished in 1853. This sumptuous brownstone mansion set amid a lawn within a low brownstone wall is Tefft's most celebrated private house.

In 1851, Tefft added the cupola to the state's early capitol, built in 1762 on Benefit, which served as a courthouse after the McKim, Mead and White capitol opened in 1900. Since 1975, it has been home to the state's historic preservation office, led by the RIHPHC. Tefft designed the town's first train station, Union Passenger Depot, in 1848. He also designed the elegant Central Congregational Church on Benefit Street and the Bank of North

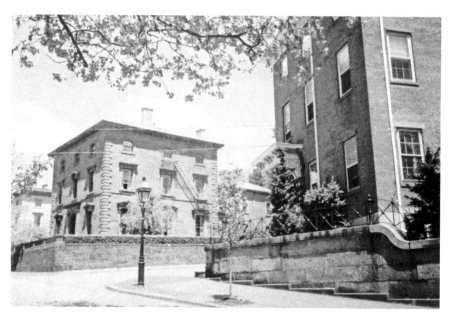

Tully Bowen House (1853), designed by Thomas Tefft, is seen beyond the Thomas Peckham House (circa 1820), designed by John Holden Greene. The latter was the residence of the author from 1990 to 1996. *Photo by author.*

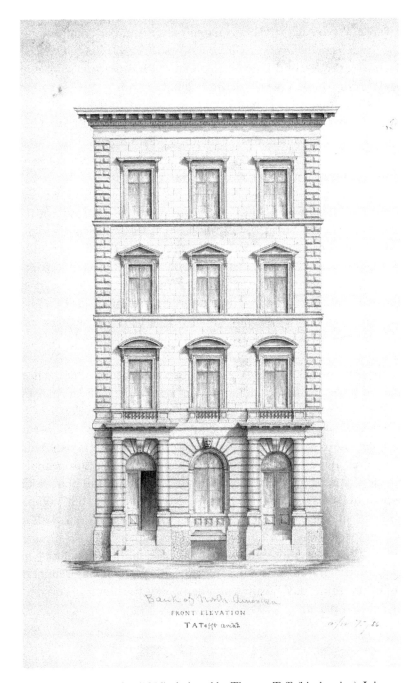

Bank of North America (1856), designed by Thomas Tefft (his drawing). It is now his last building left standing downtown and where the Downcity Diner moved after its fire. *Hay Library, Brown University Library.*

America on Weybosset Street—to name only his major commissions that survive—plus some half a dozen houses of considerable magnificence.

Of course, the Second Universalist Church has not survived, nor was it among Tefft's most notable designs, but its loss is tragic. It suffered a disastrous fire long after it had ceased its original mission and become a beloved downtown restaurant frequented by this author. The fire marshal declared it a hazard—prematurely in the opinion of many at the time, certainly before the performance of any serious analysis of its condition—and had it razed.

The kitchen fire at the Downcity Diner, as the restaurant was originally called and was still known to most of its patrons in 2006, caused its owners to relocate up Weybosset Street. Totally innocent of the historical resonance of their move, they occupied the Bank of North America Building, a handsome brownstone-fronted Italianate structure built in 1856. What the owners had done was to move out of the second-to-last and into the last surviving building in downtown by Tefft. This author felt a certain pride in noticing a factoid that, in all honesty, he cannot imagine to be of the slightest interest to the building's owners, their patrons or (almost) anyone else in the city. Nevertheless...

The property owner, Stanley Weiss, announced not long after the fire that he planned to erect a new building on the land. Weiss is the former owner of the Tilden-Thurber Building on Westminster and the developer of Hotel Providence, kitty-corner from Tilden-Thurber. The hotel embraces a square, where hotel guests and others dine, formed by the hotel, Tilden-Thurber, Grace Church and the Burrill Building. It may be the most European setting in Providence. For its existence we may be thankful to the demolition, in a private-public partnership with the city, of four lost but completely unregretted buildings, the best of which had already been destroyed by fire but not yet torn down (more on this project in chapter 22).

And yet the parking lot on the site of the Second Universalist Church has remained a parking lot for a decade. In short, it has retained the possibility of some day hosting another beautiful building (or perhaps another micro-plaza).

LOST: THE OUTLET COMPANY STORE

*The Outlet Company, built in stages between 1891 and 1914, was a rambling
series of lightly colored brick and terra-cotta structures that fell victim to fire in
1986 while awaiting renovation as an apartment complex. With one exception,
its replacement by the pleasing quadrangle of Johnson & Wales University
substantially diminishes our regret.*

The only building on the list of ten best lost buildings whose demise
does not arouse unvarnished regret is the Butler Exchange, which
will be discussed in the next chapter. The loss of all others except for the
Outlet Company Store are considered regrettable in the extreme, because
they were replaced by something worse, a category into which parking lots
must fall, whatever hope they may hold for the future. The Butler Exchange
was replaced immediately by the Industrial Trust Bank Building, now widely
known as the Superman Building. It serves wholeheartedly to diminish our
regret at the loss of the Butler Exchange.

The Outlet Company Building is different. When the vacant old
department store burned down in 1986 under suspicious circumstances, the
ruins remained for several years, a hole in the heart of downtown, plucking at
the strings of local sorrow. And then it was replaced in 1994 by the academic
quadrangle of Johnson and Wales University (JWU). In spite of Broadcast
House forming its eastern edge, the quad is attractive enough to cause a
struggle in the mind of preservationists, or at least this one, over whether
the Outlet's passing should really be lamented. Its fire might indicate rising

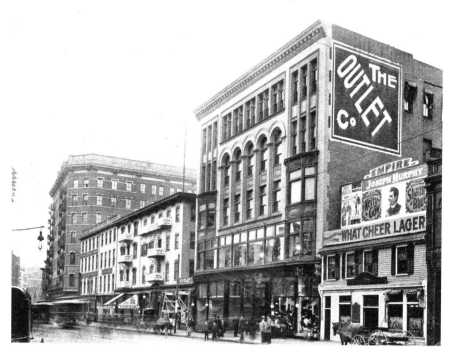

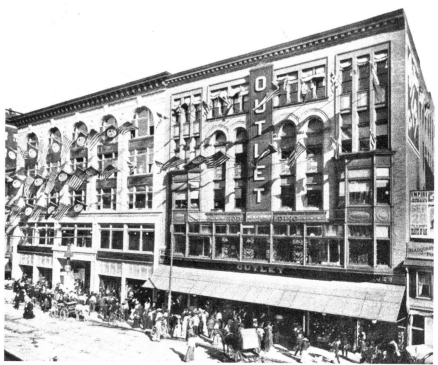

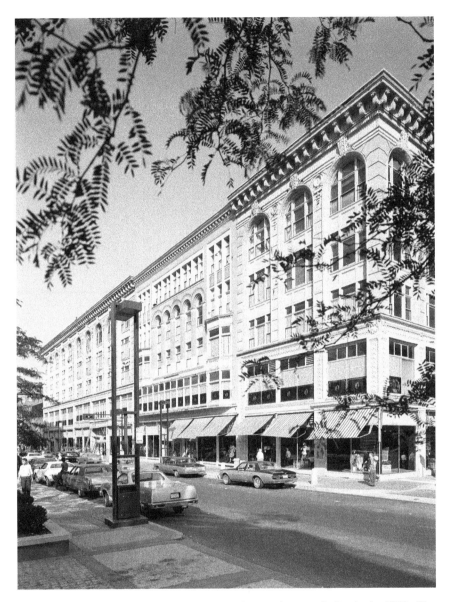

Above: Outlet Company Store, after final stage of expansion, concluding in the 1920s. Fire demolished the vacant structure in 1986. *Photo by Warren Jagger.*

Opposite, top: Outlet Company Store (1891), on Weybosset Street. This is the first set of buildings erected as the store grew over time. *"The Outlet Co." VM013_WC0326, Rhode Island Photograph Collection, Providence Public Library, Providence, RI.*

Opposite, bottom: Outlet Company Store (circa 1905), after second and third stages of expansion. *"[Westminster Street, Providence, R.I.]", PC7653-11, Rhode Island Postcard Collection, Providence Public Library, Providence, RI.*

doubt about its planned redevelopment as apartments. If that had indeed occurred, an infusion of downtown residents might have begun a decade before the one sparked by developer Arnold "Buff" Chace. His first building opened in 1999, several months before Providence Place—and this author was among the Smith Building's first tenants. Even before the Outlet fire, an apartment complex might not have been as likely a successor to the Outlet as a parking lot. So in balancing the virtues of the Outlet against the academic quadrangle that was its actual successor, taste is in a quandary.

By the time of its final build-out in the 1920s, when it occupied almost the entire block west of the Narragansett Hotel, the Outlet had accomplished the successive replacement of at least five buildings on Weybosset alone. Architecturally, the Weybosset façade was a study in the syncopated arrangement of arched fenestration, stretching a full block atop the first two stories of the five-story structure. The Outlet's expansion first orchestrated two sets of five arched windows, then a set of five arched windows inset among more regular rectangular windows and concluding with a set of three arched windows. Interspersed over some two decades were several mergers of the structure. There was an almost rumpled quality to the Outlet's glorious, block-long Beaux-Arts symphony. Like the sartorial carelessness of a swamp Yankee, it grew shabbier in the 1970s and 1980s as the once vibrant commercial district was abandoned by customers and the employees of the big local businesses that decamped for suburbia.

Because there are quite a few streetscapes in downtown of higher architectural quality than this block of Weybosset even before the loss of the Outlet, regret for its demolition centers less on the loss to beauty than on its role in the decline of prosperity downtown. The population of Providence fell by 17 percent between 1950 and 1960, part of a 40 percent decline between 1945 and 1985. After expanding its retail presence in the Providence suburbs and in other cities, the Outlet Company shifted its focus from retail to communications. The Outlet Company had long before joined the ranks of shopping empires with broadcast divisions, inaugurating a radio station in 1922 and a television station in 1949 (both under the call letters WJAR). In 1980, the company abandoned retail altogether and sold its flagship store on Weybosset in 1981 to a conglomerate that closed it in 1982. Four years later, as developers contemplated turning the empty building into an apartment complex called City Place, the October 16, 1986 fire put the kibosh on the plan. The plan was for a residential complex surrounding a large, park-like courtyard hollowed from the building's core. It found its echo two decades later in the atrium cored out of Buff Chace's largest downtown loft rehab

project, the Peerless Building, named for one of the Outlet Company's former rivals.

When the Outlet Company Building burned down in 1986, its site was purchased by Johnson and Wales College (now university). The remains were removed, and starting in the early 1990s, the university constructed an academic quadrangle amid a grouping that mostly continued the theme of brick, with variations, to anchor its downtown campus. A gatehouse in the form of a classical temple takes center stage as part of a wrought-iron railing with brick piers along Weybosset, backed by a bosque of trees and a large lawn. Two brick dormitories are arrayed on the south and west sides of the quadrangle. The east edge is held down, literally and figuratively, by the existing East German Embassy—oops, Broadcast House—now the school's library and administration building. It may perhaps be applauded for making the rest of the quad look, by comparison, as if it were designed by Palladio.

In 1991, the author was taken on a tour through downtown by former mayor Joseph R. Paolino Jr., who at the time had just done a stint as U.S. ambassador to Malta and was then Rhode Island's economic czar under Governor Bruce Sundlun, the last CEO of the Outlet Company. Pausing

Gaebe Common, downtown campus (1994), Johnson and Wales University, built on the site of the Outlet Company Store. *Photo by author, circa 1996.*

occasionally to run a red light as if he owned the place, Paolino expounded his theory that downtown would blossom with an inundation of university students, JWU merely being the first (in modern times). Paolino was correct. Indeed, he may not have anticipated quite how correct, since his optimism was based more on visits from students living beyond the edges of downtown than on the prospect of colleges establishing adjunct educational facilities downtown. But look at what has happened since he harangued this writer—then on the editorial board of the *Providence Journal*—with his "Jelly Doughnut Theory."[35]

JWU was followed by the Rhode Island School of Design (RISD), which purchased the Fletcher Building at Weybosset and Union Street from Stan Weiss, and then Brown, which purchased the Mason Building next door, and then the University of Rhode Island (URI), which opened a Providence campus in the Shepard Building. Next came Roger Williams University (RWU), which leased space in the Kinsley Building, also on Westminster. RISD ended up buying the old Hospital Trust Building, transforming its classical banking hall into a library (with one of the world's very few aesthetically successful modernist insertions) and its upper-story offices into graduate student housing. URI and Rhode Island College (RIC) have joined Brown administrators and two state nursing programs in renovating an abandoned Beaux-Arts power plant, the South Street Station. Rebranded as South Street Landing, it is expected to open in 2017 just outside of downtown. RWU has just moved its downtown facility from one space to another in a building of which it might be said, "Turn left onto Empire where 38 Studios used to be."

The allusion is to a recent corruption scandal in Rhode Island. Regardless of what some architectural historians claim to believe, buildings cannot choose their occupants, nor can they be blamed for whatever activities (good or bad) occur behind their doors. RWU, true to its namesake, will give the building at the corner of Empire and Washington a higher purpose. So, too, has Johnson and Wales exalted the place where the Outlet used to be.

LOST: THE BUTLER EXCHANGE

The Butler Exchange (1873), a Second Empire pile of mansards, was demolished in 1925 and replaced in 1928 by the Industrial Trust (or "Superman") Building. The Union Depot might have just as much claim to this spot, but I have already mentioned it above.

The Butler Exchange was built forty-five years after Butler's Folly, today known as the Providence Arcade—or rather awkwardly as Arcade Providence, its latest iteration as niche shops and micro-lofts, having rescued its briefly lost iconic status as America's oldest (not first) indoor shopping mall. The Butler Exchange, designed by New York architect Arthur Gilman, was the largest building in Providence at its completion in 1873. A fire hastened its demise in 1925.

Its replacement in 1928 with the tallest building in New England at the time, the Industrial Trust ("Superman") Bank Building (ITBB), required the demolition of the Butler Exchange, whose French Second Empire design may well have influenced nearby City Hall, designed by Samuel F.J. Thayer in the same style and completed in 1878. The Butler Exchange filled a city block, rising four elaborate stories that are topped by two more stories set back slightly from the fourth-floor cornice. Their windows emerged obliquely from a highly pitched mansard roof, at each corner of which stood mansard-style towers indebted to, or at least reminiscent of, the Louvre. The Butler Exchange's architectural style departed from the prevailing styles of this period of robust growth downtown. But it did not

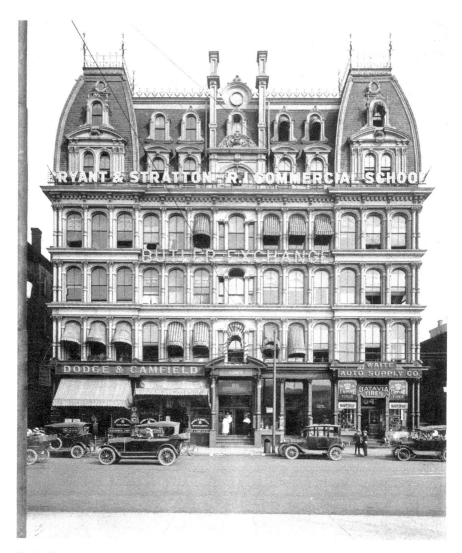

Butler Exchange (1873), upon completion, was the largest building in Providence. It was demolished in 1925 to make way for the Industrial Trust Bank Building (1928). *"Butler Exchange," VM013_WC0299, Rhode Island Photograph Collection, Providence Public Library, Providence, RI.*

disrupt the elements of design, mostly vertical bays and their embellishment, that characterized commercial buildings then prevalent in America and in Providence. Few architects of the era could or would conceive of designing a building, commercial or otherwise, in a style that diverged significantly from those of its neighbors. Architects worked from a palette of the imagination

considerably narrower than architects of today—even though styles within that palette varied as greatly as styles in our modern era. But in our age, too much stylistic diversity comes at the expense of the harmony and unity that help make cities beautiful.

The Industrial Trust arguably did step across that boundary, challenging the harmony of commercial architecture downtown after it opened in 1928. The Butler Exchange, with its two upper floors set back from the walls of its first four floors, seems to anticipate the nation's first zoning law, a 1916 ordinance forcing skyscrapers to step back their upper stories so that sunlight can get down to street level. The Empire State Building and the Chrysler Building are famous examples of the application of that law. If the Butler Exchange nods to the law, the Industrial Trust boosts it up on its shoulders. The Industrial Trust is a combination of Art Deco and classical styles, but its wedding-cake form is its chief break from conventional building practice in Providence. Its wings come close to the Platonic ideal of the modern skyscraper. In fact, except for the Fleet Center next door, whose up-stepping "hat" uses postmodernist irony to snigger at the Industrial Trust, the "Supe" is the only Providence tower of that kind. Downtown's other towers of several decades' standing are the Hospital Trust and the Textron, both of which were erected after zoning shifted from setbacks to towers as a percentage of a plaza. Indeed, the Industrial Trust's closest rival nationally is Los Angeles City Hall, also completed in 1928—and one of several models for the comic strip, film and television versions of the *Daily Planet* building, where Clark Kent hung his hat. Rhode Islanders call it the Superman Building because it fits their image of the icon better than the icon itself.

Rhode Islanders love the Industrial Trust Building more than any other edifice in their state, possibly including the Rhode Island State House, designed by Charles Follen McKim of McKim, Mead and White, the most successful firm of the American Renaissance period that followed the 1893 World's Columbian Exposition in Chicago. When the Bank of America emptied the ITBB in 2014, its owner, High Rock Development of Newton, Massachusetts, shut off its dazzling golden façade lights, designed to highlight its broad shoulders. The cost of the lights was the equivalent of a year's rent for one of Buff Chace's lofts downtown—a crumb, one suspects, off the plate of High Rock. Chace has urged the city and state to help High Rock redevelop the building as apartments. Good idea...but good luck! After turning out the lights on the Supe in the wake of the 38 Studios scandal, High Rock called for $75 million in public subsidies for its rehabilitation (the same amount the General Assembly was snookered into giving to 38 Studios,

Left: Industrial Trust Bank Building (1928) was the tallest building in New England. Now known as the Superman Building, it was vacated in 2013. *Rhode Island Collection, Providence Public Library.*

Below: Los Angeles City Hall (1928), one of several buildings considered a model for the *Daily Planet*'s headquarters in the *Superman* television series. *Library of Congress, Prints & Photographs Division, Historic American Buildings Survey (HABS), HABS CAL, 19-LOSAN, 51--19.*

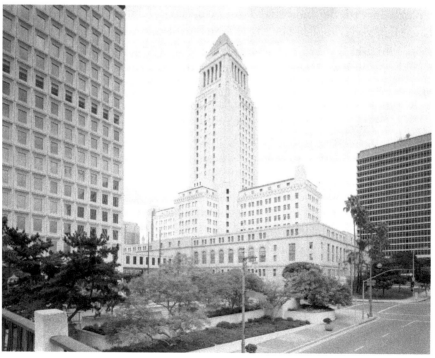

former Red Sox pitcher Curt Schilling's computer gaming development company). Rehabbing the Supe is a good and necessary idea, but it may be a political impossibility so long as High Rock remains its owner.

When the Butler Exchange was completed, the Union Passenger Depot designed by Thomas Tefft disgorged arriving passengers at a point in Exchange Place only fifty yards from the Butler Exchange. The Butler Exchange featured a ground-floor corridor lined with shops, from which one could cross Westminster directly to the Arcade, another corridor lined with shops. Today, the walk between the two successor buildings, Union Station and the Industrial Trust Building, with Burnside Park interposed, is two hundred yards. But now, the newest train depot, Providence Station, is beyond Waterplace Park on the far side of Union Station, a trek of three-quarters of a mile.

To some, that is walking distance; to others, it is not. Changes in the city cause changes in the walkability of the city. Its municipal planners now consider the Jewelry District—site of the South Street Landing project mentioned in the last chapter—to be a part of downtown. If so, then downtown can no longer boast of its walkability. But people need only refuse to think of the Jewelry District as downtown, and the city planners' needlessly ambitious expansionism can be discombobulated. And even today, most people are reluctant to call—or it never occurs to them to call—the Jewelry District by the name proposed by the city's arrogant rebranding: the Knowledge District. No, the Jewelry District is likely to remain the Jewelry District for a long time to come. (And by the way, South Street Landing is a mile from where the Butler Exchange used to be.)

This chapter has strayed a few yards, at least, from the Butler Exchange. Later chapters will stray farther, even beyond downtown—though some municipal officials deem the base of College Hill, the old Towne Street, now North and South Main, to be part of downtown even though it is across the Providence River from the city's central business district. On the other hand, we must not forget Cheapside, which was downtown before the city became a city. (Providence officially became a city in 1832, only four years after the opening of the Arcade.) In fact, this book will occasionally hop the river running down the middle of its theme when it graduates from discussing lost buildings to lost plans.

One of those lost plans might exist within the walls of the Industrial Trust itself. Was the building designed in part as a depot for airships, as Providence architectural archaeologist Noah Schwartz contends? High out on the loftiest east-facing shoulder of the building is the replica of an airship gondola.

Airship docking at Industrial Trust Bank Building, as seen from Weybosset Street. *Montage created by Noah Schwartz of Providence; author's archive.*

Inside, the top offices in the building's uppermost stories were designed to be reminiscent of passenger spaces in such an airship. Most of us are not old enough to remember when airships rivaled airplanes as the best way to fly heavy loads of passengers and freight long distances. Charles Lindbergh had made his transatlantic flight in the *Spirit of St. Louis* only a year before the Industrial Trust opened. But lethal accidents involving airships halted whatever plans there may have been for the tower's use as a depot for dirigibles. The Empire State Building scuttled its own plans after it opened in 1931. The top offices at the ITBB have in recent years been stripped of their original decor and redesigned. Building officials deny the existence of internal structures for embarkation facilities suggested by Schwartz, and for that matter by the gondola, which remains in place. Why is it there? Well, it is said to have been a favorite trysting spot for bank executives. But why was it there in the first place? Inquiring minds would like to know.

LOST BUT NOT LISTED

*Providence has no Penn Station, no lost building whose absence wounds deeply
to this day. Union Passenger Depot, designed by Thomas Tefft and completed in
1848, was replaced by Union Station in 1898, arguably its equal in beauty.
The depot's absence is sad but not irksome.*

Chapter 10 concluded this book's listing of Providence's ten best lost buildings. The passage beginning the current chapter is the opening paragraph of the original "Lost Providence" column. Tefft's depot will be discussed at greater length in chapter 12, which focuses on the city's first major series of development projects, from the whittling of the Great Salt Cove into the elliptical Cove Basin, on whose southern edge the depot was completed in 1848, to the filling in of the Cove Basin and the construction of Union Station in the 1890s.

That is the first chapter in a history of plans that will make up the second half of this book. But a tip of the hat must first go to lost buildings that, for all their beauty and (or) importance, did not make it onto the list of ten best lost buildings.

SABIN TAVERN (1763–1891). Local colonists met at South Main and Planet Streets on June 9, 1772, to plan an attack on the British revenue cutter HMS *Gaspee*, the first American bloodying of the Crown. With the building's demolition in 1891, its dining room, later renamed the Gaspee Room, was preserved, relocated and attached to the Mary Arnold Talbot House at 209 Williams Street.

CITY HOTEL (1832–1903). Located behind the Narragansett Hotel until it was demolished to make way for the first Outlet Company building on Weybosset Street, this was the city's premier hotel before the Narragansett opened in 1878.

STATE ARSENAL (EXTANT 1842). A two-story stone mill next to the Dexter Training Grounds on Providence's West Side where the Cranston Street Armory was built in 1907. Suffragist Thomas Wilson Dorr was elected governor in late 1841 among a slate of legislators after voters passed a People's Constitution, which was unrecognized by Governor Samuel Ward King. The Dorr Rebellion commenced in earnest when 234 armed citizens supporting Dorr attacked the arsenal on May 18, 1842, with two Revolutionary War–era cannons, which misfired. Rhode Island had two governors for six weeks.

STATE PRISON (1838–78). West of the Great Salt Cove and razed after a new prison in Cranston opened in 1878, the Greek Revival structure's most notable prisoners were Thomas Dorr, leader of the Dorr Rebellion of 1841–42, and John Gordon, hanged in 1845. Gordon was the last inmate to suffer the death penalty in Rhode Island—his role in the murder of factory owner Amasa Sprague is widely disputed.

WASHINGTON BUILDINGS (1843–1916). Located along the Providence River, facing east, it was just one building, designed by James Bucklin for the Providence Washington Insurance Company. Its temple pediment with six squared pilasters flanked by wings of brick rising three stories stretched from Westminster to Fulton Streets—endlessly, it must have seemed in 1843.

STATE NORMAL SCHOOL (1843–1956). On Benefit Street between Angell and Waterman, this structure served as Providence's first high school, a state normal school for teachers, the Rhode Island College of Pharmacy, a temporary state supreme court until the new Providence County Courthouse was ready in 1933 and as various social service agencies until its demolition in 1956. The site was then given to RISD and grassed over for the enjoyment of students.

PROVIDENCE OPERA HOUSE (1871–1931). Located next to the Narragansett Hotel, it was the city's major venue for theatrical performances for half a century. The two most substantial houses for live performances in the city

today, Lederer Theater for Trinity Square Repertory Company (Loew's, 1917) and the Providence Performing Arts Center (Majestic, 1928), were built as cinemas.

OLD PROVIDENCE COUNTY COURTHOUSE (1877–1930). At the southeast corner of Benefit and Waterman, this Gothic structure exemplified the "foreign" styles disliked by the mystery writer and Providence native H.P. Lovecraft, who preferred the more traditional Georgian style of the courthouse that would replace it in 1933.

DORRANCE HOTEL (1880–1920). Stretching the length of the block just south of City Hall, this building boasted a mansard roof and central tower, both eliminated by the addition in 1915 of a blockish sixth story. The hotel fronted a gangway or alley separating it from a thin, block-long commercial building two stories tall and maybe fifteen feet deep between the Dorrance Hotel and Dorrance Street.

INFANTRY HALL (1880–1942). On South Main Street, the city's primary gathering room for many years and designed by George Cady, the four-story Infantry Building, with tower, was erected by the state militia's First Light Infantry Regiment (from whom the Dorrites stole their two cannons). Three presidents spoke in its assembly hall: William McKinley, Theodore Roosevelt and Howard Taft. After a decline in use, it succumbed to fire.

RHODE ISLAND HOSPITAL TRUST (1891–1916). Amid a row of commercial buildings facing south along Westminster Street to the east of the Butler Exchange, this imposing structure designed by R.W. Gibson of New York seemed to combine Richardsonian and even Sullivanesque elements in a robustly encrusted façade of arched fenestration.

CENTRAL FIRE STATION (1903–1938). At the northeast corner of Exchange Place, it replaced a Central Fire Station built there in 1873. It was a massive, three-story Georgian structure of red and white banded brick surmounted by a tall bell tower. An Art Deco federal post office annex, opened in 1940, occupies the space today.

NICKEL THEATER (1906–1919). Now a parking lot for Grace Church, built in 1846. The Nickel was the city's first theater to show movies; its first film happened to open on the day of the San Francisco earthquake, April 18,

1906. Its predecessors featured vaudeville and its successors, including the Albee in 1919, maintained the curved entry of its ornate façade. The Albee's demolition accidentally damaged Grace Church.

ST. PATRICK'S CATHOLIC CHURCH (1916–79). This building stood just east of the old State Office Building (SOB) across Smith Street from the State House, which served until recent years as the state registry. The profusely embellished SOB was built in 1928, twelve years after the completion of St. Patrick's Church, which replaced an earlier St. Patrick's designed by Russell Warren and completed in 1848. The latest church's demolition in 1979 made way for state employee parking.

This list could be extended, and each entry would only serve to reemphasize the value of what the city has *not* lost. Fine as some of them are, no lost building on this secondary list, or for that matter on the list of ten best lost buildings elucidated heretofore in this book, qualifies as a Providence equivalent of Penn Station. None holds a candle to the quality of buildings that have survived here, buildings of a quality that have been so sadly and thoroughly lost in so many other cities. (The old Hospital Trust of 1891 might be the exception.)

Many buildings in Providence and everywhere else were demolished for ages before it occurred to anyone to mourn their passing. We tend to have records of those lost buildings that were replaced by notable buildings that survive or were part of institutions ambitious enough to record what they demolished. Other buildings recede into the woodwork of change, fading into oblivion. Old photographs that depict broad stretches of architecture, such as shots of Exchange Place, may contain buildings that seem quotidian only because their embellishment is difficult if not impossible to perceive at such a small scale. Some were indeed quotidian. Others may have been beautiful, and we will never know until the advent of H.G. Wells's time machine.

> *But, happily, the chief difficulty of identifying the city's ten best lost buildings was that so very many are not lost at all but survive to grace the streets of our fine downtown.*

This was the final passage of the introduction to the list of ten best lost buildings. It expresses the happy fact that so many old buildings that would have been goners in most other cities instead survive to please us for free

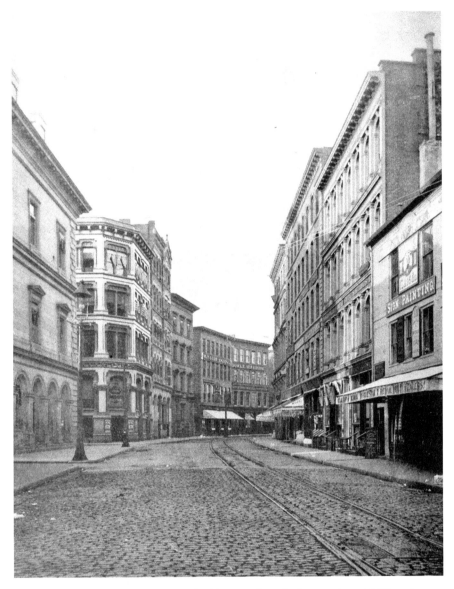

View up Weybosset Street, circa 1890, looking west from the intersection with Westminster Street. *"Weybosset Street." VM013_WC1476, Rhode Island Photograph Collection, Providence Public Library, Providence, RI.*

just by looking at them. To list them would be to unduly stretch this book beyond its natural, editor-enforced limits and serve no real purpose. More useful, perhaps, might be a list of entire stretches of buildings that have

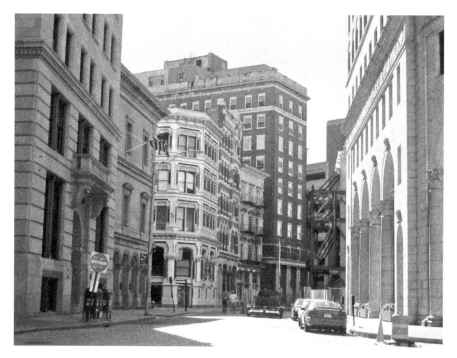

A view up Weybosset Street, with the Weybosset façade of Providence National Bank held up by girders. The Hampton Inn (2008) is as yet unbuilt. *Photo by author, 2007.*

almost wholly eluded the erosion of the symphonic city form. Block after block throughout Providence, and especially its downtown, are exemplars of historic preservation. Here is a partial list:

WEYBOSSET STREET, both sides, from Turk's Head to Empire Street (ten blocks)

WESTMINSTER STREET, both sides, from Turk's Head to Empire Street (nine blocks)

WASHINGTON STREET, south side, from Dorrance to Empire Streets (seven blocks)

CUSTOM HOUSE STREET, both sides, from Weybosset to Wirt Streets (one block)

DORRANCE STREET, both sides, from Exchange Terrace to Friendship Street (six blocks)

EDDY STREET, both sides, from Worcester to Weybosset Streets (four blocks)

UNION STREET, both sides, from Fountain to Weybosset Streets (five blocks)

MATHEWSON STREET, both sides, from Weybosset to Fountain Streets (four blocks)

EMPIRE STREET, east side, from Weybosset to Washington Streets (three blocks)

BENEFIT STREET, both sides, from Burr's Lane to Wickenden Street (eighteen blocks)

HOPE STREET, both sides, from Wickenden to Twelfth Streets (forty-eight blocks)

BROADWAY, both sides, from Dean to Toby Streets (fourteen blocks)

This list stops well short of exhaustion. It focuses on downtown, whose commercial district and financial district are listed together, in their entirety, in the National Register of Historic Places. For all its incompleteness, indeed because of the extent of its incompleteness, the list of streets pinpoints the unique quality of the architectural legacy of Providence: a largely intact historical "fabric," as preservationists like to call it. The downtown streets of many cities have an old building here, an old building there, some restored, some renovated to a new use, others still sunk in dilapidation, with one foot in the grave. But people perceive streets as a field of vision that includes many buildings at once, not as single buildings. An ugly street with one or two lovely old survivors may be a very useful and active street, but the one or two survivors, however enchanting, cannot carry the street's allure by themselves.

The Providence streetscapes enumerated here are not flawless, but they are close enough that they put—or they could put—passersby in mind of a walk down the thoroughfares of history, down memory lane, as it were. For those old enough or those sufficiently aware of the past, or those who merely intuit beauty in its architectural form, these streets are examples of heaven on earth.

Providence boasts numerous residential neighborhoods that might have been lifted bodily out of the past. They have not changed much, and when they have changed, it is often unnoticeable. In Providence, it is not just Benefit Street or the many residential streets that climb over College Hill to link up with Hope Street in the wealthier part of town. Neighborhoods throughout the city are untouched by tracts of suburban ranch housing that hollow out so many inner-city residential districts throughout America, let alone second-, third- or fourth-ring suburbia, not to mention exurbia. Even in poorer wards, city living in Providence benefits from intact neighborhood after intact neighborhood where families, whatever else may be irksome about their lives, occupy housing stock that has never been dumbed down by low, postwar building codes and standards.

A neighborhood with good bones is a boon to every citizen, every family, a boon that amounts to an art museum that sits open all day, every day, free of charge along the sidewalk. The residential neighborhoods in Providence richest in this boon, beyond College Hill, Fox Point and the East Side, are Smith Hill, Federal Hill, the North End, Mount Hope, Upper and Lower South Providence, Elmwood, Mount Pleasant/Elmhurst, Washington Park, the West End and Silver Lake. Hey, that's almost all of them! The Jewelry District seeks to join downtown as a residential neighborhood wannabe, but it is saddled with a far more extensive erosion of its built fabric—more parking lots, more new buildings that fit poorly into their setting. The Jewelry District needs more sensitive development, but today the opposite looks more likely.

Still, the Providence Preservation Society has for decades taken a proper pride in extending its services and its recognition of urban character beyond historic College Hill to almost every neighborhood in the city, almost all of which have an equal right to the moniker "historic."

PART II

COVE BASIN AND THE RAILROADS

A civic project of major importance was the filling of a part of the cove waters and the construction of an elliptical cove basin, with axes 1,300 feet long and 1,180 feet wide, surrounded by a promenade. The plan was proposed by the Providence and Worcester Railroad Company, incorporated in 1844, with the objective of establishing tracks, yards and terminals near the civic center.

John Hutchins Cady goes on to note that the work was "undertaken by the railroad company, in accordance with a City Council resolution."[36] The narrowing of the Great Salt Cove and the Providence River had proceeded intermittently since the mid-eighteenth century, largely by private individuals and firms to create dockage and wharves for ship-borne trade. Aside from the establishment of new roads, such as Benefit Street, proposed in 1743, growth in Providence proceeded with little oversight from officials or official bodies. Describing the city's "impressive" streets, Francis J. Leazes Jr. and Mark T. Motte point out in *Providence: The Renaissance City* that "[t]his architectural melange was assembled without much planning on anybody's part, as there was no zoning code in Providence prior to 1923."[37]

The Cove Basin was an early exception. It was formed not because an elliptical park was desired but to create land on which railroad tracks could be more easily squeezed between the water and the growing town. Thus did this first major civic project foretell the river relocation project a century and a half later. The later project also featured the same clash of interests, though not at quite so elevated a pitch of anger and mistrust.

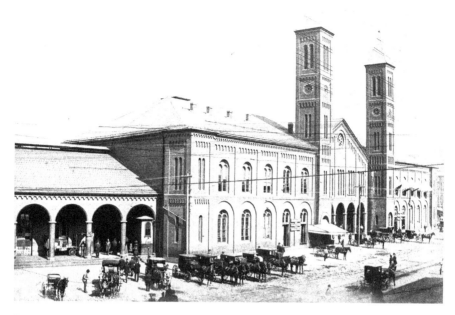

Union Depot (1848), designed by Thomas Tefft, along Cove Basin. It was the first train station in Providence and was destroyed by fire in 1896. *"Union Station." VM013_WC1546, Rhode Island Photograph Collection, Providence Public Library, Providence, RI.*

At the age of twenty-one, still studying at Brown University, Thomas Tefft was hired by the Providence and Worcester for his first major commission, an early effort in his beloved brick, and in his favorite style, the Lombard Romanesque, with its arched windows. In *Buildings on Paper*, Ruth Little Stokes writes:

> *The passenger depot, which stretched 750 feet along the north side of Exchange Place (now Kennedy Plaza), consisted of a central two-story gabled block flanked on the entrance side by tall slender campaniles, two-story wings, and one-story arcades terminating in octagonal pavilions. The wings curved backward along the curve of the tracks, giving the design a picturesque effect not obvious in the elevation drawings.*[38]

So the station, completed in 1848, cuddled the tracks that cuddled the Cove Basin, reminiscent almost of the twin bows of the Hoppin House, then still standing, with its handsome bosomy façade, its curvaceous porch and its bowed fence transmitting the modest pressure of curvature along Westminster. Stokes noted that in 1885 Tefft's depot was "voted one of the twenty best buildings in the United States by the American Architect and

Building News."[39] She cites Henry-Russell Hitchcock's encomium: "Without much question it was the finest early station in the New World."[40]

Tefft visited northern Italy and is said by Stokes to have shortly thereafter, while in England, told American architect I. Edwards Clark that "the introduction of an architecture of brick was to be his life's work."[41] Most American architecture at this point was still primarily of wood. Providence has seen no major urban conflagrations of the sort that forced London to rebuild after 1666 and Chicago after 1871. While brick may have irked architectural mavens in Providence a century later—witness the animadversions of Antoinette Downing against brick in chapter 2—and the city of Providence never embraced brick as fully as did Boston, give Tefft credit for promoting brick as good for Providence, not to mention attractive. He might have proceeded further in this mission if he had not died so young, in 1859, at age thirty-three.

An "open drive" to the Cove Promenade Park—eighty feet in width around the basin, with trees and iron railings—had been proposed by the Providence and Worcester. Subsequent grants of land to yet another railroad "and the frequent passage of trains, rendered it too dangerous to carry out this proposed plan of a drive, and it was never undertaken."[42] Yet, despite people having to cross tracks to reach the cove, the promenade after its completion in 1857 became popular with the public, especially with proponents of the contemporary fad of bicycle riding. In the August 1990 issue of *Rhode Island History*, published by the RIHS, Michael Holleran writes warmly of the promenade's role in the life of the city:

> *The city landscaped the park and ornamented it with cast-iron railings and seats. Circuses performed and holiday crowds celebrated on the shore; promenaders strolled on the promenade. Adjacent to it, Thomas Tefft's magnificent depot was a sightseeing attraction. The upstream valleys held few privies or streets to drain into the Cove; the railroads that ringed it were still small and slow enough that they only added interest to the scene. These years of success became a baseline to which later debate referred: the Cove Basin as an ornament to the city, to be adorned and protected.*[43]

Unfortunately, shallow basin wall footings that violated city construction standards prevented effective dredging. After several years, the cove's mud flats were increasingly exposed at low tide. Up both the Woonasquatucket and Moshassuck Rivers, mills arose in profusion, spewing industrial wastes into the water. New neighborhoods to house millworkers, emitting their

View of Cove Basin (1846) from Prospect Terrace on College Hill, circa 1878. *"View of Providence from Prospect Terrace," VM013_GF3245, Rhode Island Photograph Collection, Providence Public Library, Providence, RI.*

own effluviants, also played a part in the cove's decline. With the cove generating odors and, it was believed, fumes carrying illness, the popularity of the Cove Basin for strollers and cyclists proved relatively brief. A dam erected in 1850 proved ineffective after years of deferred maintenance, and it was razed in 1878. Yet, the Cove Basin Promenade held a grip on the public heart.

Meanwhile, the general assembly enacted, in 1848, authority on behalf of the city to permit laying track as needed. In 1874, after years of bickering between the city and the railroads, the board of aldermen created a Commission of the Cove Lands to assess whether the railroads were using the land properly.[44] The report detailed conflict after conflict reaching back two decades, amid hints of improper influence between officials of the city and the railroads. For example, the city had authorized track to be laid from the depot down Dorrance Street to Dyer Street, essentially across the middle of downtown, to the wharves along the Providence River. On June 18, 1862, city voters rejected that idea, opposing a ballot question by 732 to 563. Another track was proposed to stretch from the depot down Canal

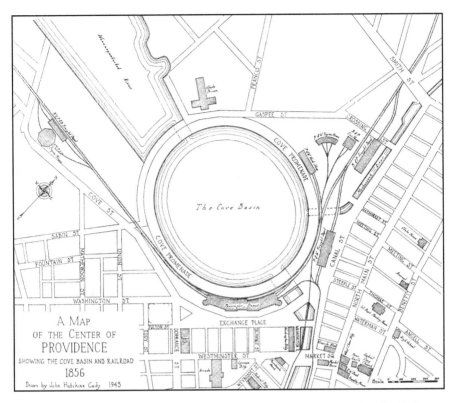

Cove Basin was created by filling in Old Salt Cove. Map drawn by John Hutchins Cady. *Courtesy of Providence City Archives.*

and South Water Streets, on the east side of the Providence River, to link up with the tracks of the New York Steamship Company on India Street along the Seekonk River, which reaches from Pawtucket down between the East Side and East Providence. It was noted that the bowsprits of ships docked at wharves would, if rails were laid along the east bank of the Providence, interfere with the passage of freight cars drawn by horses.

Citizens raised objections to railroad tracks on one side of the river as discriminatory to the interests on the other side. It was the East Side versus the West Side all over again. Seven hundred and fifty signatures, raised in a day and a half, endowed a petition against such allegedly unfair proposals. The Providence and Worcester was disinclined to run tracks down both sides.

Disputes over location, cost, design and the quality of construction of railroad tracks and buildings embattled the railroads, the city and its citizens in the decades after Tefft's depot was completed in 1848. And yet,

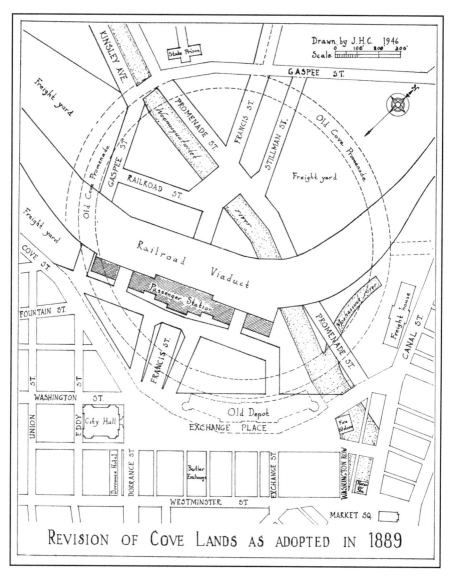

Map of Cove Lands plan, adopted 1889. It was accomplished by filling in Cove Basin in the early 1890s. Map drawn by John Hutchins Cady. *Courtesy of Providence City Archives.*

over time, even as horse-drawn and then electric trolleys were laid, the railroads managed to thrust tracks down both sides of the river south of Market Square. That more room for tracks was needed became the cry of the railroad companies. They were feeling their oats, so to speak, after only recently having revolutionized transport in Europe and America. The city's

prosperity grew and its factories hummed. It is unsurprising that a mere forty years after the Cove Basin was completed, it was filled in. Rhode Island was a state "for sale, and cheap," as Lincoln Steffens wrote in 1904.

The battle of the Cove Basin raged amid changing public perceptions of its merit. Its reputation as a civic amenity fell as its olfactory demerits rose. Notables switched sides as public sentiment shifted. In 1876, Thomas Hoppin, a former governor who had just replaced his father's Hoppin House with the Hoppin Homestead Building, urged dredging the cove "to make the park a beautiful promenade, while the basin itself would be used by pleasure boats." In 1881, he flipped: "If it is necessary to cut down the beautiful trees in our most spacious gardens, for the sake of our children and the future of our city, let us give the railroads these facilities."[45]

Civic leaders against filling in the cove, meeting at the Franklin Society, formed the Public Park Association. It ended up throwing its support behind filling in the cove—not for rail yards but for a better park. In the 1884 General Assembly elections, the Public Park Association backed a "People's Park Ticket" that won handily. Later that year, elections for city council installed a majority of vaguely noncommittal members who hedged and obfuscated until their "uncommitted" stance, widely seen as inimical to the railroads, amounted to filling in the cove for the railroads.

Several last-ditch efforts by the Public Park Association to push the city to fill the cove with parkland rather than freight yards focused the public debate on aesthetics. The association criticized the "Chinese wall" to be created by trackage raised over street level behind a new train station in the latest plan. The desire for beauty was driven in part by how the city compared with other cities. Providence chafed at sliding down the nation's list of largest cities. It had been 14th in 1840, 16th in 1860 and 20th in 1880, despite the fact that with each decade its population rose substantially. (In 2015, it was 135th.) As Michael Holleran suggested in his *Rhode Island History* article, "If Providence could not be the biggest, it could be the most beautiful, a prouder claim."[46] He quotes the PPA's report, "Sanitation: The Cove Park":

> *Whatever amount the city may spend in retaining, improving and beautifying* [the cove], *will soon be returned in increased revenue from the rise of surrounding property.*[47]

That argument had already echoed around the nation, notably during the 1850s when New York City was planning Central Park, and it regularly appears today in every controversy over city parks and waterfronts. But

while proponents of beauty won some battles in the short term, they lost the war. After the cove was filled in, a railroad station was built on top of it, set back five hundred feet northwest of where the old depot used to be—it had burned down in 1896. Stone, Carpenter and Willson, which would soon design the Providence Public Library, won a competition to design the new Union Station. RIHPHC's nomination papers for downtown's national register listing describes the station in this way:

> *American Renaissance complex of* [five] *structures…brick-sheathed, steel-framed structures with dentil cornices and hip roofs. The passenger station has a projecting central pavilion designed as a triumphal-arch "gateway" entrance.… The large canopy over the entrance, the colonnades connecting the buildings, and the original shed over the tracks had been removed by the early 1950s, when the entire complex was painted a monochromatic grey."* [48]

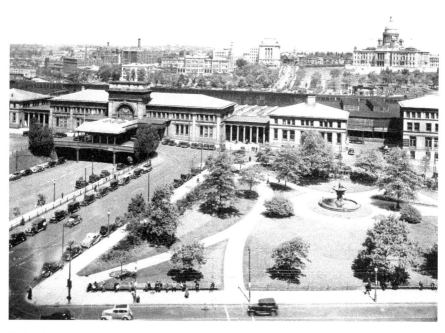

Union Station (1898), designed by Stone, Carpenter and Willson, built on filled site of Cove Basin, northwest of demolished Union Depot. Burnside Park is in the foreground. View circa 1930. *"Union Station." VM013_WC1526, Rhode Island Photograph Collection, Providence Public Library, Providence, RI.*

Soon enough, north of the new station, toward the new State House on Smith Hill, the filled land and its surroundings were jammed with railroad trackage, yards, siding warehouses and other spoor of trains (including a couple of elegant freight buildings designed by Tefft that survived the demise of his station). By the turn of the century, some three hundred trains were passing through Providence daily.

On the downtown side of the station, on the newly rising topography that looked down at Exchange Place, a park arose named for Ambrose Burnside, Rhode Island's leading Civil War general, who served briefly as commander of the Army of the Potomac from 1862 to 1863. His 1887 equestrian statue, by Launt Thompson, remains. (It is from the general's mutton-chop facial hair that the word *sideburns* derives; before that, sideburns were called "sideboards.") Burnside was elected to three consecutive one-year terms as Rhode Island governor and was the first president of the National Rifle Association.

After the Cove Basin was filled in the 1890s, the new Union Station built, the State House completed and the land laid out for what was known at various times as Burnside Park, City Hall Park and, later, Biltmore Park, plans promoted by the Public Park Association to complete the space between the new train station and the State House emerged. One of these was generated by the director of the recently instituted Rhode Island School of Design, Huger Elliott. Educated at L'École des Beaux-Arts in Paris, Elliott proposed a plan for downtown's future, "Providence, 1950," sponsored in 1910 by the Rhode Island chapter of the American Institute of Architects. In his 1990 article for *Rhode Island History*, Holleran describes the plan as "a projection of Providence's future in which the Cove reappeared as a circular pool within a Beaux Arts composition of new buildings."[49]

The new Union Station stood alone and aloof on ground that rose to permit three streets to pass beneath the "Chinese wall," one of which then passed under the station as well. "Rat holes," the Public Park Association called them. As automobile and truck transportation eclipsed the railroads' long heyday, the rail yards were transformed into parking lots, with space for many hundreds of workers' cars filling the acreage between Union Station and the State House, which had opened in 1900. By the 1970s, all who parked there made the dirty, often muddy trek through the lots and the rat holes, principally Francis Street, whose ceilings dripped standing water from puddles in the surviving trackage overhead. Where Francis emerged from beneath the station, dividing Burnside Park, the road was covered by a dismal parking deck just beyond the station's "triumphal-arch 'gateway.'"

"Providence in 1950," by Huger Elliott. The president of RISD imagined Cove Lands build-out for the 1910 edition of the journal of the Rhode Island chapter of the American Institute of Architects. *RI AIA001, Rhode Island Photograph Collection, Providence Public Library, Providence, RI.*

Beauty was thereby estranged from the utility promoted by the park association as beauty's abiding merit. By the middle of the twentieth century, Union Station advertised the city's growing distress, reflecting the disintegration of the railroad industry and the loss of people and business to cars, trucks and the suburbs. (Indeed, the rat holes of the Chinese Wall serve as eerie presentiments of Vincent Scully's description of New York's Penn Station, expressed after its replacement in the 1960s by the new, underground Penn: "One entered the city like a god. One scuttles in now like a rat.")

THE WORLD'S WIDEST BRIDGE

Even before the Cove Basin was filled in, the city set about decking over, in stages, the confluence of the Moshassuck and Woonasquatucket Rivers at the head of the Providence River. That river was first spanned in 1663 by what was known for centuries as the Weybosset Bridge. At some point it fell into disrepair and was abandoned. It was rebuilt in 1711, again in 1719 and in 1744, 1764 and 1792, each time a shade wider. The bridge was destroyed by the great gale of 1815, after which it was rebuilt at double the width in 1816, which was doubled again in 1843.

Meanwhile, to its south, creeping infill had narrowed the river from the east, and new wharves slanted into the river from its west embankment. In 1873, the original Crawford Street Bridge was built, barring vessels from reaching wharves between it and the Weybosset Bridge to its north at Market Square. Also in 1873, this stretch between the Weybosset Bridge and the Crawford Street Bridge was decked over, leaving a narrow opening up the center. This slit was further narrowed in 1930. By then, north of the Weybosset Bridge, new bridges and then decking were added, initially as part of the creation of the Cove Basin and then as part of its destruction. All of this made room not just for more tracks and more buggies but for the horses and wagons of a public farmers' market in Market Square, centered around Market House, built in 1773.

A mere five years after the first Weybosset Bridge was built but thirty-two years after he founded the settlement, Roger Williams was still the leading citizen of Providence. According to the Reverend Arthur E. Wilson in *Weybosset Bridge*:

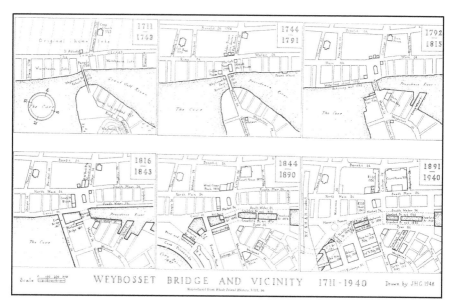

"Weybosset Bridge and Vicinity," six maps by John Hutchins Cady showing the development of "Widest Bridge in the World." *Courtesy of Providence City Archives.*

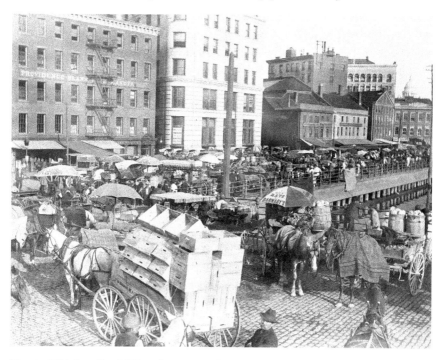

View in 1904 from South Water Street toward public farmers' market on expanded decking of Providence River. Photograph, silver gelatin print. *Courtesy of Rhode Island Historical Society, Negative No. RHi X3 4416.*

PART II

One may speculate with some amusement at how the job of toll-taker might have been carried out by Williams. His former rival, a founder of Newport, William Coddington, described him as "a mere weathercock, constant only in inconstancy."[51] He was a card-carrying controversialist, and it may be that regular users of the bridge complained to their representatives in the legislature that crossing the bridge had become not just costly but also tedious. That is, assuming Williams was not a "no-show" employee.

Often called Rogues Island, the colony was a hive of dissenters from the beginning, and it has always been a haven of controversy. The municipal affairs of Providence reflected a disorganization that arose, at least in part—probably in very large part—from Williams's rock-solid insistence on the separation of church and state. According to Henry C. Dorr, whose *The Planting and Growth of Providence* was published in 1879, Rhode Island and Providence Plantations (the full title of the colony and state; still the smallest state with the longest name) was "the earliest attempt to found a colony without capital or foreign aid."[52] For much of its history, Rhode Island had five capitols, with the legislature sitting at each in turn. Argument was in this colony's DNA, and it remains strong today. From Weybosset Bridge to the "world's widest bridge" (quoth the *Guinness Book of World Records* in 1988), "prospering too well" has had many connotations.

A description of Providence's early conditions in Dorr's book, summarized in a July 18, 1996 column by this writer called "Settlement on the Moshassuck," paints a picture of the residents as unlikely to build an impressive colony:

The founder's wealth was tied up in Boston by creditors who took advantage of his banishment. His followers were (like him) disputatious men, of even less wealth and of little or no practical knowledge or skill, even at farming. They could not afford cattle. They kept goats and hogs on Prudence Island because they could not afford to fence in the meadows behind the home lots, which they farmed with hoes because they had no plows.[53]

Dorr adds:

111

The ancient townsmen smoked their pipes in the cool of the day, in front of their dwellings, on the east side of the Towne street. From the elevation upon which these stood, the householders looked across the vacant lots, down upon their clam-beds and canoes, made themselves miserable over the latest affronts of Massachusetts or the Indians, discussed the secession of Coddington [a founder of Newport], the rise and fall of the English Commonwealth, and the disputes of Williams, Harris and Gorton, amid the annoyance of clouds of mosquitoes which arose from the marshes of the west side, and were almost a counterbalance for the blessings of religious liberty.[54]

William Harris and Samuel Gorton were rival settlement leaders just as cantankerous as Williams during the middle of the century. It is hard to know what their followers in Providence might have thought, puffing tobacco and peering across the Great Salt Cove and the Great Salt River to the marshy reaches that would become, two centuries later, the downtown of a spectacularly prosperous city. Did beauty matter to them? The topography recalled the seven hills of Rome. But as for commerce, that was somebody else's job, better left to the Puritans whose society they had fled. The first church was not erected until 1700 by the Baptists. The first known taverns beat them to the punch by at least three decades. Industry was a virtue they regarded as aspirational. That would change.

Even before the rivers were decked over as Providence reached the height of its prosperity in the late nineteenth century, it is unlikely that the city's populace considered them beautiful. By then, the Cove Basin was a byword for pollution, and the riverbanks south of the cove were lined with wharves and warehouses, some ramshackle, some mere shacks. The Blackstone Canal, which had shipped goods by barge upriver some forty miles to Worcester, Massachusetts, between 1828 and 1848, fell into disuse as newly competitive shipping by train expanded. The canal's remains are still visible. The last wooden river bridge in Providence, built in 1854 near where the Moshassuck emerged from the Cove Basin, bridging the canal, was removed in 2015. The streets of downtown were crisscrossed with an expanding maze of wires for electricity and, eventually, telephones. Especially along the waterfront, commercial buildings often housed maritime businesses that not only hung out their own signs but also rented their walls to others for the display of advertising.

These developments reflect a dichotomy—a classic catch-22—that has bedeviled Providence and almost every other sizable city in America and the world for centuries. A city that respects beauty over commerce might never

have enough commerce to finance beauty. As the nineteenth century veered into the twentieth, the civic center of Providence was amassing an enviable stock of buildings, erected by the city, the state and their leading private citizens. They were strong and often beautiful structures, most notably the new Rhode Island State House designed by Charles Follen McKim of the nation's leading firm of architects, McKim, Mead and White. McKim is said to have connived the commission by way of a design competition. It was not rigged, per se, but McKim and his firm had designed a host of "cottages" (mansions) along Bellevue Avenue and the celebrated Casino in Newport. He knew Governor John Ladd and others in the social circuit of the Ocean State. He "knew a guy who knows a guy," as they say in Rhode Island (and doubtless elsewhere).

But the infrastructure that knit the city's fine buildings together—streets and bridges, mostly, and a smattering of public spaces—rarely amounted to a noble setting for its architectural jewels. Even before the State House opened for business in 1900, the public debated how to improve the land between the capitol on the hill and the business district downtown. Many plans to remove the so-called Chinese wall were proposed for decades after the civic embarrassment became evident; until recently, none was achieved.

NEW COURTHOUSE AND OLD BRICK ROW

The harmony with the old brick row facing the water will be complete, since these genuine survivors of the Georgian era will set the keynote for the soaring tiers of neo-Georgian gables above them, forming an ideal starting point for the eye and the imagination, and bridging the years between the early maritime Providence and the modern metropolis.

This opening passage is from an impassioned letter to the editor of the *Providence Journal* published on March 20, 1929, under the headline "Retain Historic 'Old Brick Row.'" It was written by H.P. Lovecraft, the now-celebrated author of macabre suspense tales and a native of Providence. He set some of his stories in the city, wrote extensively of its architecture to correspondents and planned a book about it, never executed. Etched on his gravestone at the city's lush Swan Point Cemetery: "I am Providence."

A set of warehouses whose erection along the east embankment of the waterfront reached back to the beginning of the nineteenth century, the Old Brick Row was to be demolished in a plan to replace the old county courthouse that opened in 1878, designed in the Gothic style, with a new courthouse in the Georgian style. The new Providence County Superior Courthouse would fill the block on whose northeast corner stood the old courthouse. The new one would climb up five stories to Benefit Street from South Main Street, but across South Main an annex to hold court records would be built on the site of the Old Brick Row.

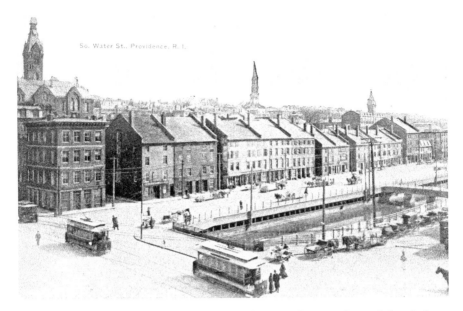

Postcard of South Water Street, circa 1900, with Old Brick Row warehouses beloved of H.P. Lovecraft. Old courthouse is at upper left. *"So. Water St., Providence, R.I.," PC8171, Rhode Island Postcard Collection, Providence Public Library, Providence, RI.*

Lovecraft's feelings must have clashed: He loved the style of the new courthouse and must also have found the appearance of the proposed annex agreeable. The latter appears at the far right, *before* the courthouse, in a perspective rendering of the project by the noted architectural illustrator Charles B. Price. Yet Lovecraft apparently loved history more and urged saving the Old Brick Row, proposing that it instead be renovated to serve as a repository for court records.

His thoughts about architecture reflect a nativism not yet fully aware of its impending decline in American culture. He loved the Georgian styles of building that characterized colonial times. In spite of the weird tales he wrote for a living that some might consider "gothic novels"—a different literary genre—he looked down his nose at "Gothic" architecture and any styles that postdated the colonial styles in Providence. Those newer styles represented, in his mind, the threat posed to "tradition" by immigration, including that of many Catholics from Ireland and Italy who came to work in the city's factories.

Whatever else it may reflect, Lovecraft was channeling an architectural controversy that gripped Europe and Great Britain in the latter half of the nineteenth century. Gothic and neoclassical design were said to symbolize, respectively, Catholicism and Protestantism. Civil contention over these

faiths in Britain, where Lovecraft traced his roots, extended very much further back in time, and reached a far more heated and even violent pitch on numerous occasions, than it ever did in America. Across the pond, this debate fronted for social concerns more sensitive than the aesthetic merits of pointed windows and canonical column capitals. Likewise, Lovecraft, who renounced his family's church at the age of eight, cast his lot as one might imagine, probably for reasons, including racism, that raise far more eyebrows now, as they ought, than in his day.

Nevertheless, setting aside such factors, the clash of tastes expressed by Lovecraft in his March 20, 1929, *Journal* letter addressed an abiding challenge that grew even more grave in the decades to come:

The American Society of Architectural Illustrators Presents the 19th Annual

ARCHITECTURE IN PERSPECTIVE EXHIBITION

PROVIDENCE

RHODE ISLAND · OCTOBER 29TH 2004

Poster for the 2004 meeting of the American Society of Architectural Illustrators, in Providence, showing a proposed new courthouse, with an annex on the site of Old Brick Row. *Author's archive*.

Opposite: Old Providence County Courthouse (1878), a Gothic pile at College and Benefit Streets, demolished in 1930. *"Providence County Court House, Benefit Street," VM013_GF2979, Rhode Island Photograph Collection, Providence Public Library, Providence, RI*.

Behind it looms the far broader clash of city-planning ideals which it typifies: the eternal warfare, based on temperament and degree of sensitiveness to deep local currents of feeling, between those who cherish a landscape truly expressive of a town's individuality, and those who demand the uniformly modern, commercially efficient, and showily sumptuous at any cost.[55]

Such feelings would eventually transform what was then a niche interest in preserving historic buildings into a mass social movement to preserve not just individual houses but entire districts and neighborhoods from what many perceived as *alien* incursions into their communities. The phrase "alien spacecraft" summarizes the general fear felt by so many far better than today's phrase "illegal aliens," which was beside the point in 1926, when so many were alarmed by legal immigration. Whatever Lovecraft's inner demons, he was early to raise issues that resonate today under the rubric of historic preservation.

In an October 5, 1926 letter to the *Journal*, Lovecraft advocated, in the words of historian Timothy Evans writing in the *Journal of Folklore Research*:

a city-funded rehabilitation program for historic structures, especially the rows of Colonial and Federal houses along North Benefit Street (a slum during Lovecraft's lifetime) and zoning laws which would protect historic neighborhoods from destruction, and would regulate new buildings so they were compatible with the historic fabric of the city. Such views, while not unique, were on the cutting edge of historic preservation in 1926.[56]

Today, a municipal ordinance similar to what Lovecraft sought requires that new buildings downtown respect its historic character. In his age, a case might have been made that the Gothic style of the old courthouse was out of character in Providence, but Gothic, Victorian and French Renaissance buildings were in vogue during the third quarter of the nineteenth century, in Providence as elsewhere. Tastes change, and thinkers like Lovecraft understandably had their preferences. In light of the architecture by which we are beset today, one can only envy the narrow parameters of Lovecraft's likes and dislikes. He likes Georgian! He dislikes the Gothic! What would he make of the GTECH headquarters—the Ice Cube in Diapers—squatting today at Waterplace Park? Lovecraft is famous for the aliens of his own imagination; nevertheless, the question answers itself.

In terms of building cities, the key lies not so much with what is in vogue at any given moment but with what a collection of buildings looks like after

the broad stretch of time has caused different styles to settle cheek by jowl in many quarters of the city.

The most famous "hodgepodge" of architectural styles in the world may be the Piazza San Marco, in Venice. Few will argue that this most celebrated of architectural jigsaw puzzles fails to hang together well. In Providence, the most famous streets are fairly lacking in stylistic regularity. Benefit Street has a reputation for its colonial styles, but it is, in fact, a mixture of almost every style except modernism, hence its nickname "Providence's Mile of History." Both Westminster and Weybosset Streets host the most divergent of styles, yet both streets display few examples of blocks, or even sets of buildings within a block, boasting a unity of style. Because Georgian and Victorian styles, and every other traditional style, formal or vernacular, have their roots in and have evolved from the classical orders of Greco-Roman times, these most divergent of historical styles speak the same root language.

Replacing the Gothic courthouse (and a dozen or so other buildings on the block) with a neo-Georgian courthouse did nothing to offend the neighbors. No stylistic ribs were jabbed. No noses were put out of joint. On Benefit Street, the new courthouse danced amiably with the Athenaeum's Greek

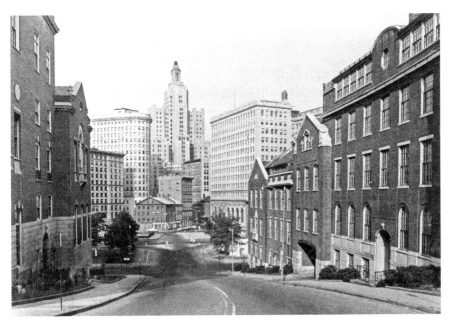

The view west down College Street, circa 1960, between Providence County Courthouse (1933) and RISD's Helen Rowe Metcalf Building (1936). *"College Street,"* VM013_WC1334, *Rhode Island Photograph Collection, Providence Public Library, Providence, RI.*

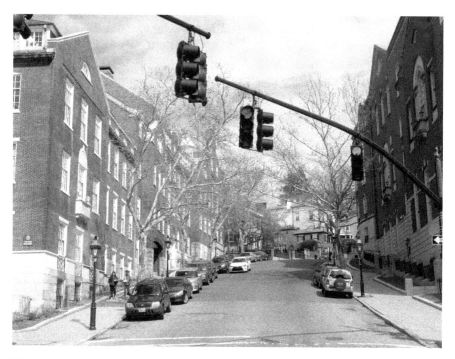

The view up College Street today between the courthouse and RISD's College Building, as Metcalf Building is now more widely known. Both the courthouse and the RISD building were designed by Jackson, Robertson and Adams. *Photo by author.*

Revival, with Athenaeum Row's five Georgian townhouses and with the Unitarian Church's pastiche of Gothic and classical influences. Things were equally balmy at the downhill end of the building along South Main Street.

Indeed, on College Street, climbing uphill from Market Square, the firm of Jackson, Robertson and Adams, which had designed the courthouse, threw the idea of variation on a theme into a cocked hat by designing the Helen Rowe Metcalf Building (now known as the College Building) for the Rhode Island School of Design. Its divergence from the style of the courthouse was so minimal as to suggest a pair of bookends. Indeed, the two buildings seem to form a triumphal passage from College Hill to downtown. So far as this author is aware, nobody complained, not even H.P. Lovecraft, who died the year after the later building was completed in 1936.

DOWNTOWN PROVIDENCE 1970 PLAN

T his account of Providence's storied architectural history has already hinted strongly that even before the 1950s, mistakes were made. Decking over the rivers between downtown and College Hill was one error. Neglecting the void between the State House and downtown was another. Decisions to route a pair of federal highways through the city so as to cut off downtown from districts to its north, west and south are today considered a serious error by almost all sensible people. However, the City Plan Commission had proposed, in the early 1940s, to run a highway right up the middle of the Providence River between the old East Side and West Side. A 1947 report written for the State Department of Public Works by the Charles A. Maguire and Associates engineering firm describes the plan:

> *A part of the* [option] *6 scheme considers the use of the open area of the Providence River, where a depressed highway would be built from Fox Point northerly through the present congested area at Crawford Street, Memorial Square and along the general line of Canal Street.... The present Providence River, often called an open sewer, being enclosed in conduits, would be eliminated from view, greatly beautifying the City.*[57]

The "Up Yours with a Concrete Hose" highway option was rejected as too expensive, a rejection that is easy to applaud in retrospect. In the following decade, the "Eradication of History as a Development Strategy" urban removal plan picked up where "Up Yours" left off. The Downtown

This sketch of an aerial view of downtown Providence is from the Downtown Providence 1970 plan, announced in 1960 but carried out only to a very limited extent. *Author's archives*.

Providence 1970 plan, announced in May 1960, looked forward a decade, but for inspiration it looked backward a decade, to the period when an already entrenched conventional wisdom in architecture and planning dictated a new master plan for downtown that directly and aggressively challenged the validity of Providence's architectural heritage. Most of this plan for downtown was not carried through, another decision whose wisdom is said to reside in retrospect. Today it is hard to imagine city officials taking this plan in stride. It should have been no more imaginable at the moment of its announcement than it is today.

Downtown Providence 1970: A Demonstration of Citizen Participation in Comprehensive Planning describes a project announced after three years of research, begun in 1957, sponsored by the City Plan Commission and backed by the U.S. Urban Renewal Administration. The project study recognized that downtown had become run-down and proposed to spiff it up with new design that nevertheless respected existing architecture. At the conclusion of the study program, its "citizen Task Forces" were, the study's foreword asserts, "assured that this plan is tailor-made for their City."[58]

Providence City Hall (1878), designed by Samuel F.J. Thayer, was slated for demolition in the 1970 plan for downtown. *Library of Congress, Prints & Photographs Division, Historic American Buildings Survey (HABS), HABS RI,4-PROV,92--1.*

The wording leaves it unclear whether citizens were assured or merely informed that they were assured.

In their comprehensive book on the Providence renaissance, Leazes and Motte describe the 1970 plan much more straightforwardly than what is stated anywhere in the plan itself. They write:

> At the heart of Downtown Providence 1970 was a classic, 1950s-style urban renewal: wholesale redevelopment of the urban core by demolition of the historic commercial center, including the French Revival-style Providence City Hall. The new central business district would become a single-use environment focused on office development, punctuated by pedestrian zones, parking lots, large public spaces, a heliport, and numerous Le Corbusier–inspired modernist office and residential towers linked by multilevel walkways, plazas and acres of satellite parking lots.[59]

Le Corbusier is often considered the founding theorist of modern architecture and is today most widely known for his 1925 plan to demolish central Paris. Massive concrete public housing projects for the poor are considered his major legacy. They degrade cities around the world. The study's summary states:

> Beauty is as important as any of the other considerations that we apply to the rebuilding of the city. Without beauty we cannot evoke the civic pride which assures continued interest and participation by the community.… Careful placement of [new] buildings where they can be seen from afar will lend visual identity to the total Plan. Historic continuity has been emphasized in special treatment for great buildings of the past.…It is concluded that a highly coordinated professional effort is needed, if we are to turn the tide of urban ugliness and make Downtown once again a place of beauty.[60]

"Words, words, words! I'm so sick of words!" Eliza's line from *My Fair Lady* leaps to mind.

The introduction to the study's section "Design in the City" opens with a seemingly introspective set of passages regarding the role of aesthetics in the sensibility of cities.[61] None of it makes any sense in light of what the plan proposes. The section following the introduction, entitled "A New Direction," states:

If we are to realize the potential of our abundant economy and create a community of abundant beauty, we must make a concerted effort in this period of widespread urban redevelopment to apply new and truly enlightened principles of planning and design. These new principles, embodied in what Morton Hoppenfeld has called "a higher order of design," are primarily concerned with the relationship of one building to another, and to the natural and manmade environment, and have evolved from a study of the ways in which man uses and perceives his world.[62]

Apparently, the importance of what a building looks like in and of itself does not count for much compared with its relationship to other buildings. And at no place in the study is there any attempt to explain or defend or even admit to the existence of the plan's ambitious, indeed radical, conception of how the appearance of the city must change. It seemed entirely sufficient to declare that the changes will "apply new and truly enlightened principles of planning and design" and "what Morton Hoppenfeld has called 'a higher order of design.'" They are not further described, explained or justified. And who was this Hoppenfeld? The plan does not say. It was just as Tom Wolfe put it in his 1981 bestseller *From Bauhaus to Our House*. Describing the sly manner by which European modernists who fled Nazi Germany overturned tradition in postwar American architecture, Wolfe writes, "All architecture became nonbourgeois architecture, although the concept itself was left discreetly *unexpressed*, as it were."[63]

Hoppenfeld, by the way, was "a young visionary," an urban planner who "shared a desire to create new kinds of American communities," according to a 2001 book, *Suburban Alchemy: 1960s New Towns and the Transformation of the American Dream*. In 1960, shortly after he was cited in the 1970 plan, he was hired by James Rouse, a developer of new towns, such as Reston, Virginia, and Columbia, Maryland, in suburban Washington. In the 1980s, after a career designing new towns and "destination centers" such as Boston's Faneuil Hall Market, Rouse visited Providence and urged the city to open up its rivers.

Again, the 1970 plan says virtually nothing about what the "higher order of design" intended for downtown would look like, but it certainly is not shy about showing it off in the plan's architectural renderings. Such drawings were not intended to represent the final designs of buildings but rather a general sense of their likely appearance. When the plan was announced in May 1960, the city's two television stations gave the event wall-to-wall coverage. Illustrations from the plan were printed in the *Providence Journal*.

Artist's view of Kennedy Plaza in the 1970 plan. The new city hall is at left. Note the outbreak of male pattern baldness among the male "scalies" (human figures rendered to scale in architectural drawings). *Author's archives.*

The citizens of Providence could not claim to be ignorant of what was coming down the tracks.

Even from the vantage point of more than half a century, it seems the height of arrogance to have argued back then that the 1970 plan was about "the beautification of urban ugliness." After two decades that forced every U.S. city to defer maintenance pending the outcome of economic depression and world war, why did this plan call for the demolition of City Hall, Union Station and other old buildings and their replacement with dozens of new ones radically different in appearance, along with the renovation of many old building façades in this same contrasting aesthetic?

Would not the cleaning, maintenance, renovation and restoration of old buildings have served the city better—and obviously so? Would that not have represented a more achievable, bit-by-bit approach capable of fitting within fiscal constraints that had challenged the city for decades— obviously so now, to be sure, but just as obviously so even then?

PART II

One part of the 1970 plan was the proposal to "improve" the city's "ground floor." The idea, not a new one, was that better landscaping, lighting and street furniture could work wonders. But in practice the ground-floor proposal amounted to covering up the highly ornamental first- and second-floor façades of downtown commercial buildings with faux modernist siding, especially on Westminster, and installing light fixtures, benches and other street furnishings radically different in style. The plan's authors describe the concept as part of the plan's proposal to pedestrianize the city's main shopping street ("Westminster Mall"):

> *Many of the stores fronting on the Mall are old-fashioned and the façades above them are blighted and dirty.... The store fronts have been given a handsome, unified treatment and the irregular and competitive "stickout" signs have been replaced by a row of dignified "flat" signs.*[64]

And some of that faux siding was already applied before the 1970 plan. The chief example of this was the Old Journal Building, completed in 1906

Artist's view of Westminster Street as a pedestrian mall in the 1970 plan, with new "streamlined" façades. Westminster Mall was carried out partially, but it was never successful. *Author's archives.*

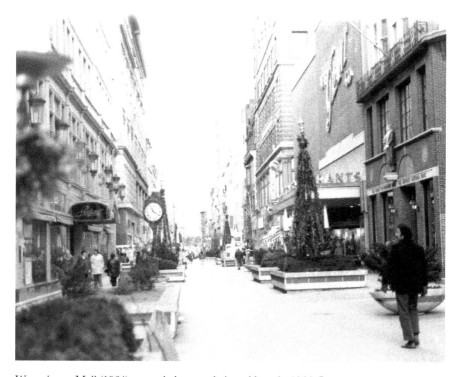

Westminster Mall (1964) as carried out and viewed here in 1966. It was reprogrammed under Mayor Joseph Paolino Jr. back to a vehicular street in the late 1980s. *Courtesy of Providence City Archives.*

Opposite, top: Old Journal Building (1906), with sheathing applied in the 1950s. Here it is being removed in the early 1980s. *Photo by John Lovell for Estes Burgin Partnership.*

and described in the RIHPHC's 1981 downtown survey: "[o]riginally one of the most elaborate Beaux-Arts buildings in Downtown Providence, the *Journal* Building was most unsympathetically altered in a clumsy attempt at modernity."[65] The ornamental capitals of its colossal engaged Corinthian columns were sawed flat to make way for aluminum sheathing of pale green below the building's cornice, covering the first two stories and housing a Newberry's five-and-dime store. Above the cornice, thirteen dormers encrusted with swags, scrollwork, florid brackets and other detail remained visible, peering down forlornly from the third story. That this desecration was performed in the 1950s, *before* the 1970 plan was announced, suggests that the attitudes that led to the plan already infested the city's planning apparat.

In 1983, the sheathing was removed and the original façades were meticulously restored by the Estes Burgin Partnership. Interestingly, the

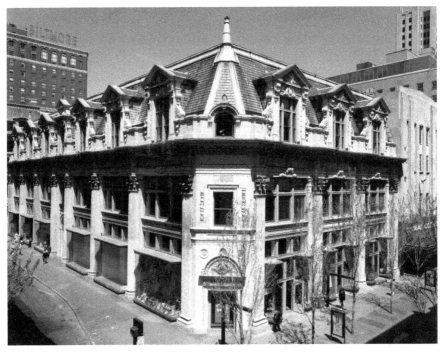

Old Journal Building as restored in 1984 to the splendor of its original design by Peabody and Stearns. *Photo by © Douglas Dalton for Estes Burgin Partnership, now Burgin Lambert Architects.*

A worker lifts a newly molded Corinthian column capital for installation during the Old Journal Building restoration, led by William L. Burgin. *Photo by John Lovell for Estes Burgin Partnership.*

language of the entry quoted above from the RIHPHC's 1981 survey was dropped from the 1986 *Citywide Survey of Historic Resources*. The "clumsy attempt at modernity" became "[t]his change, much admired at the time, was consonant with the modernization goals espoused by the city planning department."[66]

Clearly, however, by the 1980s, the plan first announced in 1960 was in bad odor. Westminster Mall had been partially completed, and so had the Weybosset Hill project. It sequestered the Roman Catholic Cathedral of Saints Peter and Paul behind modernist low-rise apartment blocks for the elderly, creating a plaza that few people actually visit. Three huge residential tower blocks known as The Regency required eradicating the entire fabric of buildings at the western end of the "bow" where Westminster rejoins Weybosset. No other major downtown portion of the plan was ever attempted, although some assert that the clunky Civic Center is attributable to the 1970 plan. There was a lot of self-congratulation when the 1970 plan was announced, but then silence—decades of silence. Mayor Joseph Doorley, who succeeded Walter Reynolds in 1965, loved federal urban renewal and

the Model Cities program—that is, he loved buckets of federal money—but he failed to push for a revitalized Providence with the sort of vigor unleashed two decades later by his successor, Mayor Vincent A. "Buddy" Cianci Jr., when his turn came around.

In *Providence: The Renaissance City*, Leazes and Motte put their finger on a salient, valiant truth:

> *The failure of the Downtown Providence 1970 plan to generate interest contains an important early lesson concerning renaissance activities: sometimes the decision not to do something is more important than actions undertaken....It was a fortunate inattention to downtown renewal planning and the eventual demise of federal urban renewal that would mark the 1960s as a critical epoch in the future of renaissance Providence. Downtown Providence remained intact.*[67]

But maybe even the movers and shakers in Providence really thought the 1970 plan was wrong, or that the public believed it was wrong or a waste of money. Mayors do not normally hold a press conference to announce the failure of a redevelopment project or to answer questions why it failed. It just peters out. In the 1950s, before the 1970 plan was announced, the railroad tracks between the State House and downtown had largely completed their conversion to parking lots. A parking slab jutting out into Burnside Park replaced the dismantled front canopy of Union Station. The station was painted gray. Buildings were being demolished to create parking lots. The wharves that still slanted out into the river now hosted parking, not rail spurs. A very few modernist buildings had arisen, but some property owners lacking the ambition to raze and roll the dice on a newfangled replacement slicked over their ground-floor façades instead. It is possible that the "visual identity" created by this "hodgepodgization" of downtown in the 1950s paved the way for the 1970 plan.

The 1970 plan proposed building up to eleven new parking garages downtown. One, considered of the highest planning priority, would have required demolishing several of downtown's most cherished commercial buildings—the Equitable Building, the Wilcox Building and the Bank of North America—along that astonishingly beautiful stretch of Weybosset as it curves to meet Westminster near the river. The plan even banned all curbside parking.

So on top of all this, on top of its eager assault on much of the city's loveliest architectural heritage, the 1970 plan might have seemed to some

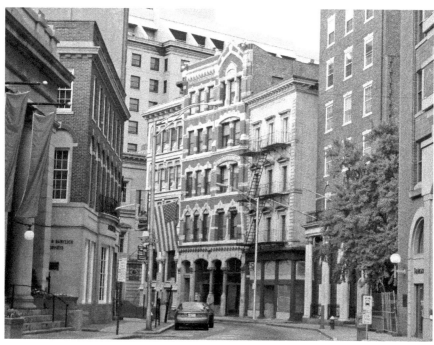

civic leaders like piling on. One thing's for sure: it did not take off. It may be supposed that Mayor Reynold's successor, Mayor Doorley, in the back of his mind, even as obstacles and opponents emerged to complicate the 1970 plan, was feeling that enough was enough. The least of his worries might have been the refusal of the railroads—there they go again!—to cooperate with the idea at the heart of the plan: the relocation of the railroad tracks that formed the so-called Chinese Wall.

Opposite, top: A view of Weybosset Street looking east as imagined in the 1970 plan. Note the Arcade at left and the parking garage replacing the set of old commercial buildings as the street curves toward the river. *Author's archives.*

Opposite, bottom: Current view of Weybosset Street looking east, with Equitable, Wilcox and Bank of North America buildings having survived. *Photo by author, circa 2006.*

THE COLLEGE HILL STUDY

While city officials, federal bureaucrats and business leaders were preparing the plan to save downtown Providence by destroying it, another massive redevelopment proposal emerged alongside the Downtown Providence 1970 plan. It was based on a study called *College Hill: A Demonstration Study of Historic Area Renewal*, actually announced in June 1959, a year before the downtown plan. In the plan to save the city's fabled College Hill, the recently founded Providence Preservation Society joined hands with the City Plan Commission and the U.S. Urban Renewal Administration. The planning stages for both plans overlapped, as did some project staff, including William D. Warner, who worked briefly for the downtown plan but was project director of the College Hill study. Both positions were among his first jobs after graduating in 1957 with bachelor's and master's degrees in architecture from MIT. Members of the City Plan Commission took part in both plans. State planning officials seem to have been largely uninvolved in either, or at least unrepresented and unacknowledged in the lists of contributors, sponsoring agencies, task force members and such that commence each plan.

The motive, at least as far as the College Hill plan's historical reputation is concerned, was to preserve Benefit Street and nearby streets from demolition and to institute an administrative infrastructure to protect College Hill going forward.

Opposite: Benefit Street today, with period lampposts erected in the 1970s, exciting the disdain of *New York Times* architecture critic Ada Louise Huxtable. *Photo by author, circa 2013*.

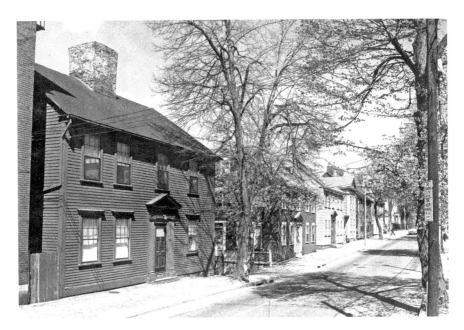

On Benefit Street, a stretch of colonial-style houses is seen on the west side of Benefit toward its north end in this 1958 photo by Laurence E. Tilley. *"Benefit Street," VM013_ WC1352, Rhode Island Photograph Collection, Providence Public Library, Providence, RI.*

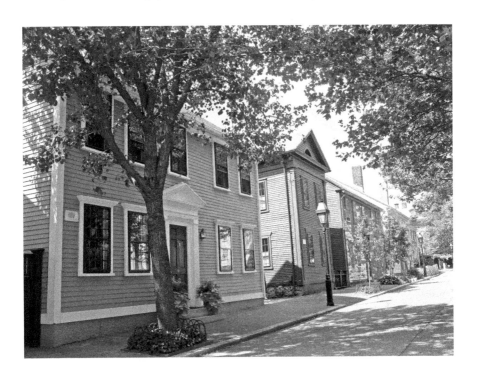

Both of those goals have been achieved in spectacular fashion. Since 1960, almost no historical buildings on Benefit Street and its residential environs have been knocked down. Within two decades, Benefit Street itself became fashionable, unapproachably so for most families. Following the enactment of federal enabling legislation, the General Assembly created the Rhode Island Historical Preservation Commission to oversee a state historic preservation office to establish, survey and monitor developments in historical districts statewide. (The words "and Heritage" were added after the Rhode Island Heritage Commission was merged with the RIHPC.) The Providence Preservation Society was founded in 1956 and became one of the nation's preeminent preservationist organizations, lobbying to save the city's architectural heritage through government bodies it was itself instrumental in creating.

The College Hill study fails, on one hand, to identify any imminent threat of large-scale demolition on Benefit or its environs. On the other hand, from page 101 of the study, "Previous Planning Studies," it is clear that the idea of tearing down parts of Benefit Street had been circulating amid various local and state planning agencies since 1945, if not before. After mentioning a number of these, the section cites "basic statistics" that point to "some degree of housing blight. Approximately 140 acres, or 35% of the College Hill study area, is included within two of the 17 Redevelopment Areas designated by City Council action in July 1948." The report adds that in 1951, "three proposals…have been the subject of serious review: (1) South Main, (2) Cohan Boulevard, and (3) Constitution Hill. None of these are currently active."[68]

This is not to suggest that fears of wholesale demolition on Benefit Street were unwarranted. After all, before the study, in the early 1950s, Brown University had razed a couple score of old houses to create its Henry Wriston residential quadrangle. (Fortunately, its design, unlike most later buildings at Brown, was sympathetic with its historic institutional character.) Opposition to that project's demolitions germinated the Providence Preservation Society and led to its participation in the College Hill study. Within a few years of the study's release, major urban removal and insensitive redevelopment occurred in Weybosset Hill downtown, spurred by the 1970 plan, and in Lippitt Hill for University Heights. The latter was a private project designed by noted shopping center designer Victor Gruen that combined shopping and a residential center just north of the College Hill study area. This obliterated parts of a black neighborhood once called Hardscrabble, where a race riot erupted in 1824 (another race riot occurred in Snowtown, a

black neighborhood on the east slope of Smith Hill, in 1831). In fact, urban removal is still happening on College Hill. Two sets of deteriorating but clearly useful old houses, sixteen in all, on or near Thayer Street (Brown's "Main Street") were recently razed, one for a private graduate housing complex, the other for a "temporary" parking lot. "Demolition by neglect" is the common name given to this process, which may have played a role before 1959 in the deterioration of housing at either end of Benefit Street.

Yet it *is* reasonable to suggest that the federal definitions of slum housing that influenced the College Hill study's expansive plans for new development were wildly out of sync with reality—although perfectly simpatico with the conventional wisdom of the postwar architectural and development establishments. It is not difficult to suppose that much housing labeled substandard was so designated in order to justify tearing it down. Assumptions regarding the economic and social benefits of "slum clearance" trickled down from federal to local agencies and hardened into dogma.

Perhaps the most famous victim of this policy trend was the West End of Boston, a vibrant neighborhood of mostly Italian and Jewish immigrants that was replaced with residential high-rises for middle- and upper-middle-class families. Part of Boston's North End was razed to make way for the Central Artery, an elevated highway that sliced between downtown Boston and its harbor. Other sections of the North End were also threatened with demolition but spared; today, the North End's good health points a stern finger at the policies that doomed the West End.

And Boston's Scollay Square was demolished for a new city hall and federal government center designed in the Brutalist style used more modestly in Providence's Fogarty Building (see chapter 6). The public in Boston has been clamoring for city hall's demolition for years. In 2006, Mayor Thomas Menino proposed razing the monstrosity, but he never followed through.

The wholesale demolition of historic settings around the nation was typically followed by an urbanism designed not to engage but to rebuke the historic settings nearby. Urban renewal blighted many downtowns and is continuing to do so, though at a much diminished rate today: thanks to the preservation movement generated by the widespread anxiety caused by urban renewal and modern architecture. Jane Jacobs examined and sharply criticized planning practices that had grown common in the 1950s in her 1961 bestseller *The Death and Life of Great American Cities*.

Almost all of the College Hill housing labeled "slum" or "substandard" by the study and slated for renewal was later privately repaired, restored and sold to private buyers. This happened largely outside the context of

the College Hill study and its seemingly precise methods of surveying and assessing the quality of housing stock. The study devotes several sections to explaining the opportunity for private investment by individuals and groups in the restoration and renovation of dilapidated properties:

> *It is recommended that attempts be made to stimulate private investment in College Hill by alerting certain individuals and groups to the opportunities for investment in the area. Stimulation of the investment of private capital to renew the historic College Hill area is one of the goals of the proposed program.*[69]

The second edition of the study, published in 1967, has a Part IV that addresses its impact, called "Progress Since 1959," noting that private investment had been substantially stimulated:

> *Publication of the study report, the publicity given to it, and the support of city agencies did much to generate confidence in the area and to change the attitudes of mortgage agencies to investment in this older section of the city. Several private companies were organized for the purchase and restoration of historic buildings.*[70]

So the study did give brief encouragement—lip service, some might say—to the private investment and rehabilitation strategy that almost totally eclipsed the study's urban renewal strategy. Perhaps it is only fair to give some credit to the study for not entirely dismissing a far more effective and far more obvious course of action. But it is also fair to wonder how much of the subsequent several decades of private activity was stimulated, contrarily, by local fears of what the study proposed to bring about on College Hill. Was the study's proposal to erect two residential towers of nineteen and twenty-two stories at either end of Benefit Street likely to allay such fears? The question answers itself.

The history of that extensive private investment effort puts the lie to claims in the study, backed by supposedly detailed analysis, that many old houses were not worth saving. Maps on pages 98 and 100 of the study show specific structures and specific areas that were judged, respectively, to be "substandard" and "slum." That these were eventually fixed up and rose in value suggests a bias in the study's assessment of "blight." The language of the assessment criteria is extensively couched in terms of rehabilitating structures; it is largely left unsaid that those structures that did not rack up

Artist's view from the north of a similar stretch of Benefit Street, appearing in the College Hill Survey of 1959. Old houses would be replaced by the new residential North Tower and townhouses. *Author's archives.*

enough points were likely to be targeted for clearance—and replaced with structures entirely insensitive to their surroundings.

Beatrice O. "Happy" Chace led an effort to buy fifteen and, eventually, forty old houses on and near Benefit, fix up their exteriors and sell them for a song to families who would restore or renovate the interiors according to their own preferences. Others followed her lead. Antoinette Downing, even as she helped to develop the analytical tools whose use is pilloried in this chapter, advised the private preservation effort. By 1980, some $20 million had been invested in restoring about 750 old houses on College Hill, more than half of the total number of houses in the study area.[71] Downing and Happy Chace are the real heroes of Benefit Street and College Hill, with a supporting cast drawn from the city's leading preservation organizations, including many members representing Rhode Island's first families. How a plan so contrary to their belief in preservation managed to be written and adopted beggars the imagination. Eventually, under Mayor Cianci's first administration in the mid-1970s, the municipality turned against urban renewal and toward preservation. It created, for example, a new program in the Mayor's Office of Community Development to help building owners

undo the faux façades that the Downtown Providence 1970 plan and earlier municipal policies had urged or inflicted on that district.

The downtown plan was coy in its textual references to the architectural shift it had in store, not seeming to mind that its illustrations let the cat out of the bag. Likewise, the College Hill study's text was coy in describing the aesthetic shift it was recommending and equally unconcerned about illustrating it. The study's summary points out that "the architectural designs of the planning proposals attempt to show how contemporary design can complement existing groupings of buildings of a past era."[72] It is difficult to reconcile the illustrations in the study with that goal. No reconciliation of old and new is shown, let alone explained or justified in words, except by naked assertion. Perhaps the closest it comes to an attempt to justify such a goal is in a description of the South Tower planned for Benefit Street:

> *In the conception of this building, the project makes a break with the past in such a way that the structures of each era are clear expressions of individual integrity. (Page 148)*[73]

So the tower and its traditional neighbors express a sort of complement-by-contrast? Only in its condescension to the public's continuing reverence for historic styles does the study abandon generalities. Regarding the scarcity of contemporary design on College Hill, the study is unable to resist thumbing its nose:

> *Most of the twentieth century domestic building* [on College Hill] *has been of mixed character with Colonial revival predominating. Only one or two houses have been designed in the contemporary idiom. (Page 35)*

> *Rhode Island building of the twentieth century continued in an eclectic path and in this respect is not representative of contemporary architectural concepts. (Page 38)*

> *A few rather minor College Hill buildings have been executed in the contemporary idiom, although contemporary building modes are still suspect in conservative modern Providence. (Page 39)*

> *A new Computing Laboratory at Brown is currently being designed by Philip Johnson. It will be the first Brown University building to reflect today's approach to architectural concepts. (Page 70)*

PART II

Artist's view, appearing in the College Hill Survey, of a typical set of new apartment complexes along South Main Street, near South Tower. *Author's archives.*

Get with the program, Providence! A passage from the study on page 187 reads:

> *Detailed studies of the structures in the area confirm the fact that College Hill does not have a concentration of any one style as is the case in many other cities that have enacted historic area controls. This fact emphasizes the validity of the statement that it makes no sense to prevent the design and construction of any one style of architecture.*

And yet every style except for contemporary modernism had been excluded from recommendations by the study for new infill construction.

The passage quoted from page 187 is entirely incoherent. The fact is that the design element of the plan as a whole did not, in the eyes of the planners, need to make sense. It was assumed that there would be no critical analysis of any aesthetic judgment in the study from the design community, let alone civic leaders or the public—the latter were clearly expected to remain mute in the face of all this expert opinion. These expectations were largely borne out.

The planners' attitudes resulted in errors of assessment. The errors fall into two main categories. First is the exclusion of houses built after 1830 from consideration as of primary or even secondary importance, as described in the "Categories of Building Priority" on page 80. This omitted many historic Victorian and revival-style buildings from the primary and secondary lists of buildings worth preservation rather than clearance. The second error is the grouping together of two necessarily separate categories of twentieth-century architecture. On page 78, a chart codes as blue all structures in the final category of architectural periods "Modern: 1900–date." This lumps six decades' worth of traditional buildings in a range of styles—neoclassical, eclectic, revivalist, regional, etc.—together with contemporary modernist styles, mostly of later vintage. More and more modern architecture had been popping up in Providence for three decades by the time the study was published in 1959; more and more, to be sure, but given the tut-tutting by the study's authors, not nearly enough.

The production and public release of the College Hill study were generally coterminous with the production and release of the Downtown Providence 1970 plan. Both plans embraced the conventional wisdom of their time. Both sacrificed patterns of urbanism and design that had evolved incrementally over centuries in favor of massive experimental dislocations based on untested planning and design theories that are viewed with suspicion by most people and had, by then, generally failed at every level of implementation over half a century. Both plans would have continued to deck over the Providence River. The redevelopment proposals of both plans were abandoned with little or no acknowledgment of error. And redevelopment proposals that were implemented had minimal impact on Providence—almost all of which was detrimental to the city and its residents. But without diminishing the College Hill plan's accomplishments outside the realms of planning and design, it has, unlike the downtown plan, a much better reputation in today's public consciousness than it deserves.

In the early 1970s, the city sought to burnish the tourist allure of Benefit Street by bricking its sidewalks and replacing its highway-style steel cobra-head lampposts with historic posts reminiscent of gas lighting. "This is not preservation," wrote Ada Louise Huxtable after a visit to Providence, "this is Las Vegas." As the architecture critic of the *New York Times*, she was entitled to her opinion, but clearly she lacked the will to acknowledge traditional architecture's potentially constructive role in a historic city. One naturally harks back to H.P. ("I am Providence") Lovecraft's letter to the editor of the

Providence Journal in 1929 defending the Old Brick Row. Of the tendencies that dominated the currents of change even then, he wrote:

> *The side of tradition, which finds the soundest beauty in the retention of forms and proportions evolved from the continuous history of a proud old seaport, is well-nigh unrepresented; all the commentators apparently taking for granted the cruder, flashier ideal of a stridently modernized city of pompous vistas and spruce, mid-Western architectural luxury—not a haven to charm the connoisseur of richly mellow old-world lanes, but a tungsten-drenched midway to lure the hard-boiled buyer from Detroit, or a scenic flourish in deference to Seattle and Los Angeles aesthetes attuned to a futuristic Chicago.*[74]

THE INTERFACE PLAN

The failures of the College Hill and Downtown Providence 1970 plans instituted a decade or two of chin-pulling among the civic elites charged with doing something about the exodus of business and shoppers from downtown, and of residents from the city. Its population had declined from a historic high of 253,504 in 1950 to 179,116 in 1970. Yet look at 1953, not long before planners began to contemplate ripping the core out of downtown and building it anew. Reporter Thomas Morgan of the *Providence Journal* looked backward to 1953 from the perspective of 1993. He described the vigor of downtown life in one one of those memorable articles that feature lists of old restaurants, clubs, movie houses and stores long gone. Writing of that year's Christmas season, Morgan paints a lurid scene of downtown activity:

> *They came from the north. They came from the south. The result was a seething, pushing, creeping, jostling mass of humanity that choked the revolving doors, elevators and escalators and set up a continuous ringing of cash register bells.*[75]

Truly? In downtown Providence? Many Rhode Islanders still recall "going down city" to shop. Granted, the streets may have been too crowded with cars, but isn't that the sort of problem many cities today wish they had? Well, if Providence did have such a problem, it embraced a solution that created far worse problems.

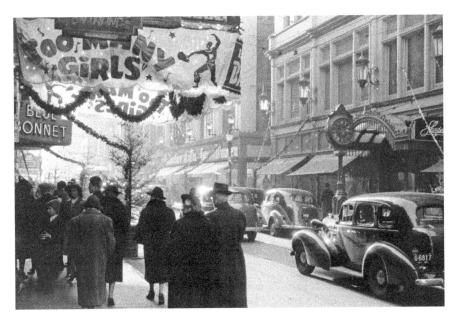

Rhode Islanders shopping on Westminster Street during Christmas season, circa 1950. *Library of Congress, Prints & Photographs Division, Historic American Buildings Survey (HABS).*

It is always assumed that the decline of Providence resulted from the movement of families into the suburbs, who were then followed by business, shopping, industry and other commerce, which further fed the population exodus. More than a kernel of truth exists in that scenario, but it is possible that urban flight was intensified rather than diminished by the steps taken to resist it by the city, state and federal governments.

By the middle of the 1940s, plans were moving forward to clear large residential districts encircling most of downtown to make way for highways. These plans were not secret. Battalions of bulldozers tend to concentrate the minds of homeowners. With cheap federal mortgages and G.I. loans to help families relocate, with highways planned to make it easier to commute to and from downtown and with well-publicized plans to demolish much of downtown and refurbish the remains in unfamiliar ways, it might be a bit of a surprise if, by the 1950s and 1960s, the suburbs were *not* gaining population at the expense of the city. About the only migration *into* the city was from Boston. The Raymond Patriarca crime family made Providence the headquarters of the New England mob, run for thirty years out of a vending-machine company on Federal Hill. The mob's grip on the city was rubbed out by the state police in

the 1980s and '90s. "Mobsters and Lobsters" remains a popular Rhode Island sobriquet.

Again, it may be easy to hypothesize in retrospect, but might the various plans and prospects for downtown and College Hill have seemed sufficiently dodgy, in the non-expert mind, to cast a pall over expectations for Providence? To imagine so is not far-fetched.

By the early 1970s, it was long clear that what had been done to implement the downtown and College Hill plans was not reversing urban out-migration by people or institutions, and that most of what had been planned was not going to happen. At that point it might have been difficult for most people to perceive that this was a *good thing*.

How to stop suburban flight was a topic facing the nation. And yet the conversation seemed to reflect rather than to resolve the problem's complexity. But one discussion, seemingly unconnected, would prove very helpful. On a national level, many architects could see that their industry was creating products that were failing to win the hearts and minds of the public. Under the banner of the postmodern movement, practitioners and theorists challenged the modern movement's shibboleths, including the inelegant architecture that arose from its "Form follows function" mantra. In the 1970s, Robert Venturi, Vincent Scully, Michael Graves and other renegades rejected the academic formalism of the International Style, as early modernism was known. Their arguments were sound, even obvious, but they had no effect.

Tom Wolfe, acclaimed originator of "the New Journalism," in the introduction to *From Bauhaus to Our House*, tries to understand how a form of architecture so widely disliked could gain a chokehold on elite society in America. Why, he wonders, do the top executives of growing companies move into modernist buildings they dislike: "Without a peep they move in!— even though the glass box appalls them all."

> *Every great law firm in New York moves without a sputter of protest into a glass-box office building with concrete slab floors and seven-foot-ten-inch-high concrete slab ceilings and plasterboard walls and pygmy corridors— and hires a decorator and gives him a budget of hundreds of thousands of dollars to turn these mean cubes and grids into a horizontal fantasy of a Restoration townhouse. I have seen carpenters and cabinetmakers and search-and-acquire girls hauling in more cornices, copings, pilasters, carved moldings, and recessed domes, more linenfold paneling, more (fireless) fireplaces with festoons of fruit carved in mahogany on the mantels, more*

chandeliers, sconces, girandoles, chestnut leather sofas, and chiming clocks than Wren, Inigo Jones, the brothers Adam, Lord Burlington, and the Dilettanti, working in concert, could have dreamed of.[76]

Wolfe proceeds to describe the debate among architects about what to do, writing with his patented verve:

In any event, the problem is on the way to being solved, we are assured. There are now new approaches, new movements, new isms: Post-Modernism, Late Modernism, Rationalism, participatory architecture, Neo-Corbu, and the Los Angeles Silvers. Which add up to what? To such things as building more glass boxes and covering them with mirrored plate glass so as to reflect the glass boxes next door and distort their boring straight lines into curves.[77]

The postmodernists did not follow the obvious alternative of returning to the traditional vernaculars and classical orders of the architectural establishment the modernists had overthrown. Instead, they decked out the modernists' glass-and-steel boxes with cartoon renditions of traditional ornament and called the result "ironic." The modernist establishment easily squelched the revolution with a jujitsu move of sublime panache: architects twisted their principles (such as remained after the postmodernist assault) from the tedious to the ridiculous, trading in their supposedly functionalist conceits for wacky new designs seemingly intended to astonish the public (or at least the editors of architecture magazines) by appearing to challenge the laws of nature, physics and gravity.

And yet, groans Wolfe, the CEOs kept coming back:

All at once they are willing to accept that glass of ice water in the face, that bracing slap across the mouth, that reprimand for the fat on one's bourgeois soul, known as modern architecture.

And why? They can't tell you. They look up at the barefaced buildings they have bought, those great hulking structures they hate so thoroughly, and they can't figure it out themselves. It makes their heads hurt.[78]

Amid the turmoil, which lasted for about a decade and amounted to nothing, the postmodernists' assault on modern architecture did create a small opening for architects interested in reviving the traditional building practices that had been declared null and void by the modernists. The history and technique of classical architecture and its traditional brethren

had been expunged from the curricula of every school of architecture in America, but even as late as 1970, the growing accumulation of built modernism was surrounded by reminders of what might have been. Organizations arose to oppose modern architecture, such as Classical America, cofounded in 1968 by Central Park curator Henry Hope Reed, author of *The Golden City*. His book paired photographs of comparable modernist and traditional architecture; no words were required (not that he didn't provide them anyway). Penn Station in New York was demolished while jaws hung open among the elite in Manhattan. The preservation movement went on high alert. In 1976, the year of America's bicentennial, the Providence Preservation Society celebrated its twentieth anniversary. But from the National Trust for Historic Preservation on down, they hesitated to challenge the reigning modernist orthodoxy.

Both major plans for the two most celebrated historic districts in Providence, downtown and College Hill, were steeped in modern architecture. Not so with the next major plan to emerge, *Interface: Providence*, published in 1974 after a study led by RISD professor Gerald Howes. Although initiated as a transportation study by way of a class project, it eventually became the first plan to uncover the city's downtown rivers. Thus did it foreshadow the River Relocation Project of the 1990s. The Interface plan might also be characterized as neutral on the question of architectural style. That was a big step in the proper direction. Yes, it featured, in Kennedy Plaza, a small version on stilts (page 88) of Montreal's Habitat 67—the stacked modular residential development designed by architect Moshe Safdie. But it also proposed a PRT—personal rapid transit—circulating through downtown on tracks raised above the street level by a "colonnade" of clearly traditional design (page 120). The plan's gently quavering illustrations express a pleasure in the city's built environment that is incompatible with plans to remove or cover up its longstanding architectural delights.

The plan would not have removed the Chinese Wall. It would, however, have removed automobiles from downtown streets. Its two parking megastructures go unillustrated in the study, for some reason, though each multilevel parking garage was the size of the Financial District. Together they were to provide, at opposite edges of downtown, what curbside spots and sixty acres of existing parking lots provided in 1974. Those lots would have been re-dedicated as infill development opportunities but also as pocket parks in the plan's extensive proposal for more green space. Above all, the plan would have daylighted the downtown rivers, even adding a large pond (called the "Cove Pond") on the leafy grounds around the State House.

Artist's view of proposed residential and retail pods, *left*, at Kennedy Plaza, in the 1974 *Interface: Providence* study. *Author's archives.*

Artist's view of quasi-classical colonnade upholding Personal Rapid Transit platform on Weybosset Street, from the *Interface: Providence* study. *Author's archives.*

After commenting on the extraordinary ability the downtown's layout affords the average person to orient themselves geographically and to identify primary uses of downtown areas by their appearance, the authors state:

> *Few cities have this clarity of definition. Also the town has not prospered in the last forty years to a similar extent as other cities, and, while one might think at first sight that this is an unfortunate factor, it has not suffered within its business area from the mad scramble for land with its concomitant high-rise construction.* [79]

And while the Interface plan certainly has a "feel" congenial to those who consider the city's historic architecture to be among its most important advantages, that quote is about the closest it comes to commenting on matters of architectural design. Because we all know about urban renewal and the towering sterility to which the words refer. And Rhode Islanders of that day—more than forty years ago now—had had these connotations pounded into them by a pair of earlier civic plans astonishing in their insensitivity to the city's architectural heritage.

By 1974, downtown had been built black and blue by the brutal (and occasionally Brutalist) buildings of the period. Beginning with the fourth Howard Building in 1959, there were in quick succession Dexter Manor (1962), the (Sabin Street) Bonanza Bus Terminal (1963), the Regency (1966), the Blue Cross (now city planning) Building (1966), the Fogarty Building (1967), Beneficent House (1969), the Textron Building (1969), One Weybosset Hill (1971), the Civic Center (1972), the Hospital Trust Tower (1973) and the Civic Center (1973), with the Garrahy Judicial Complex (1978) and Broadcast House (1979) soon to follow.

Perhaps Interface reflected the dismay that must have been in the air after such a bout, however much people welcomed the attendant jobs and spending. In fact, the Interface plan's reputation, like that of so much else, comes down to us as a single idea. For College Hill, that has been "Saved Benefit Street." For Downtown Providence 1970, that has been "Never happened, thank God." For Interface, is is "First to uncover the rivers." Reputation does not always align with actual legacy, but in the case of Interface (virtually none of which was implemented) it did. And too bad it was not implemented. Without assessing its practicalities—especially the PRT and the elimination of cars from the central business district—it was an alluring plan.

CAPITAL CENTER PLAN

Even if Interface disappeared down the rabbit hole too quickly, its legacy was stellar. Still, the legacy required another decade to gestate. Meanwhile, the next major downtown plan was announced in the late 1970s. This was the Capital Center Plan. Amtrak, the national passenger rail system that emerged from the decline and insolvency of the Penn Central (Pennsy) rail system, had decided to renovate the train stations along its Northeast Corridor lines. City and state officials working with Rhode Island's congressional delegation persuaded Amtrak to redefine "renovation" in this case as moving the tracks and rebuilding the Providence station at the foot of Smith Hill, across Gaspee Street from State House Park. The time had arrived to get rid of the Chinese Wall.

It is fun and maybe even edifying to compare the machinations that resulted in filling the old Cove Basin full of railroad trackage in the 1890s with the Rube Goldberg device of city, state, federal, corporate and institutional relationships that led, almost a century later, to the tracks' eviction from the gulch in which the Capital Center was built. A small group of unelected bureaucrats, consultants and businessmen maneuvered, waited and maneuvered some more until the moment was right to persuade elected officials, such as Rhode Island senator Claiborne Pell—a notorious train buff—to sign off on an expenditure of $170 million ($165 million of which came from federal highway and rail agencies) that did an immense amount of good for the citizens of Providence, of Rhode Island and, indeed, of New England and the nation as a whole.

This—not just slipping a ballot into a box—is democracy. Behind the scenes, movers and shakers did what was good for themselves and, perhaps, for voters. It might be argued that the same could be said of the different set of movers and shakers in the 1890s. Perhaps three hundred trains a day through Providence at the height of its industrial ambition was a small price for a prosperity strong enough to carry the city through almost a century of economic decline. Perhaps this smacks too much of Voltaire's "All is for the best in the best of all possible worlds," from his satire *Candide* on the over-optimism of philosophers. Simply put, it is sometimes difficult to identify the line between the interests and the voters. Suffice it to say, as Leazes and Motte emphatically do in *Providence: The Renaissance City*, that moving the railroad tracks was crucial to revitalizing the city in the late twentieth century.[80]

So, having buried the tracks, what could be more natural than to fill the void with a new suburban-style office and residential district? By 1979, the "modernization" of downtown and of College Hill had long since ground to a halt. So why not try again?! Lock and load!

Skidmore, Owings and Merrill, the nation's preeminent architectural firm (modernism's answer to the Gilded Age starchitects McKim, Mead and White), was hired to produce a master plan for Capital Center. Under the plan, land largely given over to railroad tracks and crumbled asphalt parking lots would be filled with low-rise modernist office blocks. Major retail was to be excluded so as to avoid stepping on Westminster Street's toes. A centrally located pool forming a diamond was the plan's only acknowledgement of the city's rivers. The decking on the world's widest bridge was left untouched.

A Capital Center Commission (CCC) was formed in 1979, and a Design Review Committee was assigned to create guidelines for the new district. Those guidelines erected principles by which the regulation of building heights, setbacks, view corridors, signage and a full range of other matters could proceed. But it also included the following fateful declaration:

> *Beyond these principles, however, the Plan is reticent about mandates to architectural expression. Because it may take more than 20 years to develop the 60 acres, it seems inappropriate to dictate taste or preordain conformity over that much territory and that much time. The Plan grows out of a conviction that in the evolution of cities, design is not only a mirror of the present but an intricate and evolving reflection of all that the city has been.*[81]

Almost forty years later, the result confirms the adage that a camel is a horse designed by a committee. The architectural development of Capital

Artist's rendering of Capital Center initial conceptual design, circa 1980, by Skidmore, Owings and Merrill. *Author's archives.*

Center has passed through three awkward phases that might be loosely described as postmodern, traditional and modern. This development will be more specifically criticized in chapter 20. "[A] high value was placed" by CCC's design panel, supposedly, "on sensitivity to the historic context of the district," write Leazes and Motte.[82] The historic context consisted of downtown, College Hill and the State House. Authorities of that era could be relied on to genuflect before the god of context before sacrificing it.

But before the commission had the time to fail so spectacularly in expressing its limp contextual sensitivity, another challenge arose. In addition to relocating the railroad tracks, the project envisioned adding a new highway interchange for traffic to exit from Route 95 into the planned new section of downtown. The interchange was to funnel traffic onto a broad avenue, with a meridian, called Memorial Boulevard. In the initial plan, the boulevard was to travel five hundred yards to Memorial Square, an intersection where seven roads met atop the decking near the confluence of the Woonasquatucket and Moshassuck Rivers at the head of the Providence River.

Memorial Square was originally called Post Office Square, after the building under which the two rivers met to form the third, all running

through granite channels built long before. By 1979, Memorial Square was known as "Suicide Circle." Vehicles hurtled from those seven roads into a roundabout encircling a columnar World War I Monument, designed by Paul Philippe Cret and completed in 1929. For five decades, vehicles and pedestrians had hazarded this convoluted crossing. The new Route 95 interchange would multiply the traffic entering Suicide Circle. A series of ideas from various official and unofficial quarters to deal with this impending chaos included a city proposal to finish covering up the rivers.[83]

In the lore of the Providence renaissance, a napkin looms large. On the evening of March 19, 1981, at the Blue Point oyster bar on North Main Street, the white cloth napkin sat on a table. Architects Friedrich St. Florian, Irving Haynes and William D. Warner and Warner's fiancée, Peggy, a former scenic artist for Trinity Repertory Company, sat around the table grumbling, in St. Florian's recollection, at "what they saw as a lack of inspired planning at Providence's City Hall." Maps and ideas were scratched on the napkin. While a splotch of spilt wine obliterates a key sketch, none of the doodles suggested moving the rivers. Still, most agree that the evening's cogitations led Warner, over the next three years, to the grand solution of a critical problem at Capital Center's intersection with the rivers. "I went home and

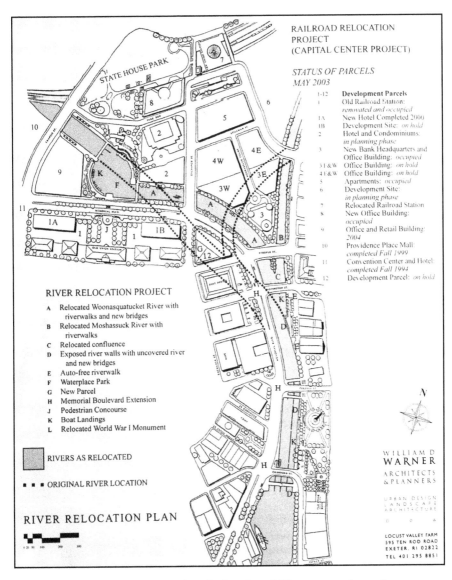

STATUS OF PARCELS
MAY 2003

1-12	**Development Parcels**
1	Old Railroad Station: *renovated and occupied*
1A	New Hotel Completed 2000
1B	Development Site: *on hold*
2	Hotel and Condominiums: *in planning phase*
3	New Bank Headquarters and Office Building: *occupied*
3 E & W	Office Building: *on hold*
4 E & W	Office Building: *on hold*
5	Apartments: *occupied*
6	Development Site: *in planning phase*
7	Relocated Railroad Station
8	New Office Building: *occupied*
9	Office and Retail Building: *2004*
10	Providence Place Mall: *completed Fall 1999*
11	Convention Center and Hotel: *completed Fall 1994*
12	Development Parcel: *on hold*

RIVER RELOCATION PROJECT

A Relocated Woonasquatucket River with riverwalks and new bridges
B Relocated Moshassuck River with riverwalks
C Relocated confluence
D Exposed river walls with uncovered river and new bridges
E Auto-free riverwalk
F Waterplace Park
G New Parcel
H Memorial Boulevard Extension
J Pedestrian Concourse
K Boat Landings
L Relocated World War I Monument

RIVERS AS RELOCATED

● ● ● ORIGINAL RIVER LOCATION

RIVER RELOCATION PLAN

WILLIAM D
WARNER
ARCHITECTS
& PLANNERS

URBAN DESIGN
LANDSCAPE
ARCHITECTURE

LOCUST VALLEY FARM
595 TEN ROD ROAD
EXETER. RI 02822
TEL 401 295 8851

Map showing Capital Center parcels and relocation of Woonasquatucket and Moshassuck channels to form a new confluence at the head of daylighted Providence River. *Aurthor's archives.*

Opposite: Napkin, from 1982, with maps inked and signed by Friedrich St. Florian, Irving Haynes and William D. Warner. *Photo by author.*

forgot about it," St. Florian told a memorial gathering after Warner's death in 2012. "Warner didn't."[84]

St. Florian maintains possession of the napkin as if it were a sacred relic.

Warner incorporated his ideas in *The Providence Waterfront: 1636–2000*, a study backed by the Providence Foundation, the National Endowment for the Humanities and others. It was published in 1985. He suggested moving the rivers' confluence out from under the Post Office, about one hundred yards east, so that traffic could squeeze between the edge of the Financial District and the Providence River along an extended Memorial Boulevard. That was the beginning of the Memorial Boulevard Extension/River Relocation Project, which changed the face of Providence. But that plan was stuck into the study along with proposals to improve the harbor district beyond the Hurricane Barrier, the Fox Point district at the confluence of the Seekonk and the Providence and the shoreline facing East Providence as it headed north toward Swan Point Cemetery. In fact, it might almost be said that the expensive proposal to relocate the rivers was hidden in plain view.

Predictably, backers of the as-yet-unbuilt Capital Center objected to Warner's ideas, which he unpacked to authorities in stages, with the actual relocation of the river emerging last. After all, his plan would require not just moving the rivers but moving the property lines of the Capital Center's land parcels. At one meeting, an engineer upset at Warner's proposals threatened to absquatulate from the proceedings unless Warner's plan was withdrawn. At another meeting, Capital Properties president Joseph DiStefano accused Warner of "smoking funny cigarettes."[85]

Supporters of the idea worked to secure funding for a comprehensive proposal. The money was raised. The boulevard's extension and the rivers' relocation were added to the Capital Center plan using mostly federal money (85 percent) after $600 million was freed up by Rhode Island's cancellation of its portion of Route 84 linking Providence to Hartford, Connecticut. Senator John Chafee pushed legislation through Congress to let Rhode Island use cancelled funds for a rural highway on an urban highway project.[86] (Yes, that was illegal!) Leazes and Motte explain the essential conundrum:

Opposite, top: Artist's rendering of new river confluence, from memorial exhibit of the late William D. Warner by the Rhode Island chapter of American Institute of Architects. Warner was chief designer of the waterfront. *Author's archives.*

Opposite, bottom: Artist's rendering of Waterplace Park, substantially improved from the 1980 plan by Skidmore, Owings and Merrill. Drawing from memorial exhibit of the late William D. Warner by AIAri. *Author's archives.*

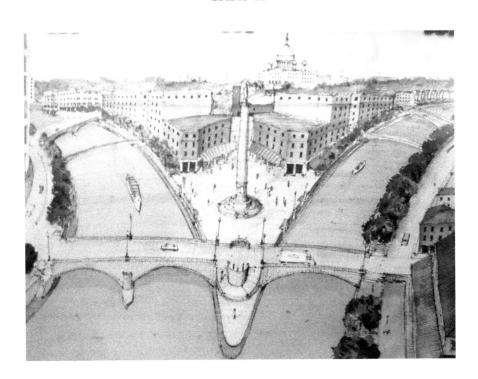

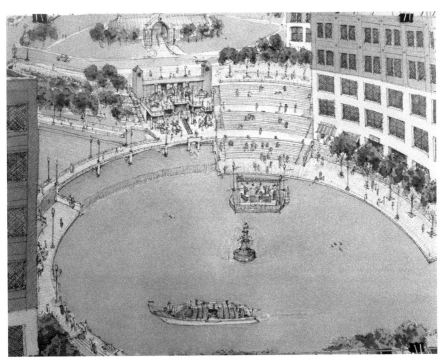

Despite senatorial blessing, it still took administrators to figure out how to define the Memorial Boulevard extension project. It was a river project unless someone could convince the [Federal Highway Administration] *otherwise. The challenge was to convince the FHWA that Warner's ideas were not a river relocation project but an extension of Memorial Boulevard.* [Rhode Island Department of Environmental Management director] *Robert Bendick was simultaneously engaged in selling the project locally as a riverfront park designed to attract people to the city. The two efforts needed to strike a tricky balance.*[87]

Bill Warner, whose first big job out of architecture school at MIT was as director of the modernist College Hill study, clearly managed to transcend his design education by the time he had the idea that transformed Providence. He had the courage to design the city's new waterfront in a traditional character at a time when every waterfront project in the world was heading in the opposite direction. But Warner is rightly remembered not just as the man with the plan, or even as the architect who put the plan into form, but as a master diplomat who pushed the plan through a complicated set of local, state and federal bureaucracies over a strikingly extended period of years. His last project was the relocation downriver of Route 195 from its path slicing downtown from the Jewelry District. The bridge that carries the highway over the Providence River deserves to be named the Bill Warner Memorial Bridge.

"WE HATE THAT"

In the fall of 1984, I was standing next to Michael Metcalf, publisher of the *Providence Journal*, at a window looking east toward College Hill from the Turk's Head Club, on the eleventh floor of the Turk's Head Building, erected in 1913. It was the day Metcalf offered me a job on the newspaper's editorial board. He pointed out the window and said, "We hate that."

I did not need to be told what "that" referred to.

It was Old Stone Square, newly erected by the development arm of Old Stone Bank and designed by celebrity architect Edward Larrabee Barnes of New York. Metcalf pointed to an eleven-story square building that loomed against the backdrop of College Hill, with big square spaces cut out of its huge square mass from the lobby entrance and from the opposite upper quadrant of the building. It stuck out like the proverbial sore thumb. It did not start out this way. It was originally to be a pair of shorter buildings flanking a plaza, through which would be visible the dome of the Old Stone Bank.[88] Its look was to have been postmodern, somewhat squishy but identifiably traditional, even Georgian. Its key defect, however, was to mask views of all but a sliver of historic South Main Street as seen from corporate suites in the upper floors of downtown towers across the river.

The Providence Preservation Society, by then a recognized pillar of the city's business establishment, vociferously opposed this initial design but, after some Old Stone pushback and some redesign, became more ambivalent. David Macaulay, an author and illustrator of books on

View of Old Stone Square (1984) and College Hill from Turk's Head Building (1913), site of author's Turk's Head Club luncheon with *Journal* publisher Michael Metcalf in 1984. *Photo by author.*

architecture, spoofed the design in a cartoon published on June 13, 1982, in the *Providence Sunday Journal*, riffing off Old Stone's new corporate brand, Fred Flintstone. Mayor Cianci stepped in to negotiate a compromise, which involved a new design by Barnes. The result was not as wide but much taller than the two buildings of the original design. It sits on the southern half of the lot with a park on the northern half. It did not hide as much of South Main Street's historic frontage as the original proposal, but it was starkly modernist. Squares of light and dark gray gridded its square façades, not unlike the pattern on a box of Ralston-Purina cat chow. Why suddenly such an angry confrontation with its historical context? It seemed to me that a desire on the part of the Old Stone rainmakers for revenge against the preservationists might have been part of the answer.

In 1999, after years of failure to ferret out an admission of revenge as a factor in the design of Old Stone Square, I visited Old Stone's lead developer, Scott Burns, at a café in the Chelsea district of London. He, too, refused to confirm my suspicions, and I have allowed them to fester undisturbed ever since.

Cartoon by David Macaulay lampooning original Old Stone Square design by Edward Larrabee Barnes in 1982. Providence Journal, *clipping, courtesy of David Macaulay*.

And yet, the years following Old Stone Square's erection saw an efflorescence of new traditional architecture that seemed to come out of nowhere. It did not come out of nowhere. I cannot pinpoint the wellspring of this shift, but I can point to evidence of its appearance on the Providence stage.

Strong hints of a reaction against the modernist conceits of the Downtown Providence 1970 plan and the College Hill study came one after another in the 1970s and 1980s. The Mayor's Office of Community Development instituted a program to finance small projects, such as helping building owners remove faux modernist ("ugly is just skin deep") façades erected in the 1950s and 1960s, especially along Westminster Mall, the Old Journal Building being a prime example. The Providence Preservation Society widened its attention to preserving historic fabric throughout the city, but focused even more on downtown. Mayor Cianci joined preservationists and the business community to ensure that the Wilcox Building—one of the grand dames of Weybosset Street—was restored after a fire in 1975. Cianci, Outlet chief Bruce Sunlun and publisher Metcalf of the *Journal* managed to resuscitate the Biltmore Hotel (1922) in 1979 after three years of closure. Cianci also led an effort to block the demolition of Loew's Theater (1928) and then to restore it as the Providence Performing Arts Center. The Majestic (1917) was renovated as the Lederer, a live venue for Trinity Square Repertory Company.

The Arcade (1828), which had almost been razed in 1944, was purchased by Gilbane Properties and restored in 1980 by Irving Haynes, who had just restored City Hall and was present for the famous napkin doodle of 1981. Johnson and Wales College started buying and fixing up old buildings for its widely dispersed downtown campus, including the Burrill Building (1891), long the Gladding's department store. Paolino Properties, after demolishing the Hoppin Homestead Building, turned from whacking old buildings for parking lots to renovating old buildings for new and more hopeful pursuits. In fact, despite their good works, JWU and Paolino Properties vied in the public mind for the role of "evil landlord," alleged nefarious owners of the entire downtown.

Mayor Cianci, who died in 2016, may be the most controversial figure in Providence's history since Roger Williams, or at least since Thomas Dorr. His two administrations straddled a 1984 conviction for assault. Still, he would kiss a pig for a vote, attend the opening of an envelope and was tops at talking up Providence or locating hidden pots of money for this or that project. And yet, the civic renaissance gathering steam during Cianci's second administration (1991–2002) made progress as much in spite of as because of his leadership. Keeping Cianci's hand out of a project's pocket made already complex developments harder to manage politically. His reputation alone probably kept some entrepreneurs from investing in Providence. His shady dealings, suspected by many, emerged only during his 2002 corruption trial, where he was convicted of conspiracy, a single count among a score or so of charges. It may be fair to say that, in spite of his professed love for the city and his cheerleading for its revival, he hurt it as much as he helped it.

But as the city entered the 1980s, all that was in the future.

Having been convicted in 1984 of assaulting the alleged lover of his estranged wife, Cianci gave way to the son of Paolino Properties founder Joseph Paolino Sr. Joe Jr. was president of the city council when he took over the mayor's office, and though it was not quite his father's cup of tea, he continued his predecessor's dedication to preservation. His signature effort was the restoration of traffic to Westminster Mall, a part of the Downtown 1970 plan that was accomplished but had failed to reignite the interest of shoppers, whose abdication coincided with official efforts to revive downtown by obliterating much of it. The mall was crowded during the noon lunch hour but empty almost every other hour. Paolino commissioned a study, the "Providence Development Strategy," by consultants Carr, Lynch Associates and Melvin Levine and Associates, released in 1986. Within the context of a broad set of retail, office, residential, entertainment and administrative

proposals, it put the kibosh on the mall, decrying the failure of a major mall overhaul in the late 1970s. More radically, the report voiced displeasure with the appearance of the mall and of downtown's street furnishings:

> *In the case of Westminster Mall, added planters, lights, benches, graphic panels, canopies and a police booth/stage all tended to clutter and congest the available space, with little or no positive aesthetic effect. Indeed, the insistently "modernist" design style chosen for the lights and signals on Westminster, Washington and Weybosset Streets is sadly out of character with the rich 19th Century fabric of downtown Providence.*[89]

The document recommended further narrowing the hours in which the mall was open only to pedestrians and left unclear whether vehicles should be guided by painted lines or actual curbs. Paolino chose the latter and opened the street to traffic full time. He went on to flip the mall's aesthetic by 180 degrees, lining a reopened Westminster with brick sidewalks; granite pavers set in circular patterns at each intersection of Westminster; ornate tree grates around new street trees with tiny leaves that filter sunlight agreeably; and twinned acorn-style luminaries on decorative lampposts that stretched onto side streets beyond Westminster. The new street furniture

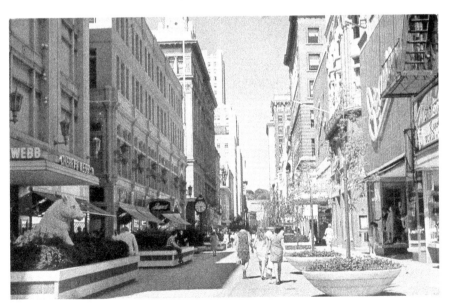

Postcard view of Westminster Mall, looking east circa 1980, before the return of automobiles and a radical redesign of the street in a traditional style. *Author's archives.*

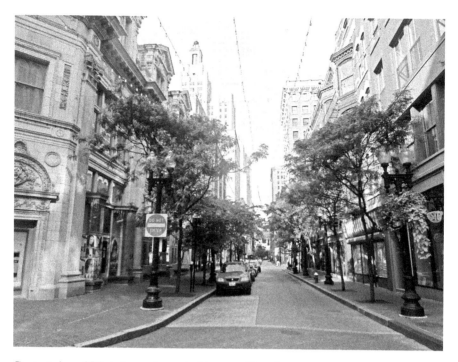

Current view of Westminster Street, looking east. Note the restored Old Journal Building at left. Compare this image to earlier views of Westminster Mall (see pages 127 and 128). *Photo by author.*

tended to build on the existing strengths of Westminster's fine commercial architecture, even though the elegant ground floors of many buildings were still covered up by faux façades that contrasted awkwardly with the floors above. Granted, many people rarely raise their eyes to admire those floors, but the highly stylized look of history cannot have failed to impress itself on their subconscious perceptions. This is how we perceive beauty—not by "understanding" it but by receiving its influence on our sensibilities, which are easy for us to ignore but difficult for us to shut down entirely.

Paolino's Westminster Street beautification strengthened the spine of a downtown whose preservation ethic was, as they say nowadays, "trending." Along with the many smaller projects noted above, the sharply pleasant change in the look of the pedestrian mall might have helped developers and other local authorities to buy into a more open-minded attitude toward historical context as a factor in the style of new development. Among the echelons of municipal planning staff, employees of major construction and development firms, members of design review panels and the design

PART II

professionals and academics who may be expected to keep track of the latest news in architecture and planning policy, the twists and turns of the debate between modernists and postmodernists surely must have affected the intellectual climate of city planning in ways that bent the arc of style toward tradition.

THE CAPITAL CENTER BUILD-OUT

To the extent that the analysis in the last chapter holds water, its workings may be seen in the three phases of design at Capital Center referred to in chapter 18. Rolling out over two decades as if somehow ordained by a confused zeitgeist lodged in the Capital Center Commission's evolving worldview, the district's first ten buildings break down into three successive phases of postmodern, traditional and modern architecture.

The first four buildings arose as the streets, bridges, river walks and new river channels took shape in the mid-1980s and early 1990s. Together, these four buildings are a tutorial on postmodern architecture. Providence Station, the new, relocated depot completed in 1986, was modernist, even mildly Brutalist—a low flat slab of limestone sheaths with a square clock tower and shallow stainless-steel dome. The dome was said to evoke the State House dome, but it was shorn of detail, winking at tradition. The second building, a low-rise office complex called the Gateway Center, completed in 1989, snuggled up to tradition with its green, faux-copper attic roofline and bowed central front, but it kept its distance with flanking concrete façades embellished, unenthusiastically, with classical stringcourses. The third building, a residence called Center Place completed in 1990, also doffed its cap to the Platonic ideal of "a building" but expressed its reluctance with shallow detailing in its brick and precast façades, into which square windows were "punched," as modernists like to say. The fourth building, an office tower called Citizens Plaza, was completed in 1990 on a temporary island as the new channels of the relocated river confluence were laid on either side

of it. Violating one of the key principles of the Capital Center guidelines, it blocked views of the State House from downriver. A sliver of its dome and the *Independent Man* can still be seen squished between Citizens Plaza and the Hospital Trust Bank. The triangular building seems to imagine that its three very slightly classicizing towers, capped at each corner, make up for the sin of closing down a major view corridor. Not.

Those four buildings were followed by three new buildings along the western edge of the district, beyond Waterplace Park and across Francis Street but still on parcels attached to Capital Center. These three buildings arose in the last half of the 1990s, advancing beyond the hodgepodge of the district's postmodernist beginnings. They spoke in the traditional language of architecture that had characterized Providence for more than three centuries. The Westin Hotel, a publicly financed facility connected to the newly completed Rhode Island Convention Center in 1994, boasted actual gables, tinted green as if copper, atop a base of cast concrete and a shaft of brick. I cut my critic's teeth during the review process for the Westin, during which Brown architecture historian William Jordy, quoted in my column "A Review of Design Review" (February 18, 1992), said he wanted it to be "more modern and less archaeological."

> *To their credit, the* [Westin] *architects did not make the major changes that the initial criticism seemed to call for. How could they? The criticisms were vague to the point of pointlessness: The hotel design was a "pastiche," it wasn't "honest" enough. It resembled other buildings in other cities too much.*[90]

The second building was Providence Place, completed in 1999. Its two classicized anchor stores were connected by a mill-like central stretch with a three-story glass "wintergarden" that bridged the river and the railroad tracks. Because of its complexity and its size, extending from the Westin Hotel to the Masonic Temple near the State House, about four hundred yards, its review process was lengthy. Architects for the two anchors, Nordstrom and Filene's, designed each end in robustly classical styles; the middle picked up on the city's industrial heritage. Friedrich St. Florian, who soon after designed the National World War II Memorial on the Mall in Washington, D.C., was in overall charge of the exterior design. By the end of the long review process—which reflected the same inanities that had slowed the Westin design—the mall managed to retain an unapologetically traditional appeal.

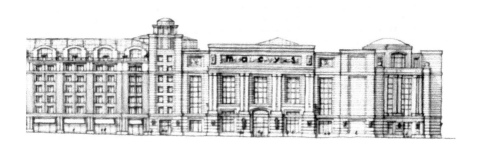

North segment of early design of Providence Place in classical style, by Adrian Smith of Skidmore, Owings and Merrill. *Author's archives.*

A surprising earlier design for Providence Place was proposed by the office of Skidmore, Owings and Merrill, whose Marilyn Jordan Taylor did the original master plan for Capital Center. A principal of that firm, Adrian Smith, inked a thoroughly classical design for Providence Place. His work on the mall suggested not only the eclecticism of the architect but his bravery, embracing American Renaissance heritage amid a period of aesthetic angst among members of his profession. Smith—who recently designed the Burj Khalifa, in Dubai, the world's tallest skyscraper (for now)—saw his mall design jettisoned after former Outlet Company CEO Bruce Sundlun lost the governorship in 1995. He was succeeded by Lincoln Almond, whose campaign had deployed a shifty opposition to the mall or, more precisely, to its proposed "tax treaty" with the city and state. Almond's critique evaporated soon after his election, followed by the hiring of St. Florian to lead the mall's exterior redesign.

The third traditional building was the Courtyard Marriott Hotel, built between Union Station and Memorial Boulevard with a sweet yellow brick from the same quarry used for Union Station and trim of burnt sienna (as Crayola denotes this color). The hotel, completed in 2000, was a larger version of the earlier station's five brick rectangular structures, the easternmost of which had burned down in 1941 and was not rebuilt until 1984. That its design program replicated the lost building's style rather than "following a different drummer" was another indication that an inclination toward the city's traditional appearance was trying to reassert itself.

These three new buildings demonstrated one of the abiding merits of traditional styles. They love one another. And they do not need to be

perfectly suited to one another, or especially beautiful, to do so. Viewed from either downtown or from the governor's balcony of the State House, the three buildings (plus a traditionally designed residential tower added to the Westin complex in 2004) evoke the camaraderie of the classical orders: they gentle the condition of Francis Street, illustrating the complementary nature of architecture that stems from the classical orders. Neither the mall, with its serial cupolas, nor the Westin towers that dominate either view are paragons of classical virtuosity; their ornamental detailing ranges from somewhat lame to downright clunky. Yet they smile at the pedestrian, who has something nice to look at for a change, and whose belittlement alongside such large buildings is minimized by the palette of scales incorporated in these structures, urban and urbane.

The view from downriver toward this set of traditional buildings just beyond Waterplace spoke with equal force to the same principle of architectural camaraderie. The photograph by Richard Benjamin, a former photographer at the *Providence Journal*, looks like a painting, and not only

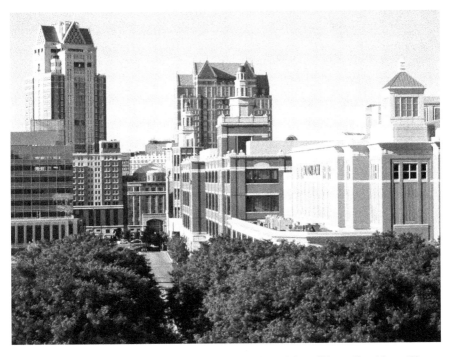

View looking south to Francis Street from the Rhode Island State House. Providence Place (1999) is at right. GTECH (2006) is at left. The buildings in the foreground are of recent vintage. *Photo by author, 2008.*

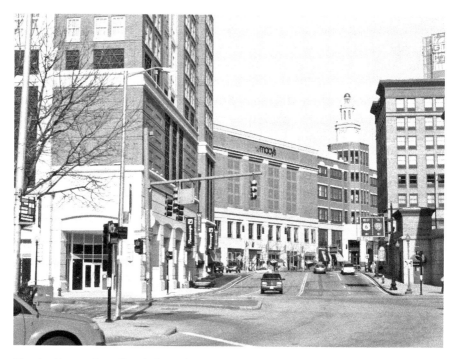

View looking north up Francis Street from near Biltmore Hotel (1922). *Left to right*: Westin addition, Providence Place (1999) and Courtyard Marriott (2000). *Photo by author, 2008.*

because of the smattering of happy clouds in the sky over the horizon. Shot in 2000 near dusk at the outset of a WaterFire (more later on this phenomenon), the three traditional buildings form a splendid backdrop to Bill Warner's traditional infrastructure at Waterplace Park. Had the Capital Center Commission continued to plan the district's future on a reverence for its past, Providence would have found itself blessed by the most unique new urban center in the annals of modern American planning.

In 1999, buoyed by the optimism of these developments and suffused by the dubious idea that my writing had played a role in tradition's recent successes, I contacted Quinlan Terry, the favorite architect of Prince Charles, who was crusading against modern architecture in Britain. I asked Terry whether he would be interested in doing a project in Providence and described the collection of parcels still available for development in the Capital Center district. He said "yes." I contacted Joe Paolino, the former mayor, ambassador and state economic czar, who was by then back at his post in private real estate development. I asked him to serve as an intermediary between Terry and Robert Eder, the

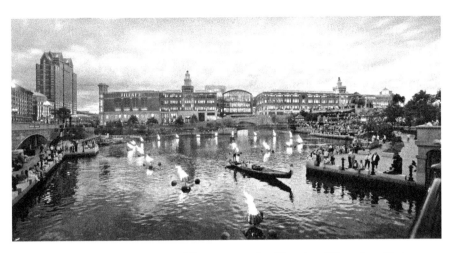

View looking west, in 2000, up the Woonasquatucket River into Waterplace Park, during WaterFire. Providence Place is in the background. *Photo by Richard Benjamin, richardbenjamin.com.*

head of Capital Properties, the development arm of the Providence and Worcester Railroad and owner of almost all of the development parcels in Capital Center. Paolino, too, said "yes." But nothing ever happened, and I never found out why. Having the prince's favorite architect design a major project in Providence would have outraged establishment architects throughout America, if not the world. Maybe that is why nothing happened. Still, it would have been a great show, and great P.R. It would have put the city on the map.

Instead, the curtain rang down on this heady urbanist vision. Capital Center Commission chairwoman Leslie Gardner declared that the district needed new buildings to be "different." Mayor David Cicilline, asked by me to call for the redesign of Capital Center's next building, a modernist monstrosity on Parcel 9, declared that Francis Street needed stylistic "diversity." And it was off to the races.

The first of four buildings in the third tranch of new architecture in Capital Center, the ten-story headquarters of a lottery machine manufacturer, was completed in 2006 on Parcel 9 west of Waterplace Park, blocking views of Providence Place from downriver and generally stinking up the joint. The architect for GTECH actually plopped a sketch of the building onto a poster-sized copy of Richard Benjamin's lovely photograph. The montage looked ridiculous, even blasphemous. The architect added that the design's reflective glass would enable the building to "disappear." Its completion proved that notion fanciful, as anybody would expect. The

argument that a building won't be so bad because it will be virtually invisible hardly stands as a ringing endorsement of its architecture.

The original building proposed for Parcel 9, in 1998, had been the square version of a circular firing squad. As designed by New York modernist Hugh Hardy, each of its sides vied to out-uglify the others. I visited Mayor Cianci and asked him to call for it to be redesigned. He did so on NBC's *Truman Taylor Show*. A new, far better design was proposed and set forth by Christopher "Kip" McMahan of Robinson Green Beretta, in Providence. It was shelved after a top Providence law firm signed on as lead tenant, only to learn that its major client, a top national bank, was threatening to end its relationship with the law firm if the latter moved its offices out of a building owned by the bank. (Providence know-it-alls may enjoy filling in the scandalous blanks.)

The second and third modernist buildings in this phase are the two towers, seventeen and nineteen stories, of the Waterplace Luxury Condominiums on the eastern edge of Waterplace Park, completed in 2008. Some observers may find it baffling that these two buildings are considered by the public to be less appealing than the boxy coldness of GTECH. My wife, Victoria, provided the most plausible reason I have heard: reversal of expectations. People have internalized the expectation that where they work will necessarily be less attractive than where they live. Some critics have said that the towers appear to be constructed of materials liberated from the warehouses of the Providence Housing Authority. Maybe so, but they do not come near to challenging GTECH as exercises in frigidity, sterility and unneighborliness.

The fourth modernist building in this set is the new Blue Cross and Blue Shield of Rhode Island headquarters, whose completion in 2009 just beyond the northern edge of Waterplace Park blocks views of the State House from the Waterplace condo towers. Aside from a relatively pleasing curvature of its south-facing façade, it is a typical Miesian glass box. "Miesian" is the term of art for the flood of buildings (by architects known as "Mieslings") that arose along Manhattan's Park Avenue and, alas, elsewhere. This glass-box frenzy erupted after the Seagram Building, designed by Ludwig Mies van der Rohe, captured the already stunted imagination of America's newly empowered architectural establishment in 1958. In defense of those architects, it may be suggested that with a toolbox of rectangular glass windows set into a metallic grid, and an outright ban on ornament, there was little potential for creative differentiation in this branch of modernist style.

In response to the challenge posed by postmodernism, modernists shucked their rigid International Style principles and plunged into the sort

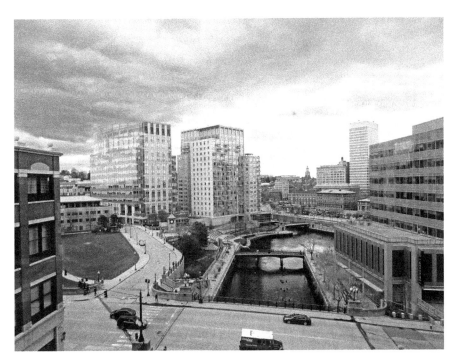

View from Wintergarden of Providence Place, looking east toward Waterplace Park. The photograph shows the four most recent Capital Center buildings, plus part of Gateway Center (1989). *Photo by author.*

of loopy-doopy somersaults, epitomized by Frank O. Gehry, the purpose of which seems to be to appear to defy the physical laws of nature. Providence has mostly managed to dodge bullets of that sort, perhaps because so little has been built since the "Great Recession." Modernists like to insist that architecture reflect its era, so it should not surprise anyone that so much of it blows up in our face.

WATERPLACE AND WATERFIRE

The encirclement of Waterplace Park by sterile modernism terribly degrades the experience of visiting the park, but objectivity requires admitting that in one sense even these buildings serve a useful purpose (aside from housing people and their activities). In surrounding the park with their bulk and height, they provide it with "walls" that transform the park into the sort of outdoor living room that best defines public space in a city. This creates the sense of enclosure that people crave in a civic square.

But even this service might have been inadequate to the needs of the park as a public space were it not for the extraordinarily attractive infrastructure designed by Bill Warner. The soft edges of the pond; the many ledges to sit on; the rusticated granite abutments salvaged from the old embankments; the cobblestone pavements; the old and new stone of the walls between the multiple levels of walkways; the gentle arcs of the classically inspired bridges flanked by arched openings to passageways carrying river walks beneath twin pedestrian spans; the stylish and often witty embellishment of bollards, lampposts, tree grates and railings lining the rivers, walkways and parks—all of these humanist features forge both a conscious and an

Opposite, top: The new river confluence today, after relocation, in 1990, about one hundred yards to the east of the old confluence underneath the John O. Pastore Building (1940). *Photo by author.*

Opposite, bottom: The Steeple Street Bridge (1994), one of a dozen new bridges replacing the "Widest Bridge in the World" (*Guinness Book of World Records*, 1988). *Photo by author.*

unconscious simpatico among the project, its buildings and the people who stroll amid its precincts.

These features serve as a saving grace at Waterplace Park, since they form an aesthetic bulwark against the glass-and-steel chill of the buildings that make up its outdoor room. The charm of the beauty that we walk by and see close up overwhelms the sterility of the buildings that occupy that western section of the waterfront. The "deep structure" of infrastructure softens the superstructure of Waterplace's architectural build-out. It ties the two sections of the riverfront together, to the advantage of both. All these elements that save the bacon of the modernist western riverfront serve to lift its more traditional southern stretches to a degree of beauty unknown in contemporary waterfront redevelopment around the world. Unlike the waterfront's stretch along the Woonasquatucket, its stretch along the Providence sits between parts of the city fully built up for many years. Heading south from the confluence, a row of historic institutional and academic buildings along the east embankment, including Market House, heads into Memorial Park, whose central feature is the World War I Monument by Paul Cret, relocated from Suicide Circle. The buildings that create the "room" of architecture around Memorial Park are Market House (1773); RISD's College Edifice (1936); Providence County Superior Court (1933), with its cupola and its gabled wings climbing up College Hill; and the commercial buildings down South Main Street, starting with the counting house with the baroque ogee gable that was originally designed as his own residence by Joseph Brown in 1774, and concluding with the domed Old Stone Bank (1898) and its neighbor, the Benoni-Cooke House (1828).

The panorama of these buildings amply displays the symphonic aspirations of classical brick. As an accomplishment of two centuries of creative architectural craft, the cityscape of College Hill is downright inspirational. The clunker at its southernmost terminus, Old Stone Square, is insufficiently obnoxious to destroy the view. The building is tremendously obnoxious, but not enough so to ruin the masterpiece of its setting.

It is a setting that looks across the river to downtown's Financial District, a crescendo of new and old towers that epitomizes what a city skyline should look like. This skyline has been remarkably stable, its last tower arising three decades ago, the Fleet Center—a postmodern building whose stepped gable is said to pay tribute to the Industrial Trust "Superman" Building (1928). Joined by the city's first high-rise, the Banigan Building (ten stories, completed in 1896), the Turk's Head Building (seventeen stories, 1913) and the Old Hospital Trust Building (eleven stories, 1919), the skyline's

modernist contributions are conservative, upstanding fellows that do their duty, contributing to the civic crescendo to the best of their ability, which reflects modern architecture at the utmost of its potential for achievement. They are the Textron Building (twenty-three stories, 1969) and the Hospital Trust Tower (thirty stories, 1974). The former windows are deeply recessed into a concrete-aggregate grid that rises with more solidity than the seemingly insubstantial glass and travertine of the latter, which looks as if a stiff breeze could push it over. Yet both contribute admirably to the skyline—far more so, however, as seen from College Hill or downriver than from Kennedy Plaza or Waterplace Park. From the latter angles, the skyline seems less to lift the heart than to toe the line of march. (Oddly enough, it is this less-appealing angle that seems to enchant most of the city's iconographers.)

Although the Providence River stretch of the waterfront runs through a mixed architectural environment of traditional and contemporary buildings, both the immediate vicinity and wider context are dominated by historical buildings. Thus the generally traditional elements of Warner's waterfront design reinforce rather than undermine the dominant theme of the city, of diversity amid unity. It is very important to keep in mind that innovation, whether old or new, is baked into an environment in which those artists called architects paint beauty onto a canvas that evolves over generations of work, often with one building replaced by an even more attractive building. In turn, that context strengthens the allure of the waterfront infrastructure and all of its ornamental paraphernalia. Turning the pages of the several compilations of new waterfronts around the world, published over several decades by the Waterfront Center in Washington, D.C., one learns to appreciate the unique beauty of Providence's new waterfront.

In fact, one very savvy urban theorist, James Howard Kunstler, seems to have been hoodwinked by Warner's design into committing an error in his book *Home from Nowhere*, published in 1996 to follow up on his bestselling *The Geography of Nowhere*. Of the new waterfront, he writes:

> *Finally, in 1993, the state of Rhode Island liberated the little Woonasquatucket River, which had been decked over by a six-lane highway in the 1950s. Its fine granite embankments with pedestrian paths, dating from the nineteenth century, remained intact.*[91]

Leaving aside the minor mistake of inflating the river decking into a "six-lane highway," Kunstler's description of embankments less than a decade old as "dating from the nineteenth century" demonstrates the beauty of the

River Relocation Project far beyond the abundant praise of mere awards and prizes, even from the White House, which has honored the waterfront.[92] The possibility exists that Kunstler, who coined the brilliant word *crudscape* to describe suburban strip development, was pulling his readers' legs by purposely misconstruing the age of the embankments. Perhaps, to be generous, a similar excuse may be made for River Relocation winning the Silver Medal in the 2003 Bruner Awards, which recognize civic cooperation in the creation and use of urban space. River Relocation involved the full range of public, private and institutional organizations working together over the span of a quarter century to relocate, revitalize and reuse an abandoned trio of downtown rivers. To piggyback a beautification project on top of a transportation-infrastructure project was an achievement of Promethean creativity that continues to revitalize the city and the state. This project got the Silver Medal. The Gold Medal went to a Los Angeles charter school in a vacant, inner-city mini-mall. Did its students invent a new form of penicillin? Who won the bronze? God?

During the final year of building the park, on my way to work from my apartment in Benefit Street or on postprandial excursions by foot with dinner guests—a sort of forced march of the captive audience led by Dr. Downtown (my journalistic nickname)—I would visit Waterplace to view the latest wrinkles in its construction. When it was completed I would venture down on a weekend evening and sequester myself just beyond the passageway under the pedestrian bridge east of the basin and listen to strollers emerging from under the span, all of whom would express astonishment. "This is not Providence, this is Paris," they'd say, or, "This is Venice." I heard it again and again.

To the magnificence of the waterfront may be attributed much of the popularity of WaterFire Providence. WaterFire is an art installation by Providence artist Barnaby Evans, the first of which was lit on New Year's Eve in 1994, the year that Waterplace Park was completed. Two years after its first lighting, WaterFire was relit for an international conference of sculptors. Since then, it has grown to a dozen or more events annually, spaced every two weeks or so from May to October, with an average attendance of over forty thousand per lighting. The events consist of up to one hundred braziers lined up mid-channel, their cedar and pine logs stoked by volunteers dressed in black plying black boats up and down the channels all evening long, from Waterplace Park to the (new) Crawford Street Bridge. Amplifiers hidden along the embankments play classical, operatic and traditional music from a range of cultures around the world. Food, art, music and ballroom dancing

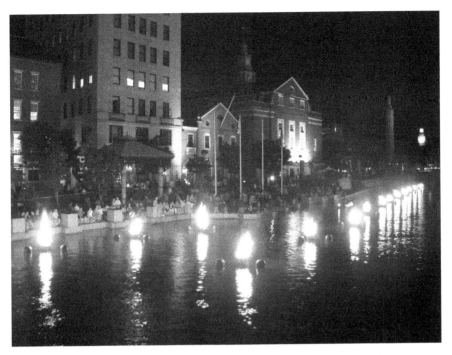

A segment of WaterFire, conceived and directed by Barnaby Evans, along Canal Walk. Shown here are, *from left to right*, Insurance Building (1929), Morris Plan Building (1926) and RISD Auditorium (1940). *Photo by author.*

are featured nearby. WaterFire has raised the global visibility of Providence beyond that of the waterfront itself, but its setting along such a beautiful, intimate waterfront is the key ingredient of WaterFire's success.

For years, I have told anyone who would listen that "I cover the waterfront." Few have attended as many WaterFires as this correspondent. The mixture of water and fire, music and serenity, people and buildings has no parallel. I often see Barnaby Evans there, walking up and down the embankments, putting out the "fires," so to speak, that inevitably arise in conducting a complicated event. I call him "Generalissimo." I would estimate that my own attendance at WaterFire averages upward of ten a year, or maybe two hundred since 1994. When I first met my wife, she googled me, and found an essay I wrote in the late 1990s called "Sex and WaterFire."

> *Many have noticed that WaterFire turns the Providence waterfront into an Italian piazza, where people sit and walk and talk and watch others sitting, walking, talking, and watching. Romance suffuses the evening along with the aromatic smoke. After most of the crowds have gone home, after the*

crush on the river walks subsides at midnight, there still remains a devoted throng of quiet lovers enthralled by each other and the fires—lost in each other's eyes or gazing together over the city skyline. These souls, for whom WaterFire is the cheapest date in the state, the stage for grand passion, or some delicious thing in between, reflect the work of art at its most profound intensity, not to mention its most intense profundity.[93]

So, yes, WaterFire may be an interesting metaphor for the various mixtures that stoke human combustion. But none of it would be imaginable without its sensual setting.

Few cities have the cozy rivers that WaterFire requires to achieve its greatest subtleties of aesthetic and symbolic resonance. Many cities have a wealth of carnivals, recurring festivals and other "programmed" events that bring hundreds and even thousands to their downtowns. New York, Boston, Chicago and San Francisco mix sizable populations and an abundance of tourist attractions to create a tourist mecca. Providence, whose population has stabilized after decades of decline, relies on its beauty to hook tourists and on WaterFire to reel them in. The event arose in the nick of time, because WaterFire counteracts the waterfront's modern architecture. It enforces congeniality on what might otherwise be the waterfront that shot itself in the foot.

THE DOWNCITY PLAN

E conomist Richard Florida's 2002 book *The Rise of the Creative Class* revealed, as if it required exposure (which in fact it actually did), that people want to live and work in places with character. Of Providence, he wrote:

> *Many members of the Creative Class also want to have a hand in actively shaping the quality of place of their communities. When I addressed a high-level downtown revitalization group in Providence, Rhode Island, in the fall of 2001, a thirty-something professional captured the essence of this when he said: "My friends and I came to Providence because it already has the authenticity that we like—its established neighborhoods, historic architecture and ethnic mix." He then implored the city leaders to make these qualities the basis of their revitalization efforts and to do so in ways that actively harness the energy of him and his peers.*[94]

Florida may well have been referring to Andrés Duany and Elizabeth Plater-Zyberk, whose firm, DPZ, worked with Providence native Arnold "Buff" Chace and his firm Cornish Associates to revitalize downtown. By the early 2000s, they had hosted brainstorming sessions in Providence called "charrettes" for a decade. Duany had helped to found the Congress for the New Urbanism in 1993. The CNU organizes a movement that has updated concepts that had lain fallow in America since before World War II, concepts that might as well be called "the old urbanism." The new communities built under the banner of the New Urbanism often require

long negotiation with local authorities, because suburban zoning laws across the nation typically bar new enclaves with narrow streets on short blocks with a variety of housing types within walking distance of shopping, such as corner groceries and small stores on the ground floors of residential structures or granny flats above garages in the rear.

Duany first worked with Buff Chace and his Cornish development team on Mashpee Commons, in the town of Mashpee on Cape Cod. Beginning in 1986, Chace sought to turn a typical suburban shopping plaza into a traditional town center. By the early 1990s, DPZ had joined the project, inviting Chace onto the board of the CNU. In 1991, Chace purchased several underused buildings in downtown Providence—he recalls first checking them out with his seven-year-old twins, his daughter saying, "Daddy, why don't you do something about it?"[95] He then sought DPZ's assistance in their redevelopment—a boon, as DPZ and the CNU had sought to broaden their base of mostly suburban greenfield development to include urban infill projects designed to revitalize city centers. After a series of charrettes beginning in 1992, DPZ and Cornish produced *The Downcity Plan*, followed in 1994 by the *Downcity Project Implementation Plan*.

"Downcity?" Glad you asked. Duany says he heard the term from Antoinette Downing, the preservationist leader who was still going strong when a real plan to save downtown was finally afoot. Back in the day, families often used the term to refer to an activity rather than to a place. To "go down city" was akin to "let's go shopping." Some troublemakers sandbagged the term as a working-class signifier, asserting that no one on fashionable College Hill ever used it. Duany nonetheless picked it up, supplied it with an initial cap, turned it into a proper noun and applied it to the city's old retail quarter between Dorrance, Weybosset, Empire and Fountain, which was the focus of his plan. The name was an effective rebranding of the shopping district, but eventually Mayor Cianci started misusing it as a synonym for downtown, a solecism that spread like kudzu. By 2004, following yet another charrette, even the final Downcity report itself uses Downcity and downtown interchangeably, often omitting the latter entirely. When others started to

Opposite, top: Artist's rendering of Westminster Street from the Downcity Plan. Shown are, *from left to right*, Wilkinson Building (1900), O'Gorman (1925), Burgess (1870) and Alice (1898). Randall Imai, *author's archives*.

Opposite, bottom: Current view of the same block of Westminster Street. At left is a glimpse of Hannah Greene Estate Building (1879) and Old Journal Building (1906). *Photo by author, circa 2014*.

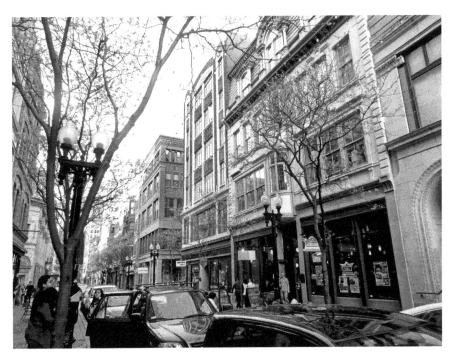

upper-case the *c* in the middle without even adding a space—DownCity—it was the last straw for many who had long defended the word's use.

Nomenclatural niceties notwithstanding, Duany summarized his plan in a 1992 report called "Downcity Providence: Master Plan for a Special Time," which he recapitulated live for an audience at the Lederer Theater, home of Trinity Rep. In his patented speaking style of sarcastic good humor, he deplored the big projects such as the Rhode Island Convention Center as "dinosaurs" that must be countered with many "chipmunks"—small projects scattered around downtown. And he pointed out that while "no single building downtown is of the highest quality,"

> *there are streets worthy of London and Boston. There is wonderful detail and innovative, vigorous architecture.... The only thing you could have done better would have been to do nothing at all.* [A] *1939 aerial photograph of Providence is heart-breaking. The urban fabric it shows is exceptionally continuous. Its geometries are elegant. The streets get narrower and wider in subtle, picturesque ways.*[96]

He notes that Westminster Street especially boasts a perfect ratio of building height to street width: the low- and mid-rise commercial buildings along its narrow pavement provide excellent "enclosure," creating, with its delicate canopy of trees, a human-scaled corridor of the highest order. This was plain to see even before the removal of faux façades kicked into high gear on Westminster. Downtown's quirky street pattern raised the syncopation of its grid to an art form. Streets getting "narrower and wider in subtle, picturesque ways" clearly refers to Weybosset Street. Its curvature recalls the sensuality of a woman of pulchritude lying on her side—even after Weybosset's well-turned feet were sliced off at the ankles by the Downtown Providence 1970 plan.

Months prior to my interlude at the window of the Turk's Head Club with *Journal* publisher Metcalf, while in town for my first interview with the paper, I went to fetch a shirt at a laundry in the Arcade near my hotel, the Biltmore. I entered from Westminster Street. Afterward, I exited the Arcade at the other end, onto Weybosset Street, and happened to turn my head left. I saw the curved row of old commercial buildings bending toward Weybosset's meeting with Westminster at the Providence River. I was struck by its beauty. I said to myself, "I have got to live in Providence." This was half a decade before I began to conceive of myself as an architecture critic.

Later wrinkles in the Downcity Plan included a historic district overlay for the downtown master plan, then the plan for a downtown academic

quadrangle for Johnson and Wales University and finally an even more ambitious downtown plan in 2004, an effort to connect the city center to neighborhoods beyond Route 95. The first residential rehabilitation, the Smith Building, was completed in 1999, the same year Providence Place mall opened. Before the next decade was out, five other downtown building rehabs housed two hundred new units and shops on the ground floors. Other building owners followed suit. Eventually, although little of the more ambitious 2004 plan has been accomplished, many earlier proposals had been, and they bore considerable fruit. Downtown's popularity had become the economic basis for several proposals to build new residential towers in Capital Center, two of which were built, including the Westin addition, with hotel rooms and condominiums, and the Waterplace Luxury Condo twins. A proposal in late 2016 to build three residential towers of thirty-four, forty-four and fifty-five floors on the vacant Route 195 land raised hopes that there might indeed be a big market for living in or near downtown—predictably, however, they were way out of scale, way out of place and way out of character for Providence.

Chace has continued rehabbing buildings, mainly for lofts, and recently proposed yet another set of downtown rehabs on Clemence Street, an alley running from Westminster to Weybosset. He has also proposed the construction of a new residential building. The number of shops, restaurants and arts venues has continued to grow. Schools keep moving facilities into downtown, stuffing Joe Paolino's "jelly doughnut" to the max. To compare today's downtown with that of 1984, when I arrived, is to define success in the art and science of urban revitalization.

Between 1984 and 1999, I lived in three consecutive apartments on Benefit Street, 283, 395 and 372. Early on, just for kicks, I used to drive downtown at night, crossing the river, creeping down Westminster Mall, whose pedestrian sidewalks had been rolled up for the night. I would drive slowly, looking for "action"—something to gawk at, really, for I was a dweeb. Block after block, nothing but dreary men lurking in dreary doorways. Then, pay dirt: I would reach Lupo's Heartbreak Hotel, a live-music club in the old Conrad Building just before Westminster T's at Empire. I would slow down (never any cars behind to rush me) and peer through Lupo's open doors at the writhing, pulsating scene within. I'd never go in myself, at least not until the club moved next door to me after I moved into the Smith Building.

Lupo's had been forced to relocate from the Conrad by the gentrification forces unleashed by Buff Chace. Rich Lupo moved his establishment, which included a smaller nightclub, just as noisy, called the Met Café, into the

Peerless Building next to the Smith Building, where I was among the first tenants. I was writing about development issues for the *Journal*. Chace was my landlord; his projects were often the subject of my weekly architecture column. Chace had bought the Peerless to rehab as lofts, and a legal battle erupted between him and Lupo. Young metal-heads supporting Lupo's and the Met accused loft dwellers like me of wanting downtown to resemble Barrington (a quiet, wealthy, dry town southeast of Providence known as Borrington). Not so! Bad, bad, bad, bad vibrations! Eventually, Chace helped Lupo move his club yet again, into the Strand Theater a block away on Washington Street. (The Strand eventually went condo, too, in parts of the building not used by Lupo's; condo buyers enjoyed the free live music, I trust.) The Peerless, which had been a department store, opened in 2004 with ninety-seven units around a seven-story atrium with a roof garden, a sort of urban Peyton Place where tenants, peering out into the atrium, could keep an eye on who was being entertained in who's loft. Ah! City life!

This sort of churning captures the heart of a living city, indeed of life itself, the life well lived, you might say. Stasis is the status of a city in decline. Like every other active city, citizens confront what they perceive as parking and traffic problems. In fact, those who live or work (or both) in downtown Providence have relatively little to complain about in terms of where to park or how many red lights they must wait on before penetrating an intersection. Providence is at equilibrium, developmentally, which means that its comforts and discomforts are in relative balance. Unlike stasis, equilibrium implies pressure from both the forces that propel development and those that retard it. That is, in stasis there is nothing going on. In equilibrium it may still be very difficult to line up the permits and secure the finances necessary to move a project forward in Providence, but the conditions that provide incentives to do so push developers and entrepreneurs to persevere.

The first project under the Downcity Plan in the early 2000s required, of all things, demolition. Four buildings were torn down at the intersection of Westminster and Mathewson Streets, kitty-corner from the Tilden-Thurber Building. Stanley Weiss's office on its second floor today overlooks

Opposite, top: Shown here are four buildings on Westminster Street prior to their demolition in 1994 to create Grace Square, a public/private project proposed by the Downcity Plan. *Courtesy of Providence City Archives.*

Opposite, bottom: A view through Grace Square from Hotel Providence, in the Lederer Building (1897). Shown are the Lapham Building (1904), the Tilden-Thurber Building (1895) and Grace Episcopal Church (1846, Richard Upjohn, architect). *Photo by author.*

the project, now known as Grace Square. Its full name, Grace Square at Robert E. Freeman Memorial Park, honors the late Rob Freeman, a former director of the Providence Foundation. This group, an offshoot of the chamber of commerce, was the major instigator of the Capital Center and river relocation projects. Its board and its succession of directors, Romolo ("Ron") Marsella, Kenneth Orenstein, Rob Freeman and (to this day) Daniel Baudouin, have been there for downtown, first and last, throughout its revitalization.

Overlooking Freeman Park, Weiss had one of the best views in town once the four buildings were gone. They were dilapidated. The only attractive one of the four had sustained heavy damage by fire but remained unrepaired. The corner looked like Beirut, the Aleppo of its day. No doubt the rents paid by its two tenants, a pizza joint and a private mailbox emporium, reflected its "sense of place." The tenants were understandably reluctant to seek new digs, even with city assistance. Around the same time, Weiss evicted the Safari Lounge, a resolutely downscale bar, from another of his buildings nearby. The club sued, but lost. I thought the eviction showed poor judgment. In a January 30, 2003 column, "In defense of gentrification," with the pre–revitalized downtown in mind, I wrote:

> *One can no more expect landlords to neglect buildings in perpetuity as welfare programs for struggling artists or buck-a-beer joints than one can expect those same tenants to embrace building improvements that will raise their rents. They whistle past the graveyard as the gathering clouds of renaissance darken, praying that their landlord fixes up all his other buildings before getting around to theirs.*
>
> *There is a certain vitality to dark streets empty most nights until drunks stumble in a rowdy mass from clubs at 1 a.m. But it will be a sad day if City Hall ever determines that the preservation of this vitality should be the urban policy of Providence.*[97]

Thankfully, Providence has not sought to preserve its decline. It has even followed the New Urbanists' advice, replacing a series of suburbanized one-way streets with two-way streets. Andrés Duany still reminds audiences that a historic district is nothing but a neighborhood built before urban renewal and modern zoning. The Downcity Plan has preserved the beautiful buildings of downtown but not the seedy lifestyle that prevailed after the dark clouds of urban renewal sent urbanity fleeing from downtown. Still, an old friend of mine visiting from our native Washington, D.C., deplored the

disappearance from Providence's downtown of its ubiquitous dives where you could get a drink for breakfast, and I could see his point. His father and mine were both city planners. They would have realized how difficult it is to find and then sustain a balance among the many competing aspects of urban life. This Providence has done.

The downtown of 2016 is not much different in appearance than the downtown of 1984, when I arrived. What is different is the little things. It is cleaner. There are more people. The faux façades are gone. There are more trees. Many streets are lined with period lampposts. It is amazing how much of a difference such lampposts, purposely designed to be beautiful, can make, and for a relative pittance of city funds. Hanging from the lampposts are flower baskets, installed in warmer months by the Providence Downtown Improvement District's "clean-and-safe" teams, who also plant flower beds at strategic intersections and are, in general, specialists in "City Beautiful." They are also ambassadors on the street for visitors. The sum of all these little things is one big thing: there is more vitality.

The only constant is change—and it is vital that change be for the good, as judged by people, not experts.

Epilogue

PROVIDENCE LOST, PROVIDENCE REGAINED

The purpose of the D-1 District is to encourage and direct development in the downtown to ensure that: new development is compatible with the existing historic building fabric and the historic character of downtown; historic structures are preserved and design alterations to existing buildings are in keeping with historic character.[98]

This passage from Chapter 513, Article 6, Section 600 of the Providence Zoning Code, passed in 2014, is the law that protects historic character in downtown. It carries forward language similar to that of local zoning codes reaching back many years. Of course, wording such as "compatible," "in keeping with" and even "historic character" is subject to interpretation. The existence of an unsympathetic building or two in a historic district can, in theory, be used to justify another unsympathetic building. Still, in the district encompassed by the Downcity Plan, almost no new construction, additions or alterations out of character with downtown's historic appearance—as the average person would interpret the words—have occurred since the 1980s. That is in step with the unofficial moratorium on building demolitions that prevailed, with few exceptions, between 1979 and 2005, a period that encompassed at least three bona fide building booms.

Thus it might seem that Winston Churchill's "We shape our buildings; thereafter they shape us"—the quotation at the beginning of this book—has in some inchoate manner guided development in Providence. An enactment of law speaks with force, the more so when it has been honored not in the breach, as have so many, but by intelligent observance over decades.

The city carried out very little of the Downtown Providence 1970 plan. In 1960, when that plan was announced, laws defending downtown's historic character had not been enacted. And yet it was observed by the city as a sort of intuitive municipal credo. Only thereafter did modern architecture's rise call for a defense of historic character in the language of the law.

Although welcome signs such as "Beautiful Rhode Island" and "Historic Providence" still stand alongside the major highways into the city and state, the Ocean State has recently struggled to update its "brand" to replace earlier logos and mottos emphasizing the state's beauty. The need for such campaigns is debatable. Visitors travel to Rhode Island on vacation, and organizations schedule meetings in Providence and Newport because the state's beauty and historical character are widely known commodities. That fact has little to do with branding campaigns. Still, the campaigns do suggest that officials have long understood that beauty is vital to the state's health and well-being.

Now, in its effort to develop land near downtown Providence vacated by the relocation of Route 195, the state seems to have suffered a massive brain fart, causing it to overlook the importance of beauty. Already, although progress in redeveloping the I-195 land has been slow, Johnson and Wales has just opened the district's first building, a new modernist facility to house its engineering and design department. Other plans for new "high-tech" buildings in this corridor are in early stages of design development, with three newly proposed towers of high-tech design in prospect. An "innovative" engineering school facility at Brown University is also under construction on College Hill. All of this promises to undermine Rhode Island's brand—if not the official brand, whatever that is at this stage, then certainly its longstanding natural brand promoting the state's beauty and historic character.

The current governor, Gina Raimondo, should phone all the developers involved to urge them to revise their plans in ways that will strengthen rather than weaken the state's brand, its beauty—a major competitive advantage it has over other states. Under Section 603 of the zoning code, the I-195 Redevelopment District Commission can offer development incentives. "The purpose of these incentives," the code states, "is to encourage development that will be compatible with the character of Downtown and carry out the goals of the comprehensive plan."[99] The governor can advise developers of the existence of such incentives. She can also remind them of the protections for historical character in Section 513.6.600 of the zoning code and note

that the state prefers initiatives that strengthen rather than undermine the competitive advantage embodied in such laws.

In the lax design environment that has shaped development in Providence in recent years, officials may be understandably reluctant to even appear to "mandate" design. The bill that in 2011 created the I-195 redevelopment district and the commission managing its build-out took as its model the Capital Center, which was "reticent about mandates to architectural expression." With the conflicting results of that reticence in mind, the I-195 commission should not hesitate to express a preference for buildings that strengthen rather than weaken the state's brand.

After he took office in 2014, Boston mayor Marty Walsh gathered that city's developers to urge them to propose "bolder" new buildings. His advice may have been dodgy, too inclined to abet the further erosion of historic character in the Hub, but he was not "mandating" style. He was using his bully pulpit to encourage his idea of better development in Boston.

Rhode Island leaders such as Governor Raimondo and Providence mayor Jorge Elorza should do likewise. That's their job. They may find that developers are more eager to have state and local government on their side than they are to stamp their proposed developments with this or that statement of aesthetic design.

The Rhode Island School of Design has offered its services to assist the I-195 commissioners in producing a successful design template for the 195 land. To shape its guidance, RISD should touch base with its origins. The school was formed in 1877 to soften and sweeten the local manufacturing process. As set forth in its original bylaws, its first goal was to foster "[t]he instruction of artisans in drawing, painting, modeling, and designing, that they may successfully apply the principles of Art to the requirements of trade and manufacture."[100]

At a time when Rhode Island was competing with the world in a range of light and heavy industries, RISD may have been more instrumental in the state's prosperity than it realizes today. For a century, the state's private sector accomplished manufacturing miracles in mills of brick that housed the latest technological advances. It was only toward the middle of the twentieth century, as the high cost of doing business in Rhode Island sent more and more plants South, that Rhode Island industrial leaders—and RISD—embraced a very bad idea.

The bad idea is that the machine age requires a machine architecture. Reformers of architecture a century ago had toyed with basing building

design on the principles of the Arts and Crafts movement. They did an about-face and embraced the "form follows function" credo. The meaning of the term was vague to begin with, and it was botched in practice. The world got architecture conceived as a metaphor for the machine but without the efficiency promised by machinery, let alone a form that might have made the absence of efficiency more bearable.

This train of thought originally came to me from Nikos Salingaros, a mathematician and architectural theorist based at the University of Texas and the author of *Anti-Architecture and Deconstruction: The Triumph of Nihilism* and other books. Working with the architect and design theorist Christopher Alexander and others, Salingaros has also done research linking most people's preference for traditional architecture to neurological patterns in the human brain. The thinking, briefly, is that the widespread allure of ornament and detail in architecture comes from the prehistoric defense mechanisms of humans. For primitive man, the more information, the better. To see, and to subconsciously recognize, the shadow of the head of a lion against a rock near a tree was a matter of life or death. Today, survival mechanisms have evolved considerably, but the love of ornament stands in for cues of visual perception on the full range of scales that long ago served to sustain the individual and, ultimately, the species.

Many others are researching the relationship between the human brain and the widespread skepticism toward experimental architecture and the preference for traditional buildings and public spaces.

In a 2006 essay on the relationship between music and architecture, "La Voilon d'Ingres" (The Violin of Ingres), Steven Semes, a professor of architecture at Notre Dame and author of *The Future of the Past* (2009), writes:

> *Scientists are interested in pattern and proportion once again. Neuroscience is beginning to reveal ways in which pattern recognition is built into the complex and subtle mechanisms of the brain. From this viewpoint, classical architecture and music are analogous, not just because they reflect one another but because they reflect us and the way our minds work. It should come as no surprise, then, that both music and architecture today are engaged in retrieving their respective traditional languages: melody, tonality, proportion, ornament, the classical orders—the whole lot.*[101]

Governors and mayors may well be disinclined to muck around in neurophysiology, and who can blame them? But there are other reasons why developers should prefer traditional to modern architecture.

On the agenda of most architects, and governors, today is climate change, with developers and architects seeking to reduce their projects' carbon footprints. Buildings account for 39 percent of annual carbon dioxide emissions in the United States. Weaned on cheap oil before its risky environmental impact became evident and its low cost evaporated, the architecture of the Thermostat Age cannot do much to soften its negative impact on climate. Replacing an old building with a new one piles up an insurmountable carbon deficit even before adding in the high cost of operating complex systems in new buildings, the inefficiency of driving ever farther to work in petroleum-based vehicles or the new buildings' short shelf life—planned obsolescence, the half-sister of demolition by neglect—often less than a half or a third the life of a traditional building, requiring multiple replacements over time.

Buildings erected before the Thermostat Age are intrinsically more sustainable than are modernist buildings. Before oil and electricity, buildings used many natural strategies to address the challenges of climate. Depending on region, they had thick walls or thin walls to retain or disperse heat or cold; high ceilings or low ones for the same purpose; roofs designed to shed rain and snow; porches, courtyards, awnings, shades, shutters and windows that open and close to regulate light and shade; ceiling fans for cooling in summer; fireplaces for heat in winter; site placement to harness the seasonal angle of the sun or the breeze; landscaping to enable trees to provide shade and oxygen as well as beauty; and so many more features, including natural materials locally sourced. Builders enlisted the help of Mother Nature to regulate the environment within houses and other buildings.

All of those climate-friendly features are still in use today wherever older houses and buildings survive, and are available for use wherever new traditional buildings are sold. These natural efficiencies do not require us to go "back to the future." They can make our comforts better, more durable and more affordable.

The manufacture of architecture will change as beauty resumes its role as a factor of production. Man-made materials can often bridge the gap between current design practices and the design practices of the future, which will see natural materials become more affordable. Advances in fabrication will be especially useful to marketing as high technology continues to reduce the cost and increase the capacity of machines and computers to create ornament and other architectural detail from matter such as wood, stone, precast concrete or plastic.

So, governors are free to ask developers to pitch in against climate change by proposing projects that feature natural strategies to reduce

carbon emissions. Most of those strategies will cause buildings to look more traditional—more natural—and this will make even large development projects easier for the public to swallow.

5 a.m. I'm falling apart. My boyfriend is sleeping with a bronzed giantess. My mother is sleeping with a Portuguese. Jeremy is sleeping with a horrible trollop. Prince Charles is sleeping with Camilla Parker-Bowles. Do not know what to believe in or hold on to any more.
—Helen Fielding, *Bridget Jones's Diary (1996)*[102]

Architect Friedrich St. Florian has been mentioned often in these pages. As dean emeritus of architecture at RISD, designer of Providence Place and the National World War II Memorial, and signer of "The Napkin," he was frequently a presence in my writing on architecture for the *Providence Journal*. We had lunch often, and once he told me that he believed traditional architecture's revival would be fostered by the individual's need for an anchor in an unstable world. Traditional buildings serve as a psychological handhold for people made anxious by the swift pace of change in every human endeavor and society at large. Modernist buildings, where it is sometimes difficult even to find the front door, do not promote stability in a turbulent world. That's the last thing they want to do.

Architecture that has evolved over time as best practices improve the building process in ways handed down generation by generation trumps an experimental architecture based on a hybrid of ideologies that exalt innovation over experience. For more than half a century, architecture has become the only industry—nay, the only field of human endeavor, from art to zoology—that officially rejects precedent as the primary strategy for moving from past practice to future practice. It is not logical. It has not worked. And few modernist architects practice it, whatever they may say. Their ambivalence makes their architecture more complex, costlier and more difficult to enjoy.

A third grader need not be especially precocious to perceive the practical and aesthetic superiority of traditional architecture. All of us are immersed in architecture from early childhood, and our intuitive sense of what works in architecture rests on so much more experience than our judgment of other arts we experience only intermittently.

All research and almost all anecdotal evidence shows that a large majority of people prefer traditional to modern architecture. Architects' intuitive sensibilities are purged in schools of architecture and replaced by supposedly

more sophisticated attitudes. Modern architects treat public disdain for their work as a feather in their cap. Proof of that disdain may be found in the purchase or rental of houses. The market for housing is overwhelmingly traditional because most people choose their houses themselves. Modernist houses are built or bought mostly by wealthy professionals or trustafarians who seek to establish their "street cred" as "edgy"—artist wannabes. Almost all large commissions for new buildings are modernist because such decisions are made by committee, almost always led by the same people who commission modernist homes, and for the same reasons. Yet modernist architects themselves frequently live in traditional houses: they are unwilling to inflict on themselves what they inflict on others.

A mayor or governor who wants to reform this situation will get pushback from design professionals and academics but support from the public. That is even more true in Rhode Island, where citizens are accustomed to a level of beauty in their built environment that is rare in many other states. Providence and Newport are only two of many among Rhode Island's thirty-nine cities and towns whose historic centers and neighborhoods retain a large portion of traditional fabric. Cultural tourists visit Newport, Westerly and Providence more than Johnson, Warwick and North Providence for the same reasons global tourists visit not Houston, Brasilia and La Defense (outside Paris) but old Paris, old Rome and old London—what's left of it. It should be noted that much remains of London's vast expanse of historic fabric. Like Paris, Rome and Providence, the extent of beauty remaining in London can survive decades of assault by architectural ideologues who, in their arrogance, believe that only their sterile, production-for-use tastes are appropriate or valid for the twenty-first century.

The civic leaders of Providence and Rhode Island are at a crossroads— they can choose to foster such arrogance, at continued great cost to the character of their city and state, or turn the practice of design here in a more salutary, salubrious and sustainable direction. In Providence, they can simply choose to obey the law and encourage developers to do likewise. The relatively minor cost of this shift will be incurred by architecture firms hired for projects now on the boards. They would have to redo their designs. Some may need to diversify their practices by hiring architects who know how to provide what the public likes rather than what the design establishment demands. Developers may regret the upfront cost of such a shift, but they will save money over the long run as design review and permitting is simplified, and as the public learns to understand that new buildings need no longer

be a cause for anxiety. People will welcome new projects as offering positive change, as was the norm just half a century ago.

A shift toward traditional architecture in Rhode Island would be not only cheap but easy. The widely recognized ills of the built environment may be healed without having to address complexities that challenge reformers hoping to solve the problems of poverty, crime, injustice, family breakdown, disease, economic stagnation, ignorance and the rest, not to mention war and peace. People in authority, such as the governor, would need to do little beyond deciding that such a change should take place. Returning beauty to the forefront of design would place Rhode Island at the head of a bottom-up movement already afoot in America, leading in a direction huge majorities would like to go. And the emergence of beauty and civility in public buildings and spaces might even create a social atmosphere conducive to greater participation and cooperation in the public policy debates that set our course as a democracy.

This book addresses change as the only constant and tracks its progress in Providence. But it challenges ideas that privilege only Big Change, leaving small, manageable change in the lurch. This book challenges those failed ideas everywhere they prevail. Providence's success in revitalizing itself proves that—not withstanding Daniel Burnham's "Make no small plans!"—it is not the size of the plan but its beauty that counts. Beauty is a free gift to every level of society, a sort of art museum with no charge wherever a street of lovely buildings exists, and perhaps most sincerely appreciated by those least fortunate. The future is not about trying to copy the past or keep up with the Jetsons. Tradition is not just about the past but about the steps we take to progress into the future—the traditions of tomorrow. Moving society into the future isn't about reconceptualizing everything we know until we overtake our capacity to understand it. That is where we stand today in many fields, but most visibly, most egregiously, in the field of architecture. The future is part of a millennial continuum held hostage by modern architecture in a mere sliver of time. That can change, too.

Providence and Rhode Island are uniquely positioned to raise the status of beauty and tradition in architecture, just as many people are striving to do in the field of cuisine. Architecture and food are flip sides of the same coin:

EPILOGUE

What would our dinner tables look like if culinary culture were half as hung up on the rigid rulebook of progressive aesthetics as architectural culture is? Would we be allowed to eat bread or rice, or would they be forbidden due to their unspeakable antiquity? Would regional fare using locally harvested ingredients be celebrated as part of a rich, diverse, interconnected world of unique traditions, or would it be condemned as provincial nostalgia?[103]

The passage is from an essay by Nathaniel Robert Walker, a professor of architectural history at the College of Charleston. In "From the Ground Up: How Architects Can Learn from the Organic and Local Food Movements," he notes that by the 1950s processed food had become America's dominant cuisine, much as processed architecture is dominant in America (and elsewhere) today. Change for the better in food came because people at every point in the food chain got fed up, so to speak, with the status quo. From the bottom up, the slow-food movement has challenged the agricultural establishment and its downstream confederates, Big Food

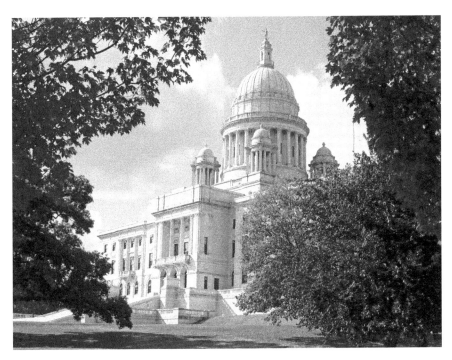

The Rhode Island State House (1900), designed by McKim, Mead and White, as viewed from Providence Station (1986). *Photo by author, circa 2015.*

and Big Grocery, with some success. Big Architecture can be reformed, too. It may not be as delicious, but it can be more fun.

Reform of our built environment will also be a bottom-up process. It can be a movement. It can start with activists clamoring for change at design-review meetings. It can start with civil disobedience, with a sit-down protest in front of a bulldozer on the Brown campus. It can start with a rock propelled at night through the plate glass of a glass box. (Who inserted that line?!) It can start in a state with the DNA of revolt in its history. It can start with a governor who wants to carve out a place in that history. It can start in Rhode Island.

NOTES

Introduction

1. Scruton, *Classical Vernacular*, 38–39.

Prologue

2. *Guinness Book of World Records*, 257.

Chapter 1

3. *Civic and Architectural Development of Providence*, 97.
4. Ibid., 97.
5. Downing. *Early Homes of Rhode Island*, 327.
6. Joyce, *Chamber Music*.
7. Sanderson and Woodward, *Providence*, 219.
8. Lovecraft, "The Case of Charles Dexter Ward," in *Uncollected Prose*.

CHAPTER 2

9. Sanderson and Woodward, *Providence*, 214.
10. Cady, *Civic and Architectural Development of Providence*, 126.
11. Ibid., 155.
12. *Federal Office Building, Providence*, 336.
13. Castellucci, "Conversation with…Architectural Advocate Derek Bradford."

CHAPTER 3

14. Joni Mitchell, "Big Yellow Taxi," Siquibomb Publishing Company/ jonimitchell.com, 1968.
15. Woodward, *Downtown Providence*, 61.
16. Hitchcock, *Rhode Island Architecture*, 46.

CHAPTER 4

17. Rhode Island Historical Preservation and Heritage Commission, May 9, 2012, 5.
18. Achorn, *Fifty-nine in '84*, 91.

CHAPTER 5

19. Woodward, *Downtown Providence*, 50.
20. Brussat, "Full Facial for the Fourth Howard."

CHAPTER 6

21. "Downtown Providence Historic District," 17.
22. Woodward, *Downtown Providence*, 54.
23. Fleming, Honour and Pevsner, 51–52.

CHAPTER 7

24. Cady, *Civic and Architectural Development*, 99.
25. Woodward, *Downtown Providence*.
26. Downing, *Early Homes*, 438–39.
27. Historic American Buildings Survey.
28. Rhode Island Heritage Hall of Fame.
29. Woodward, *Downtown Providence*, 56.
30. The facts about earlier arcades in this paragraph were assembled via Internet citations of the name of each arcade. The author recalls reading of an even earlier arcade than those in New York and Philadelphia in a small New England town but cannot today locate any mention of it, let alone verify its dates of construction or demolition.
31. Jordy and Monkhouse, *Buildings on Paper*, 191–92.

CHAPTER 8

32. Brussat, "Providence's 10 Best Lost Buildings."
33. Woodward, *Downtown Providence*, 67.
34. Curran, *Thomas Alexander Tefft*.

CHAPTER 9

35. Brussat, "Wanted: A New Civic Role for the Old Downtown."

CHAPTER 12

36. Cady, *Civic and Architectural Development of Providence*, 115.
37. Leazes and Motte, *Providence*, 31.
38. Jordy and Monkhouse, *Buildings on Paper*, 159.
39. Ibid., 160.
40. Ibid.
41. Ibid.

42. "Cove Lands," 8.
43. Holleran, "Filling the Providence Cove," 68–69.
44. "Cove Lands," 8.
45. Holleran, "Filling the Providence Cove," 72.
46. Ibid., 82.
47. Ibid.
48. "Downtown Providence Historic District," 13.
49. Holleran, "Filling the Providence Cove," 85.

Chapter 13

50. Wilson, *Weybosset Bridge*, xi.
51. Ibid., 13.
52. Dorr, *Planting and Growth*, 56.
53. Brussat, "Settlement on the Moshassuck."
54. Dorr, *Planting and Growth*, 99.

Chapter 14

55. Lovecraft, *Uncollected Prose and Poetry*, 42.
56. Evans, "Horror and the Uses of Tradition."

Chapter 15

57. *Expressway System for Metropolitan Providence*, 19.
58. Hammerschlag, *Downtown Providence 1970*, vii.
59. Leazes and Motte, *Providence*, 56–57.
60. Hammerschlag, *Downtown Providence 1970*, x.
61. Ibid., 196.
62. Ibid., 197.
63. Wolfe, *From Bauhaus to Our House*, 50.
64. Hammerschlag, *Downtown Providence 1970*, 174.
65. Woodward, *Downtown Providence* survey, 62–63.

66. Sanderson and Woodward, *Providence*, 239.
67. Leazes and Motte, *Renaissance City*. 59.

CHAPTER 16

68. Providence City Plan Commission, *College Hill*, 101.
69. Ibid., 195.
70. Ibid., 219.
71. Klemesrude, "Her Mission Is Preserving Providence."
72. Providence City Plan Commission, *College Hill*, ix.
73. To assist readers interested in following this critique alongside the study, page numbers of cited passages describing the study's survey techniques have been included in the text rather than in these endnotes.
74. Lovecraft, *Uncollected Prose and Poetry*, 43.

CHAPTER 17

75. Morgan, [story describing downtown Providence forty years ago].
76. Wolfe, *Bauhaus to Our House*, 5.
77. Ibid., 6.
78. Ibid., 7.
79. Howes, *Interface*, 10.

CHAPTER 18

80. Leazes and Motte, *Renaissance City*, 101.
81. *Capital Center Project*, 1987, 3.
82. Leazes and Motte, *Renaissance City*, 93.
83. Ibid., 114.
84. Parker, "Architect William Warner Dies."
85. Leazes and Motte, *Renaissance City*, 115.
86. Ibid., 109.
87. Ibid., 122.

CHAPTER 19

88. Chiappinelli and Rosenberg, "Opposition to Old Stone Bank Project Is Building."
89. Carr, Lynch Associates and Melvin F. Levine and Associates, *Providence Development Strategy*, 88.

CHAPTER 20

90. Brussat, "Review of Design Review."

CHAPTER 21

91. Kunstler, *Geography of Nowhere*, 159.
92. Rhode Island Heritage Hall of Fame.
93. David Brussat, "Sex and WaterFire," WaterFire website, http://waterfire.org/about/a-collection-of-essays/sex-and-waterfire-david-brussat.

CHAPTER 22

94. Florida, *Rise of the Creative Class*, 232.
95. Chace, *Providence Portrait Project*, 15.
96. Castellucci, [Article about Andres Duany and Downcity Plan].
97. Brussat, "In Defense of Gentrification."

EPILOGUE

98. *City of Providence Zoning Ordinance*, Chapter 2014-39, No. 513, adopted November 24, 2014 (Providence: Providence City Council, 2014). Article 6, Section 600, Downtown District, Purpose Statements, 49, https://www.providenceri.com/efile/5782.

99. Ibid., 51.

100. Rhode Island School of Design, http://www.risd.edu/About/History_
Mission_Governance/Mission.

101. Semes, "Le Violon d'Ingres."

102. Fielding, *Bridget Jones's Diary*, 181.

103. Walker, "Architecture and Food."

SELECTED BIBLIOGRAPHY

Achorn, Edward. *Fifty-Nine in '84: Old Hoss Radbourn, Barehanded Baseball and the Greatest Season a Pitcher Ever Had*. New York: Harper-Collins Publishers, 2010.

Alexander, Christopher. *A Pattern Language: Towns, Buildings, Construction*. Vol. 2 of 3. New York: Oxford University Press, 1977.

Beckwith, Henry L.P., Jr. *Lovecraft's Providence & Adjacent Parts*. 2nd ed. West Kingston, RI: Donald M. Grant, 1990.

The Blue Book for Providence and Nearby Cities and Towns. Springfield Gardens, NY: Blue Books Company, 1936.

Brett, Roger. *Temples of Illusion: The Golden Days of Theaters in an American City*. East Providence, RI: Brett Theatrical, 1976.

Burnham, Irene, Linda Coleman and Jay Coughtry. *Creative Survival: The Providence Black Community in the 19th Century*. Providence: Rhode Island Black Heritage Society, 1980.

Byrnes, Garrett D., and Charles H. Spilman. *Providence Journal: 150 Years*. Providence, RI: Providence Journal, 1980.

Cady, John Hutchins. *The Civic and Architectural Development of Providence, 1636–1950*. Providence, RI: Akerman Standart Press/The Book Shop, 1957.

———. *Highroads and Byroads of Providence*. Providence, RI: Akerman-Standard Press, 1948.

Campbell, Paul, John Glancy and George Pearson. *Providence Police Department*. Images of America. Charleston, SC: Arcadia Publishing, 2014.

Caro, Robert A. *The Power Broker: Robert Moses and the Fall of New York*. New York: Alfred A. Knopf, 1974.

SELECTED BIBLIOGRAPHY

Chace, Buff. *The Providence Portrait Project*. Jamaica Plain, MA: Three Bean Press, 2012.

Ching, Francis D.K. *A Visual Dictionary of Architecture*. 2nd ed. New York: Van Nostrand Reinhold, 1997.

Clapp, Roger T., *The Hope Club: A Centennial History, 1875–1975*. Providence, RI: Hope Club, 1975.

Conley, Patrick T. *An Album of Rhode Island History, 1636–1986*. Norfolk, VA: Donning Company, 1986.

———. *Democracy in Decline: Rhode Island's Constitutional Development, 1776–1841*. Providence: Rhode Island Historical Society, 1977.

Conley, Patrick T., and Campbell, Paul. *Providence: A Pictorial History*. Norfolk, VA: Donning Company, 1982.

Corbett, Scott. *Rhode Island*. States of the Nation. New York: Coward-McCann, 1969.

Curran, Kathleen A., ed. *Thomas Alexander Tefft: American Architecture in Transition, 1845–1860*. Providence, RI: Department of Art, Brown University, 1988.

Dorr, Henry C. *The Planting and Growth of Providence Illustrated in the Gradual Accumulation of the Materials for Domestic Comfort, the Means of Internal Communication and the Development of Local Industries*. Rhode Island Historical Tracts, No. 15. Sidney S. Rider, 1882.

Downing, Antoinette. *Early Homes of Rhode Island*. Richmond, VA: Garrett and Massie, 1937.

Duany, Andres, and Elizabeth Plater-Zyberk. *Towns and Town-Making Principles*. Cambridge, MA: Harvard University Graduate School of Design/Rizzoli, 1988.

Dunnington, Ann L. *Greater Providence: Fulfilling Its Destiny*. Chatsworth, CA: Windsor Publications, 1990.

Early Homes of Rhode Island. Architectural Treasures of Early America. N.p.: Arno Press, 1977.

Field, Edward. *The Colonial Tavern: New England Town Life in the Seventeenth and Eighteenth Centuries*. Providence, RI: Preston and Rounds, 1897.

Fielding, Helen. *Bridget Jones's Diary: A Novel*. London: Picador, 1996.

Fleming, John, Hugh Honour and Nikolaus Pevsner. *The Penguin Dictionary of Architecture*. 3rd ed. London: Penguin Group, 1980.

Florida, Richard. *The Rise of the Creative Class*. New York: Basic Books, 2002.

Guinness Book of World Records. 23rd ed. New York: Bantam Books, 1988.

Haley, John Williams, *The Old Stone History of Rhode Island*. Vol. 3. Providence, RI: Providence Institution for Savings, 1939.

SELECTED BIBLIOGRAPHY

Hitchcock, Henry-Russell. *Rhode Island Architecture*. Providence: Rhode Island Museum Press, 1939.

Jacobs, Jane. *The Death and Life of Great American Cities*. New York: Random House, 1961.

Jones, Robert Owen. *Historical and Architectural Resources of the East Side, Providence: A Preliminary Report*. Providence: Rhode Island Historical Preservation Commission, 1989.

Jordy, William H. *Buildings of Rhode Island*. Buildings of the United States, Vol. 9. Society of Architectural Historians. New York: Oxford University Press, 2004.

Jordy, William H., and Christopher P. Monkhouse, *Buildings on Paper: Rhode Island Architectural Drawing, 1825–1945*. Bell Gallery, List Art Center, Brown University; Rhode Island Historical Society; Museum of Art, Rhode Island School of Design, 1982.

Joyce, James. "I Would in that Sweet Bosom Be." *Chamber Music*. London: Elkin Mathews, 1907.

Kellner, George H., and J. Stanley Lemons. *Rhode Island: The Ocean State, an Illustrated History*. Sun Valley, CA: American Historical Press, 2004.

Kunstler, James Howard. *The Geography of Nowhere: The Rise and Decline of America's Man-Made Landscape*. New York: Simon and Schuster, 1993.

———. *Home from Nowhere: Remaking Our Everyday World for the 21st Century*. New York: Simon and Schuster, 1996.

Leazes, Francis J., Jr., and Mark T. Motte. *Providence: The Renaissance City*. Boston: Northeastern University Press, 2004.

Lovecraft, H.P. *Uncollected Prose and Poetry*. Vol. 2. West Warwick, RI: Necronomicon Press, 1980.

Martin, Mary L., and Nathaniel Wolfgang-Price. *Postcards of Providence*. Atglen, PA: Schiffer Publishing, 2007.

McLoughlin, William. *Rhode Island: A History*. New York: W.W. Norton and Company, 1978.

Millais, Malcolm. *Exploding the Myths of Modern Architecture*. London: Frances Lincoln Publishers, 2009.

Mitchell, Joni. "Big Yellow Taxi." Siquibomb Publishing Company/jonimitchell.com, 1968.

Providence: Southern Gateway of New England, Commemorating the 150th Anniversary of the State of Rhode Island. N.p.: Historical Publishing Company, May 4, 1926.

Reed, Henry Hope, Jr. *The Golden City: A Pictorial Argument in the Raging Controversy Over "Classical" vs. "Modern" Fashion in Architecture and Other American Arts*. New York: Doubleday, 1959.

Salingaros, Nikos. *Anti-Architecture and Deconstruction: The Triumph of Nihilism*. 4th ed. Portland, OR: Sustasis Press, 2014.

Sanderson, Edward F., and Wm. McKenzie Woodward. *Providence: A Citywide Survey of Historic Resources*. Providence: Rhode Island Historic Preservation Commission, 1986.

Scruton, Roger. *The Classical Vernacular: Architectural Principles in an Age of Nihilism*. London: Palgrave Macmillan, 1995.

Semes, Steven W. *The Future of the Past: A Conservation Ethic for Architecture, Urbanism, and Historic Preservation*. New York: W.W. Norton and Company/Institute of Classical Architecture and Art, 2009.

Simister, Florence Parker. *Streets of the City: An Anecdotal History of Providence*. 3rd ed. Providence, RI: Mowbray Company, 1968.

Tallman, Mariana M. *Pleasant Places in Rhode Island, and How to Reach Them*. Providence, RI: Providence Journal Company, 1893.

Tardiff, Elyssa, and Peggy Chang. *Providence's Benefit Street*. Images of America. Charleston, SC: Arcadia Publishing, 2013.

Taylor, Maureen. *Picturing Rhode Island: Images of Everyday Life, 1850–2006*. Beverly, MA: Commonwealth Editions, 2007.

Wilson, Arthur E. *Paddy Wilson's Meeting-House: In Providence Plantations, 1791–1839*. Boston: Pilgrim Press, 1950.

———. *Weybosset Bridge: In Providence Plantations, 1700–1790*. Boston: Pilgrim Press, 1947.

Wolfe, Tom. *From Bauhaus to Our House*. New York: Farrar Straus Giroux, 1981.

Woodward, Wm. McKenzie. *Downtown Providence: Statewide Historical Preservation Report P-P-5*. Providence: Rhode Island Historical Preservation Commission, 1981.

Plans and Documents

Blair Associates. *Community Renewal Program*. City of Providence. U.S. Department of Housing and Home Finance Agency, Urban Renewal Administration. Providence, RI: Charles G. Gowan Associates, 1964.

The Capital Center Project: Design and Development Regulations. Providence, RI: Capital Center Commission, 1989.

The Capital Center Project: Design and Development Regulations. Providence, RI: Capital Center Commission, 1987.

The Capital Center Special Development District: Design and Development Regulations. Providence, RI: Capital Center Commission, 2003.

SELECTED BIBLIOGRAPHY

Carr, Lynch Associates, and Melvin F. Levine and Associates. *Providence Development Strategy*. Providence, RI: Providence Department of Planning and Development, 1986.

City of Providence Zoning Ordinance. Chapter 2014-39 No. 513. Adopted November 24, 2014. Providence, RI: Providence City Council, 2014.

"Cove Lands." Commissioners of the Cove Lands: Report, Made Pursuant to Resolutions of the Board of Aldermen of the City of Providence. Providence, RI: Angell, Burlingame and Company, 1877.

"Downtown Providence Historic District." National Register of Historic Places: Nomination Form. Providence: Rhode Island Historical Preservation and Heritage Commission, 1980.

Duany, Andres. *Downcity Project Implementation Plan*. Coalition for Community Development, Providence Foundation, 1994.

Expressway System for Metropolitan Providence. Rhode Island. Department of Public Works. Providence, RI: Charles A. Maguire and Associates, 1947.

Federal Office Building, Providence. Final Environmental Impact Statement, U.S. General Services Administration. Boston: Public Buildings Service, 1979.

Freeman, John R. *Commission on East Side Approach*. Report. City of Providence. Providence, RI: Loose Leaf Manufacturing. Company, 1912.

Hammerschlag, Dieter, ed. *Downtown Providence 1970: A Demonstration of Citizen Participation in Comprehensive Planning*. Providence, RI: City Plan Commission, 1961.

Historic American Buildings Survey. Library of Congress. http://www.loc.gov/pictures/item/ri0346.

Howes, Gerald. *Interface: Providence*. Providence: Rhode Island School of Design, 1974.

Howes, Gerald, Paul F. Pietz and Robert Y. Wong. *Kennedy Plaza Redevelopment Plan*. Providence, RI: Interface: Providence Urban Design Group, 1976.

Pawlowski, Paul R.V. *The Ship Street Canal: An Economic Development Proposal*. Providence, RI: Ship Street Canal Development Corp., 2004.

Providence City Plan Commission, Providence Preservation Society. *College Hill: A Demonstration Study of Historic Area Renewal*. 2nd ed., 1st ed., 1959. Providence, RI: College Hill Press, 1967.

Providence Place: Application for Development/Parcels 10 and 13. Providence Place Group, 1994.

Providence Place: Revised Development Application Package for Capital Center District Parcels 10 and 13, Providence Place Group, 1997.

Rhode Island Heritage Hall of Fame. Biographies of Inductees. Edited by Patrick T. Conley. riheritagehalloffame.org.

SELECTED BIBLIOGRAPHY

Rhode Island Historical Preservation and Heritage Commission. Meeting minutes. Presentation by RIHPHC staff member Richard Greenwood on Narragansett Hotel Garage, May 9, 2012.

Rhode Island School of Design. http://www.risd.edu/About/History_Mission_Governance/Mission.

Sasaki Associates. *Providence 2020*. Providence, RI: City of Providence, 2006.

Warner, William D. *I-195 Old Harbor Plan*. Providence: City of Providence, State of Rhode Island, Providence Foundation, 1992.

———. *Providence River Relocation Project*, Exeter, RI: William D. Warner Architects and Planners, 1991.

———. *The Providence Waterfront: 1686–2000*. Exeter, RI: Providence Waterfront Study, 1985.

NEWSPAPER AND JOURNAL ARTICLES

Brussat, David. "The Battle of Westminster & Mathewson." *Providence Journal*, November 13, 1992.

———. "Full Facial for the Fourth Howard." *Providence Journal*, March 7, 2002.

———. "In Defense of Gentrification." *Providence Journal*, January 30, 2003.

———. "Providence's 10 Best Lost Buildings." *Providence Journal*, March 27, 2014.

———. "A Review of Design Review." *Providence Journal*, February 18, 1992.

———. "Settlement on the Moshassuck." *Providence Journal*, July 18, 1996.

———. "Wanted: A New Civic Role for the Old Downtown." *Providence Journal*, October 29, 1991.

Buhle, Paul M. "Vanishing Rhode Island." *Rhode Island History* 49, nos. 3, 4 (1991).

Castellucci, John. [Article about Andres Duany and Downcity Plan]. *Providence Journal*, April 13, 1992.

———. "A Conversation with…Architectural Advocate Derek Bradford." *Providence Journal*, February 26, 1996.

———. "A Conversation with…Arnold B. 'Buff' Chace." *Providence Journal*, September 7, 1995.

Chiappinelli, Robert S., and Alan Rosenberg. "Opposition to Old Stone Bank Project Is Building; The Bank Makes No Apologies." *Providence Sunday Journal*, June 13, 1982.

Evans, Timothy. "Horror and the Uses of Tradition in the Works of H.P. Lovecraft." *Journal of Folklore Research* 42, no. 1 (January 2005): 99–135.

Gray, Christopher. "Not Just a Perch for King Kong." *New York Times*, "Streetscapes, Real Estate," September 23, 2010.

Holleran, Michael. "Filling the Providence Cove: Image in the Evolution of Urban Form." *Rhode Island History* 48, no. 3 (August 1990).

Klemesrude, Judy. "Her Mission Is Preserving Providence." *New York Times*, "Home & Garden," May 2, 1985.

Laffan, James F. "$102-Million Face-Lift for City?" *(Providence) Evening Bulletin*, May 3, 1960.

Morgan, Thomas. [Story describing downtown forty years ago]. *Providence Journal*, February 7, 1994 (?).

Parker, H.L. "Architect William Warner Dies." *Providence Daily Dose*. http://providencedailydose.com/2012/08/31/architect-william-warner-dies.

"A Plan to Let the City Compete with Suburbia." Editorial. *Providence Journal*, May 4, 1960.

Semes, Steven W. "Le Violon d'Ingres: Some Reflections on Music, Painting and Architecture." Future Symphony Institute. Originally published in *American Arts Quarterly* 23, no. 2 (Spring 2006). http://www.futuresymphony.org/le-violon-dingres-some-reflections-on-music-painting-and-architecture.

Walker, Nathaniel Robert. "Architecture and Food." *Architecture Here and There*, January 8, 2015. https://architecturehereandthere.com/2015/01/08/nathaniel-robert-walker-architecture-and-food.

INDEX

INDEX

INDEX

INDEX

ABOUT THE AUTHOR

David Brussat was born in Chicago, grew up in the Cleveland Park neighborhood of Washington, D.C., and graduated from American University with a degree in journalism. He got his first job in the field in 1978 as a copyboy and swiftly rose to dictationist at the Washington bureau of the Associated Press. He got his first job on a newspaper in 1981 as an editorial writer at the *Augusta (GA) Chronicle*; his second in 1983 as an editorial writer at the *Daily Press* in Newport News, Virginia, where he had his first weekly column; and his third in 1984 as an editorial writer at the *Providence (RI) Journal*.

He began writing a weekly column about architecture in 1990, won an Arthur Ross Award from the Institute of Classical Architecture & Art in 2002 for his architectural writing, joined the board of the ICAA's New England chapter in 2007 and founded his blog *Architecture Here and There* in 2009, a few days after his wife, Victoria, delivered their child, Billy. He lived at three successive addresses on Benefit Street in Providence until 1999, when he

moved into a fifth-story downtown loft in the Smith Building, where he was joined by Victoria in 2007 and Billy in 2009. In 2010, after a year of hearing that a backyard is required to bring up children (tell it to the Manhattanites!), they moved to a modest single-family house, built in 1922, his first since 1962 (in D.C., he had grown up in a semi-detached house), on the East Side of Providence, where they now live with their cat, Gato, and their fish, Bluebird.

In addition to the ICAA, he is a member of the Providence Preservation Society, the Providence Athenaeum, the Rhode Island Historical Society and the National Civic Art Society, and he is a Fellow of the Royal Society of the Arts, headquartered in London.

In September 2014, the *Journal* was acquired by a newspaper chain, which ended his three decades with the paper. Since then, he has continued his blog, formed a consultancy to offer his writing and editing to clients from the guest bedroom of his house and written this book.

CPSIA information can be obtained
at www.ICGtesting.com
Printed in the USA
LVHW082001260121
676876LV00016B/363